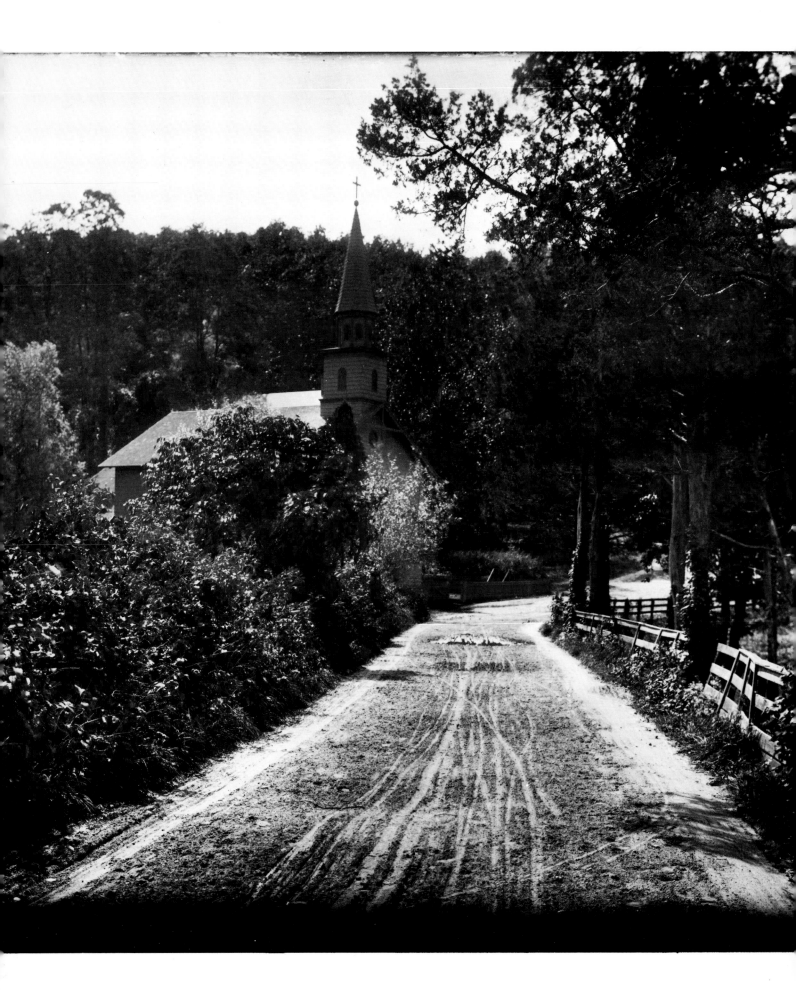

NASSAU COUNTY LONG ISLAND
IN EARLY PHOTOGRAPHS
1869-1940

Bette S. Weidman
&
Linda B. Martin

Dover Publications, Inc.
New York

ACKNOWLEDGMENTS

We were advised in our selection of photographs by our publisher, Hayward Cirker, who first suggested the book, and his staff: Clarence Strowbridge, Carol Belanger Grafton, and James Spero. For allowing us to borrow original prints for reproduction, we owe special thanks to Edward J. Smits, Director of the Nassau County Museum. For help on difficult identifications, we thank Richard Winsche, Nassau County Historian, Mary Louise Matera, Librarian, and Glenn Sitterly, of the Sands Point Preserve and the Baldwin Historical Society. Wallace Broege, of the Suffolk County Historical Society, cooperated with us by showing glass plates and arranging for printing. We are also indebted to the following: Mrs. Irwin Smith, Garden City Archives; Irene Duszkiewicz, Margaret Heller, Hempstead Public Library; Mrs. Hoffman Nickerson, Erik Eriksen, Oyster Bay Historical Society; Priscilla Ciccariello, Port Washington Public Library; Howard Ruehl, Valley Stream Historical Society; Charlotte Gershwin, Anthony Cucchiara, Bryant Library, Roslyn; Robert P. Coles, Daniel Russell, Glen Cove Public Library; Anne Kardos, Rebecca Rockmuller, Hewlett-Woodmere Public Library; Mary Jane Halley, Betty McMahon, The Phillips House Museum, Rockville Centre; Mildred Roemer, East Rockaway Grist Mill Museum; George Harrell, Floral Park Public Library; Gary Roth, Sagamore Hill Research Library; Barbara Krampitz, William Lollis, Westbury Public Library; Fred Lightfoot, Greenport; George Trepp, Long Beach Public Library; Ray Jacobs, Roslyn; Roy Moger, Roslyn; Lillian Glaser, Robert Raynor, Freeport Historical Society; Leila Mattson, Joseph Covino, Great Neck Public Library; Rikki Sowinski, Sea Cliff; Bud Latham, Long Island State Park and Recreation Commission; Harold Scully, Ann Leonard, Island Park Village Hall; Ron Ziel, Bridgehampton; Fred Hewlett, Woodmere; Genevieve Katyryniuk, Nassau County Museum; Betty Carpenter, Diane Perry, Suffolk County Historical Society; Beth and Aileen Silver, Great Neck; Film Stills Archives, Museum of Modern Art; Henry Arbatowicz, Great Neck; Caroline Mernoff, Plainview Public Library; Jerry Nichols, Freeport Public Library; Bruce Haldeman, Lakeview Historical Society; Dorothy King, Easthampton Free Library; Dr. Robert D. Martin, Great Neck; The Brooklyn Public Library. For help in correcting the second printing, we especially thank Eugene Husting of Locust Valley for his painstaking research on aviation, Mrs. Irwin Smith for her comments on Garden City, and Richard Winsche, Nassau County Historian, for patiently resolving factual errors.

FOR

Laura and Jeffrey
Nadine and Amanda

Published in Canada by General Publishing Company, Ltd., 30 Lesmill Road, Don Mills, Toronto, Ontario.
Published in the United Kingdom by Constable and Company, Ltd.

Nassau County, Long Island, in Early Photographs: 1869–1940 is a new work, first published by Dover Publications, Inc., in 1981.

Book design by Carol Belanger Grafton

International Standard Book Number: 0-486-24136-X
Library of Congress Catalog Card Number: 80-69086

Manufactured in the United States of America
Dover Publications, Inc.
31 East 2nd Street
Mineola, N.Y. 11501

INTRODUCTION

Imagine Long Island as a great sperm whale floating close to the southeastern tip of Manhattan. A line from its spouthole to its underslung jaw will set the western boundary of Nassau County. Locate Hempstead at its lashless eye, Levittown at its hidden ear, and the eastern edge, a third of the way down its length, behind the flipper, to define the shape of New York's sixty-first county.

This geographic and political entity was established on January 1, 1899, shortly after the five boroughs were consolidated into Greater New York. The Legislature so resolved a vexing question: should the 274-square-mile area, with its growing population, remain part of Queens, attach itself to Suffolk or become a new county? Historical evidence offered partial support for incorporation since Nassau was originally under the Dutch jurisdiction of Peter Stuyvesant; on the other hand, its first major town, Hempstead, had been settled by English from Connecticut, who also colonized Suffolk. Independence was the most appropriate solution for a place whose people intermingled for their own advancement without regard to the property disputes of kings and royal governors.

The name of the new county also preserved its Dutch and English heritage. It recalled the fact that in 1693 all of Long Island was renamed "Ye Island of Nassau," in honor of William of Nassau and Orange, King of Holland, who assumed the throne of England in the Glorious Revolution of 1689.

William's reign coincided with the rise of a distinct colonial culture on Long Island. Relative freedom from wars with the 13 aboriginal Indian tribes permitted development of agriculture and a coastal trade, natural to an island of varied terrain with ample wood and water. The Indians prized local clay, sandy beaches, clam shells for wampum, fish and game; the Europeans added an appreciation of deep-water harbors, streams that could power mills, and grazing lands for livestock. Sheep raising and farming capitalized on the accepted practice of slavery, in spite of the early presence of Quakers and the influence of religious tolerance. Parallel development of colonial settlements occurred because of poor road transportation. Where they existed, routes between villages followed old Indian paths; colonists required north-south roads to gain access to the water, on which they depended for most travel.

The relative isolation of Long Island towns in the eighteenth century did not prevent their involvement in political dissent. At the time of the Revolution, loyalties were divided. In the township of Hempstead, which then stretched from the Sound to the ocean, those in the southern portion were loyal to the Crown; settlers on the northern necks offered cooperation to the Continental Congress in 1775. A few years later, this split caused the formal secession of North Hempstead, today a reminder of that internal struggle.

In August 1776, the Battle of Long Island left the patriots in an especially difficult position, with the British entrenched for the duration of the war. The 32,000 enemy troops depleted farm products and permanently altered the landscape by cutting enormous quantities of wood. However, patriot resistance continued, even in Raynham Hall, British headquarters in Oyster Bay; Robert Townsend, alias Culper Jr., son of the occupied household, was George Washington's chief intelligence agent in New York. The victorious end of the Revolution was celebrated on Long Island by Washington's famous 1790 journey.

After the war, newly independent Long Islanders concentrated their efforts on recovering prosperity. They engaged in whaling, oystering, shipbuilding and a variety of milling industries. The War of 1812 stimulated local production, especially the manufacture of woolens. But postwar importing soon destroyed this industry, and by the time of the Civil War whaling, too, had declined.

In this period, the railroad offered a new source of economic development. Running through the barren plains of central Long Island to carry freight from New York to Greenport and thence, by ferry, to Boston, the railroad soon became important for local travel. It opened up Long Island for settlement, as towns grew along the tracks and visitors discovered the recreational possibilities of beaches and countryside. Along with the railroad, steamboats increased ease of travel for visitors and commuters. Regular service was provided to North Shore ports in the mid-nineteenth century.

In these Civil War years, Long Island, removed from the scene of battle, thrived in a way that was impossible during the Revolution. Stagecoaches and market wagons traveled the more reliable east-west toll roads, maintained by private turnpike companies. Relatively few volunteers traveled to war, however, as the Queens County *Sentinel* for May, 1861 lamented: "Oh Long Island, are the men of the Southside clams, and those of the Northside oysters? Where are the men of muscle?"

Instead of men, Long Island supplied ships, developing sophisticated ironworks in Greenpoint, where the *Monitor* was fabricated, and large wooden shipyards in Port Washington. Cordwood was sent to New York from towns along the North Shore. Tin for

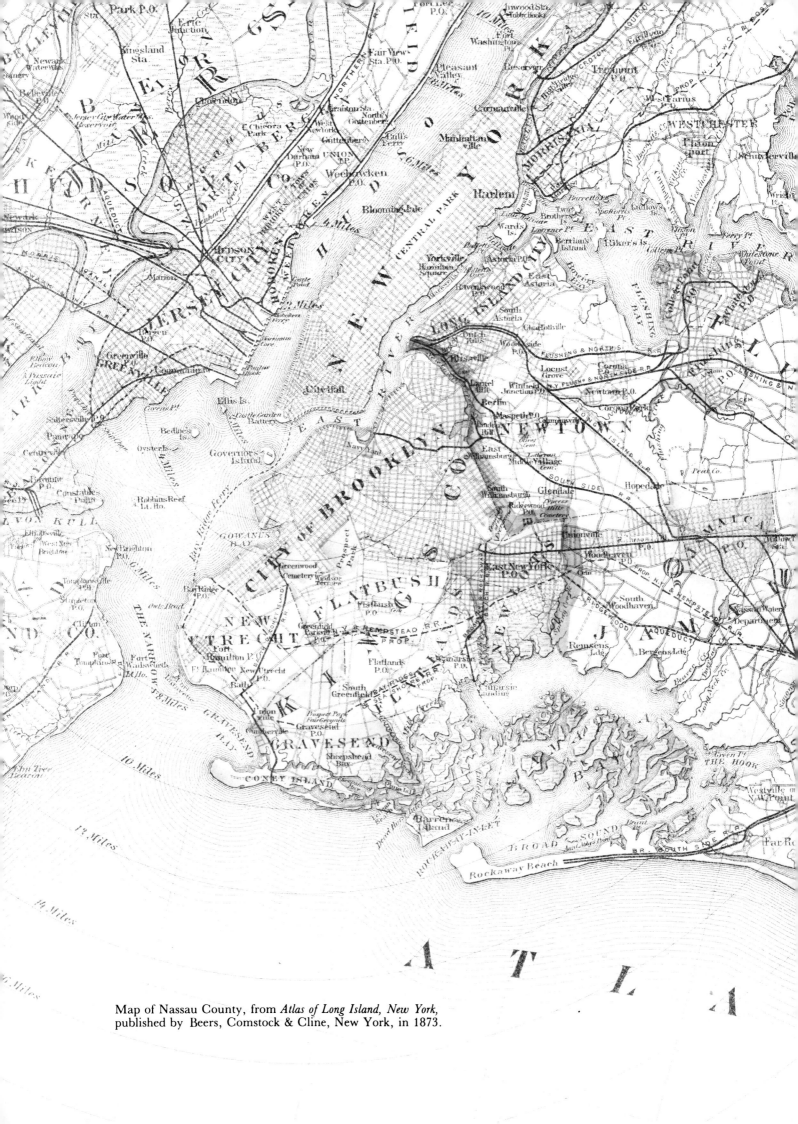

Map of Nassau County, from *Atlas of Long Island, New York*,
published by Beers, Comstock & Cline, New York, in 1873.

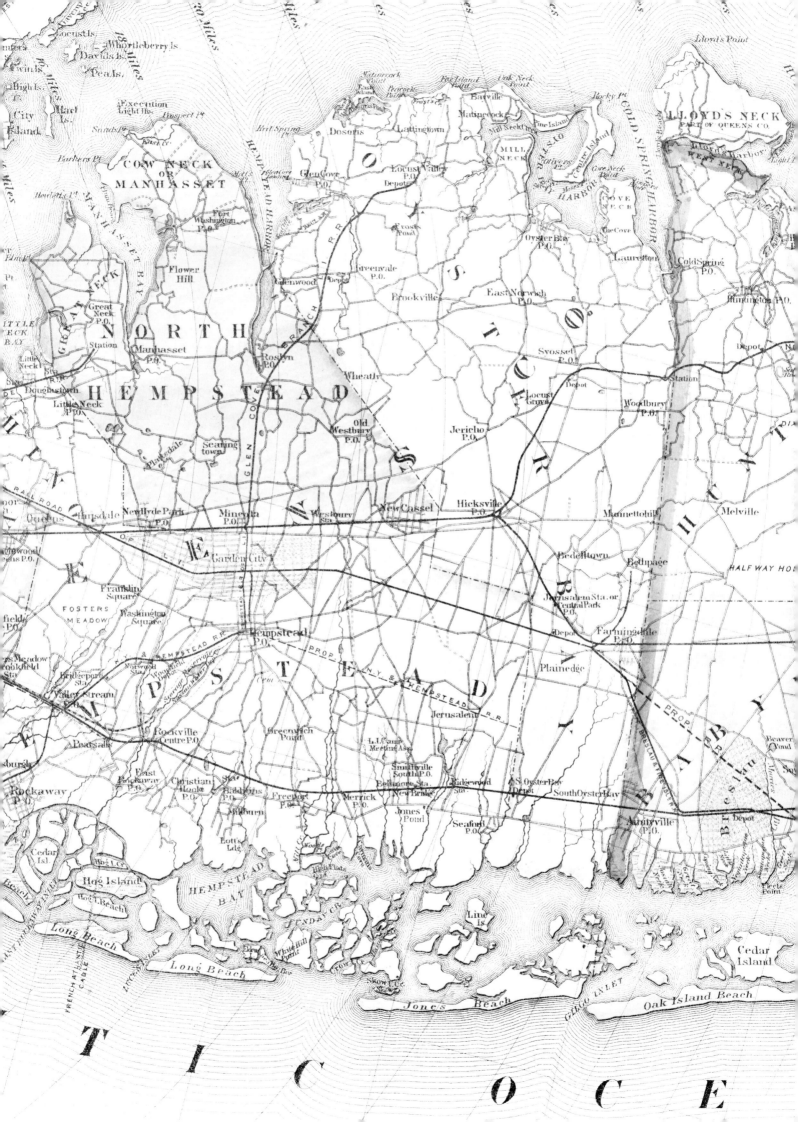

nitroglycerine containers and canning, and calfskin for drumheads were two new local products made during these years. The only battles on the homefront this time were the competitions to raise the highest liberty pole (Hempstead won at 116 feet).

In the post–Civil War years a new wave of immigrants from Europe, especially from Ireland, Italy and Germany, settled on Long Island. They farmed, built roads and worked in early industries such as brickmaking and blacksmithing, or in factories producing leather belting and cornstarch. Later they served as gamekeepers and gardeners on the estates built by the wealthy who purchased huge tracts of farmland. A commentator in 1890 wrote of the "pleasant pressure of progress," and noted that, "Nature, it would seem, designed Long Island as much for a pleasure resort as for a farming community."

The wealthy were the first to own the newfangled automobiles produced at the turn of the century. No other single force has accounted for more change on Long Island than this initially innocent toy of the rich. But a Model T Ford that cost $1,000 in 1908 sold for only $265 after the assembly line was introduced in 1914. One result of the ensuing explosion of automobile ownership was that barely adequate unpaved roads gave way to an expanding, sophisticated system of parkways. Another result was the influx of an increasingly mobile population, both as permanent residents and Sunday visitors. Real-estate development of housing and beachfront resorts characterized the early twentieth century on Long Island. Trolley cars and main streets flourished.

World War I stimulated industry and transportation, making this the center of developments in aviation. The industrial revolution came late, but when it came it consumed open lands for the production of aircraft and military supplies. Following World War II and the return of home-seeking veterans, potato fields were covered with housing. In the postwar period, Nassau County became famous for suburban subdivisions and supermarkets, for shopping centers and superhighways.

Now people have become concerned about the deterioration of our environment and the obliteration of landmarks. It is of special importance to note the historical development of Long Island, as it is epitomized in Nassau County, for change is moving eastward rapidly.

For reconstructing the history of the years between the Civil War and World War II, photography offers a valuable primary source. During these years, advances in technology, especially the development of gelatin dry plates, made picture taking easier and more widespread. Shorter exposure times and increasing portability encouraged amateurs as well as professionals to use cameras for recording daily life and local landscape.

Photographs were produced in large numbers for a multitude of purposes. Their quality varied with the photographer's capacity to define a subject, choose an angle of vision and recognize the importance of light. Few photographers, if any, considered their pictures historic documents, leaving little in the way of identification beyond an occasional date or title. Among those whose work is represented in this book are a postcard maker, whose souvenir views of main streets found an immediate market; an employee of the Long Island Railroad, hired to promote local travel; a Quaker farmer's daughter, who studied painting. Despite their original intentions, identified and anonymous photographers preserved without comment a record of what they saw.

Historians are captivated by the sense of immediacy offered by early photographs, which make us feel as if we are present in a vanished past. There is something unchallengeable in the accuracy of a photographic detail, which escapes the accident of point of view. It is fascinating to consider the revealing elements in an old picture, once so familiar that they were taken for granted by the photographer. For local historians, there is also a teasing familiarity in some views, for the outlines of main streets and waterfronts resist reshaping in spite of change.

Not only have the old pictures preserved a random record, but they too have been randomly preserved. On Long Island, some cartons of fragile glass plates lay stored in attics for 50 years, until the photographer died and his heirs destroyed the unwanted burden. Other pictures were kept by public agencies, relatives and private collectors, some of whom donated plates and prints to libraries and historical societies. Librarians and researchers added identification where they could, but specialized interests, neglect, lack of funds and insufficient archival training played a part in the uneven survival of these photographs. We compensated for these liabilities by using supplementary primary and secondary sources, such as town records and individual town histories, diaries, old maps, biographical dictionaries, periodicals, oral history and standard general histories such as those by Thompson, Ross and Hazelton.

This book, then, is the result of the photographers' skill, the collectors' luck and the authors' choice. We recovered and interpreted this visual record of Nassau County by examining the collections of private individuals, public libraries and historical societies, especially those of the Nassau County Museum and the Suffolk County Historical Society. Traveling 3,203 miles on Long Island, we visited 144 cities, villages and places in the three Nassau County townships, Hempstead, North Hempstead and Oyster Bay. From several thousand pictures, the final 175 were chosen for clarity of image, aesthetic value, geographical and chronological representation, general interest and support of central themes.

Although the photographs range in date from 1869 to 1940, most richly represented are the 30 years between 1880 and 1910; taken just before the county was transformed by industrial expansion and real-estate development, pictures of this period illustrate village life and agricultural economy, earlier styles of

dress and the discovery of waterfront recreation.

Our pictures are organized geographically, roughly from west to east, within three sections devoted to Nassau County's hilly, harbor-indented north, prairie-like middle and marshy, beachfronted south. This arrangement corresponds to the way natives speak of their home territories as "the North Shore," "Mid-island," and "the South Shore."

Throughout the book, we have also traced themes common to the county as a whole. These have wider application, not only to the development of Long Island, but to a changing American culture. They include: the uses and abuses of natural resources, such as water; the loss of activities and local industries such as blacksmithing, claymining, oystering, rumrunning, brickmaking and the manufacture of pipe organs; the destruction of buildings of architectural interest, both grand and humble; the shifting of town centers by road widening and altered methods of transportation; the substitution of commercial and residential development for agriculture and water-powered industry; the establishment of community activities such as fire companies and county fairs; the organization of religious groups; the growth of governmental institutions and public education.

One of the hazards of looking at historic photographs is succumbing to an uncritical nostalgia. We hope this book will suggest a more productive response. The pictorial history of Nassau County offers evidence of resourceful adaptation and careless destruction. How can we keep these perennial human choices in balance? What decisions will permit the expression of aesthetic standards and historical continuity?

Linda B. Martin
Bette S. Weidman

LIST OF PHOTOGRAPHS

NASSAU COUNTY
LONG ISLAND
IN EARLY PHOTOGRAPHS
1869-1940

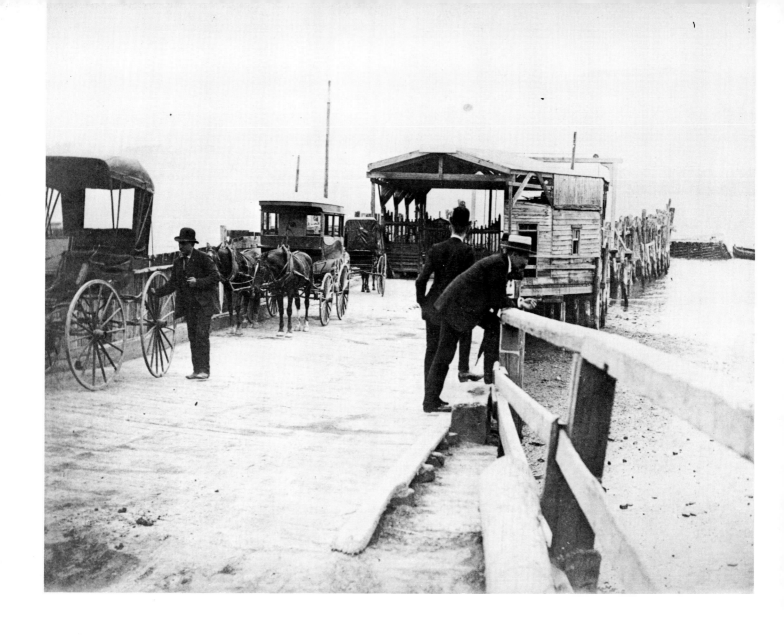

Above: **1. Steamboat Landing, King's Point (Great Neck), ca. 1880.** In the early nineteenth century, passengers traveling between Great Neck and New York were first rowed to Whitestone, where they caught a sailboat to Manhattan. By the 1830s, Whitehead, Hewlett and Udall formed the Great Neck Steamboat Wharf Company to meet the increased needs of the summer visitors and commuters who made the two-hour trip. In the 1880s, when this picture was taken, the fare from Great Neck was 50 cents and it took an hour to cross the East River and land at the 31st Street dock. Now the site of the U.S. Merchant Marine Academy at King's Point, founded in 1943, the landing was once part of the great Chrysler Estate, built in 1925. (*Official photo of U.S. Merchant Marine Academy; Great Neck Public Library.*)

Opposite: **2. Old Well with Dipper, Lake Success (Great Neck), ca. 1880.** Once called Lakeville, Lake Success was a fashionable summer resort in the 1880s, known for the fishing in its beautiful lake. Hal Fullerton caught this picture of unspoken conflict while Lake Success was still a rural community. After the abolition of slavery, the master-servant relationship still lingered. Perhaps the black child was raised in nearby "Success," a small community of freedmen who earned their living as farmers and estate workers. (*Photograph by Hal Fullerton; Suffolk County Historical Society, Fullerton Collection, #L97B.*)

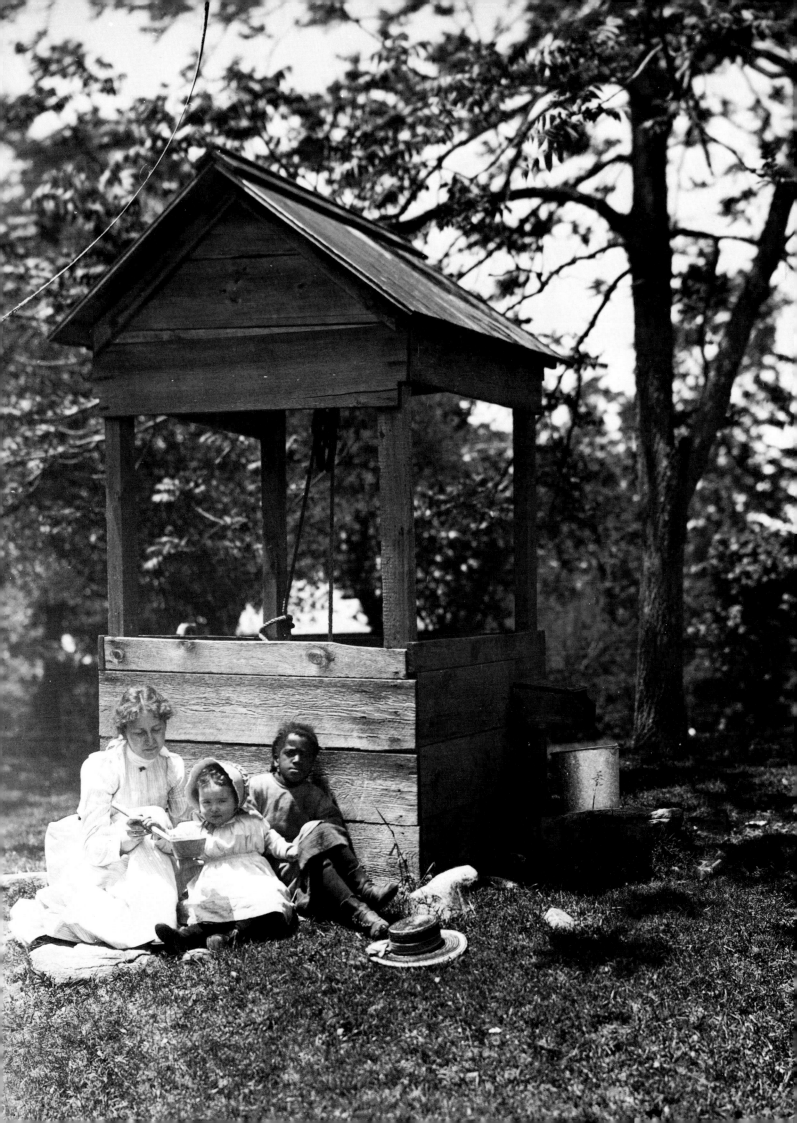

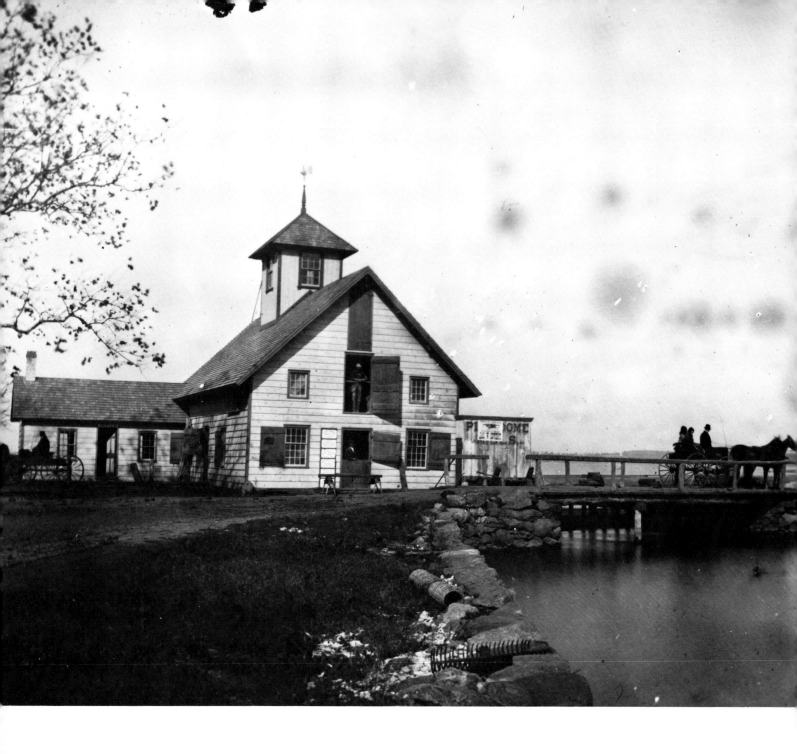

Above: **3. Plandome Mill, ca. 1880.** This old gristmill on Manhasset Bay was built in 1693 and, with its neighboring paper mill, formed the business center of a new town on the Cow Neck peninsula. In 1843, the area was named Plandome (from the Latin for "simple home") by Singleton Mitchill, farmer and mill owner, town supervisor, first judge of Queens County and brother of the famous Congressman Samuel Latham Mitchill. The mill was still in operation in the twentieth century when it became a private residence. The travelers on the right are going north to Port Washington; those on the left south toward Manhasset. (*Photograph by George Brainard; Nassau County Museum, #773.91— Brainard Plate #1450.*)

Opposite, top: **4. Manhasset Bay from Footbridge, ca. 1890.** The winding shore road still skirts the eastern edge of Manhasset Bay. Today there is no footbridge; the waters of the bay run under Northern Boulevard into Whitney Pond. Since 1898, the longest trestle of the Long Island Railroad has spanned the wetlands from Great Neck to this point in Manhasset. Sold by the Matinecock Indians to Europeans in 1639, this land was settled in the next year by 40 English families, who mingled with a few Dutch. By 1658, the settlers had fenced the Manhasset peninsula, then called

Cow Neck, as common lands for sheep grazing. The town was officially founded in 1680. British soldiers occupied it for seven years during the Revolution; they pillaged it and deforested the hills, giving Manhasset the dubious distinction of being the American territory longest held in subjection by a foreign power. (*Photograph by Hal Fullerton; Suffolk County Historical Society, Fullerton Collection, #1039C.*)

Opposite, bottom: **5. Cutter's Mill, Great Neck, ca. 1898.** Now developed with garden apartments, supermarkets and office buildings, this part of Great Neck is linked to its past only by its name— Cutter Mill Road. The old hut and big oak were on the property of Bloodgood Cutter, a grist and saw mill owner and self-proclaimed poet who lived here from 1817 to 1906. Cutter was immortalized by Mark Twain in *The Innocents Abroad* as the "poet lariat," noted for his "barbarous rhyme." Even a photographer could elicit a stirring line:

The photographer in front was seen
A getting ready his machine.

(*Photograph by Hal Fullerton; Suffolk County Historical Society, Fullerton Collection, #96B.*)

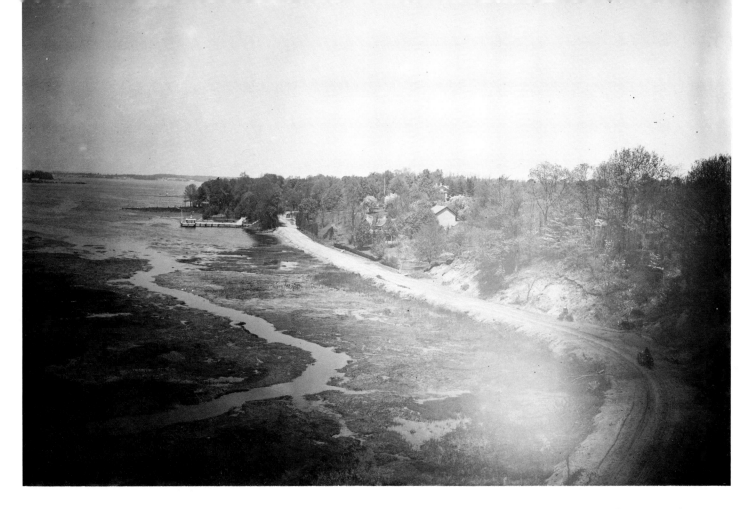

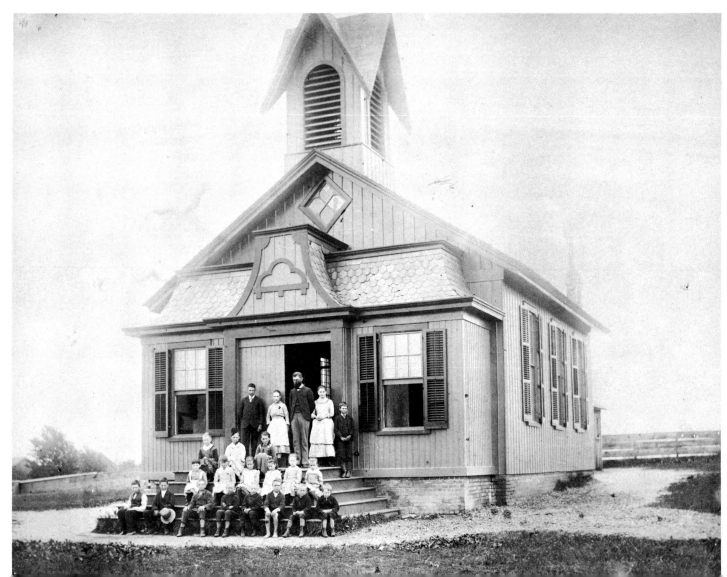

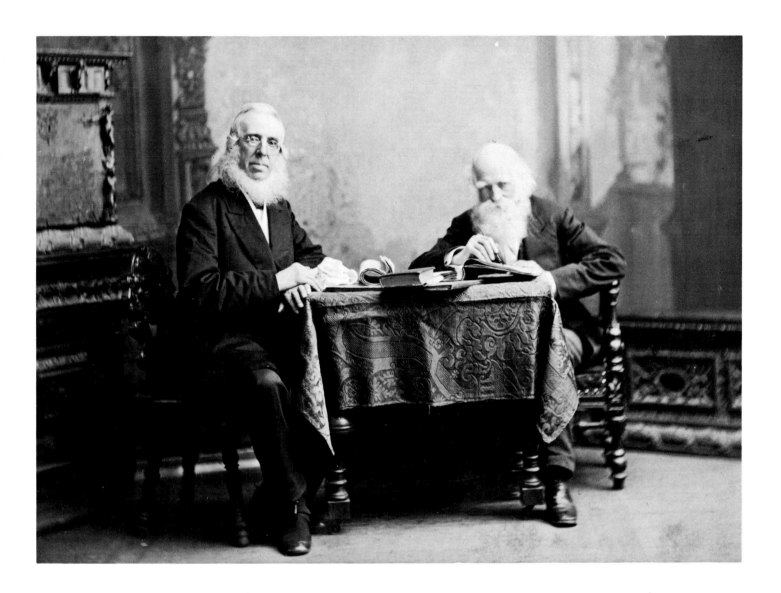

Opposite, top: **6. W. C. Fields, Great Neck, 1925.** Once treeless farmland, this community of 120 acres was made up primarily of land bought from Captain Frederick Russell in 1924. Today tall sycamores and maples arch over the village streets, grown from the 10,000 saplings, each an inch-and-a-half high, planted by the Russell Gardens Corporation in anticipation of the growth of a residential community. Great Neck was already the home of many film makers and stars, among them: Samuel Warner, Paulette Goddard, Frederick March, Leslie Howard, Maurice Chevalier, Groucho Marx, Norma Talmadge and Ed Wynn. W. C. Fields rented a house in Russell Gardens; in this photograph, autographed by director D. W. Griffith, Fields (with cigar) is promoting the film *Sally of the Sawdust*. Griffith was at the height of his career, following the success of *Birth of a Nation* (1915), in which his innovative camera technique established film as art. (*Film Stills Archives, Museum of Modern Art.*)

Opposite, bottom: **7. Herricks School, 1898.** T. B. Aldrich poses with his 21 students, the youngest seated on the bottom step, in front of one of the last of Nassau's single-room schools. Such schoolhouses were a familiar sight in Long Island villages during the nineteenth century. Among the teacher's chores were to "fill lamps, clean chimneys and trim wicks...bring a bucket of water and a scuttle of coal for the day's session." Even this prudence did not make townspeople willing to pay an acceptable salary to teachers who provided the barest elementary education in alphabet, spelling, reading, arithmetic, geography, history and grammar. In spite of their mastery of Noah Webster's spelling book, many teachers were so poorly paid that they had to be buried at public expense. Male teachers had more personal freedom than their female counterparts whose social life was severely restricted; according to an 1872 pamphlet, "Rules for Teachers," men could "take one evening each week for courting purposes, or two evenings...if they [went] to church regularly." (*Nassau County Museum, #3622.*)

Above: **8. William Cullen Bryant (right) and Peter Cooper (left), Cedarmere, Roslyn, 1875.** Two of the foremost men of their day, Cooper and Bryant are meeting at Bryant's home, Cedarmere, which still stands in Roslyn. The poet Bryant (1794–1878), who called himself "a delighted observer of external nature," was also a journalist and practical politician; he commuted by steamship from Roslyn to New York to serve as the editor of the New York *Evening Post*, a position he held for 50 years. One of the founders of the Republican Party, he introduced Lincoln to his first New York audience in 1860, in the meeting hall of Cooper Union, founded three years earlier by his friend Peter Cooper. Cooper (1791–1883) had lived in Hempstead (the house is now restored at Old Bethpage) from 1812 to 1818, where he built his fortune in wool-shearing machinery. He went on to design the first American steam locomotive, to roll structural iron and to invent the grass cutter and the self-rocking cradle. He was also a noted philanthropist. At the time of this meeting with Bryant, he was planning to run for President on the Greenback ticket in 1876. (*Nassau County Museum, #5598.*)

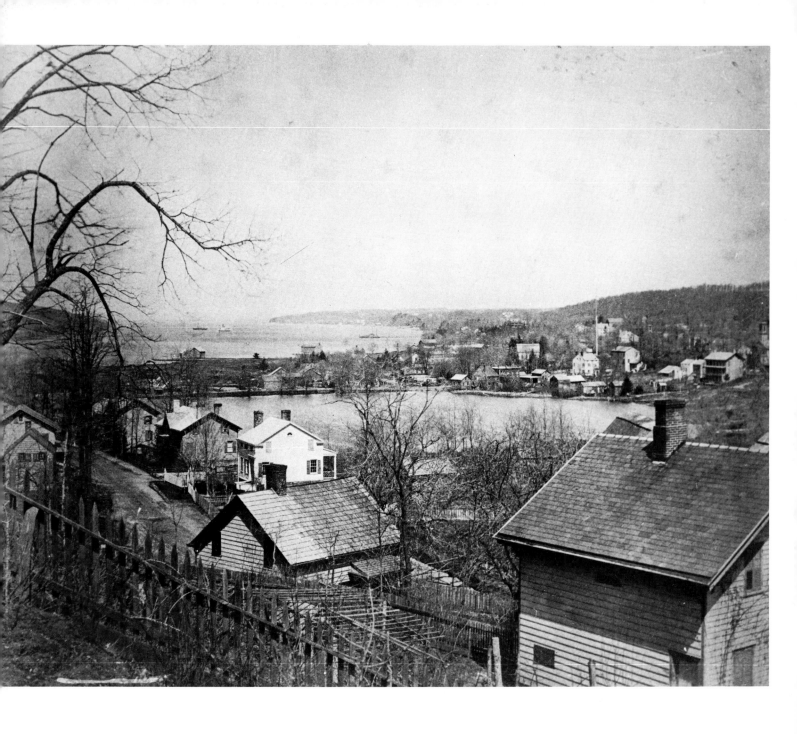

9. General View, Roslyn, ca. 1875. Remembering the Scottish regiment quartered here during the Revolution and its favorite bagpipe tune, "Roslin Castle," local residents voted to call their town Roslyn in 1844. Taken from a height, this photograph shows its favorable natural features—a protected deep-water harbor, lovely hills and many lakes. The largest of these, Silver Lake, is seen in the center, bordered by Main Street in the foreground, the milldam at the top and East Broadway at the right rear. Commercial activity, long located on North Main and North Broadway, began at this period to center on the road across the milldam. Silver Lake, used for skating and ice cutting, was a source of pleasure and community activity. In recent years, it has been partially filled in and drained to provide building lots, like many other Nassau County ponds and streams. (*Roy Moger Collection, scrapbook #L117.*)

10. Head of the Harbor, Roslyn, 1919. When Connecticut sailors decided to found a colony on Long Island in 1643, they put their boats ashore at this place, which they called Head of the Harbor. Because it served as the port of entry for their new town of Hempstead, the waterway was known as Hempstead Harbor, a name it still keeps. Ample water resources were important for the industrial development of Head of the Harbor. At the end of the seventeenth century, a milldam was erected across the wetlands to provide power for a grist mill; later milling products included paper, silk and lumber. In the center of this photograph, a schooner is unloading lumber where today barges bearing trap rock and bluestone supply the Roslyn Asphalt Company. Bypassing the old milldam (Old Northern Boulevard), a 1950 viaduct at this point now overlooks such modern activities as oil storage and "resources recovery." (*Roslyn Village Hall, Courtesy of Roy Moger.*)

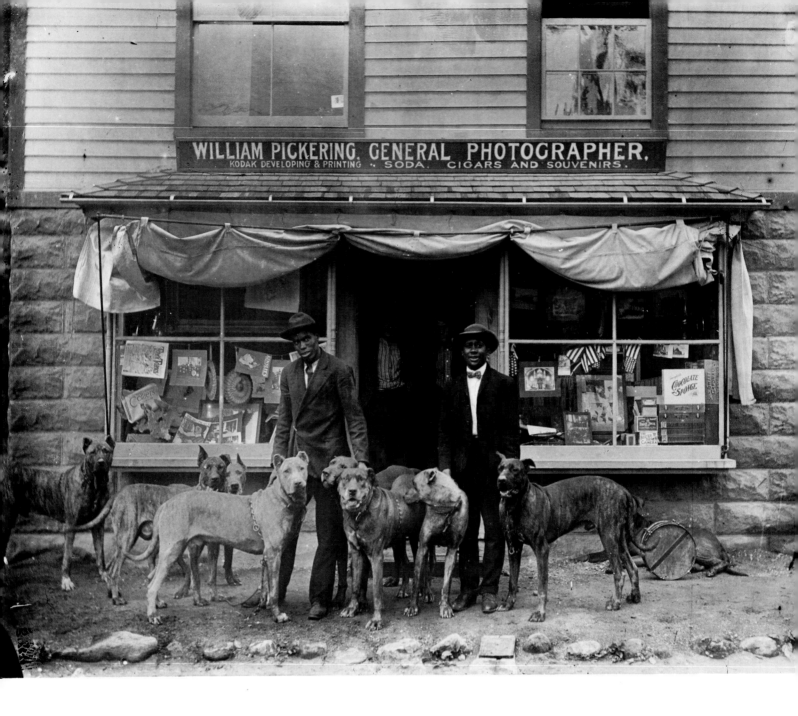

Above: **11. Pickering Studio, Roslyn, ca. 1905.** Always ready to document the passing scene, William Pickering (1865–1929) caught the spectacle of these men controlling eight fierce-looking dogs. These animals, called "Italian mastiffs" by a Roslyn historian, were used in illegal dog-fights. The Pickering Studio, at 193 East Broadway, was a popular gathering place in Roslyn, where one could be photographed or simply buy a cigar or newspaper; schoolchildren stopped at the family-run business for sodas. Pickering, who emigrated from England as a young man, developed an interest in local history as well as photography; the little shop was filled with antiques, Americana and local memorabilia. (*The Bryant Library, Roslyn.*)

Opposite, top: **12. Motoring, Roslyn, ca. 1914.** Enterprising William Pickering organized his wife and eight children into an efficient staff to run the newspaper stand and soda shop while he pursued his interest in photojournalism. Chosen as official Nassau County photographer, he captured images of wrecks and disasters for local newspapers and recorded the faces of famous and anonymous Long Islanders on hundreds of glass plates. Here, on East Broadway, one of his own children (the boy wearing a cap in the left foreground) watches as a disabled car is propped on planks of wood. It seems to be a festive occasion, as the barrel of Pilsener beer shows. The mixture of well-dressed and shirt-sleeved townspeople must have interested the photographer, who made a good record here of the fashionable motoring costume of the day: long coats and goggles for the men and scarf-wrapped headgear for the ladies. (*The Bryant Library, Roslyn.*)

Opposite, bottom: **13. Napoleon Forget, Blacksmith, Roslyn, ca. 1900.** A man with such a name is certain to be remembered! Every village in Nassau County had an establishment like this at the turn of the century. Before the horseless carriage and modern manufacturing rendered their services obsolete, blacksmiths provided hand-wrought iron for nails, tools, horseshoes and machine parts. It took endurance to withstand the heat of the forge, strength to hammer the iron bars. The leather-aproned workers in this photograph remind us of Longfellow's famous lines

> The smith, a mighty man is he,
> With large and sinewy hands;
> And the muscles of his brawny arms
> Are strong as iron bands.

(*Long Island Research Associates.*)

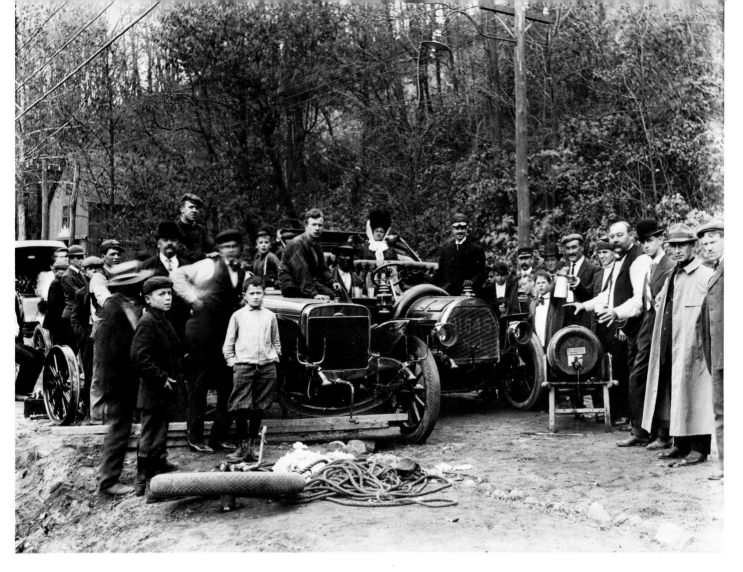

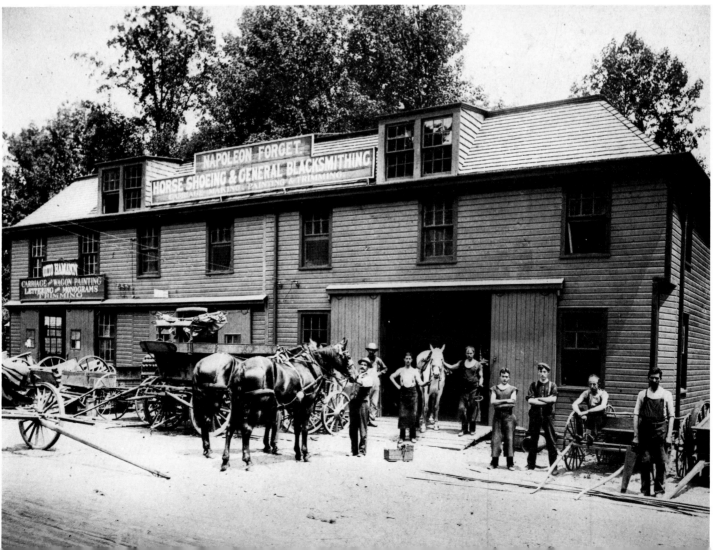

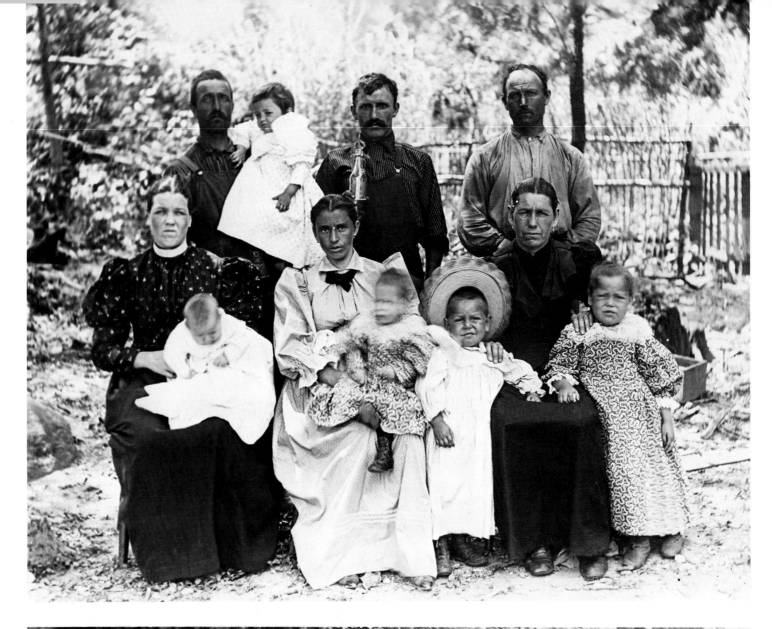

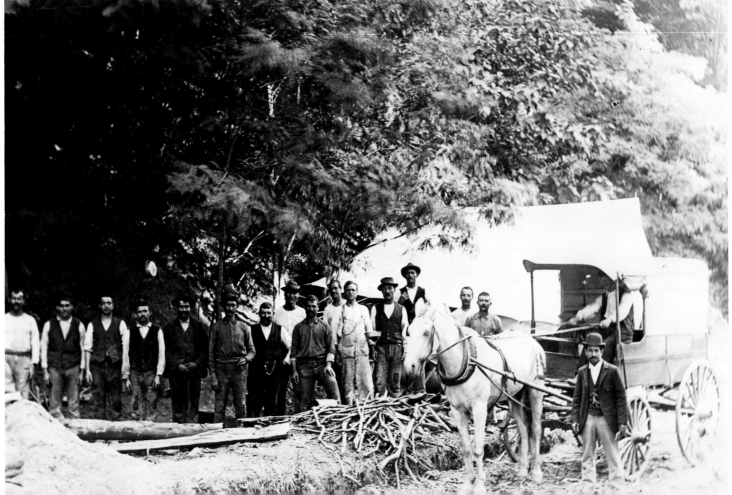

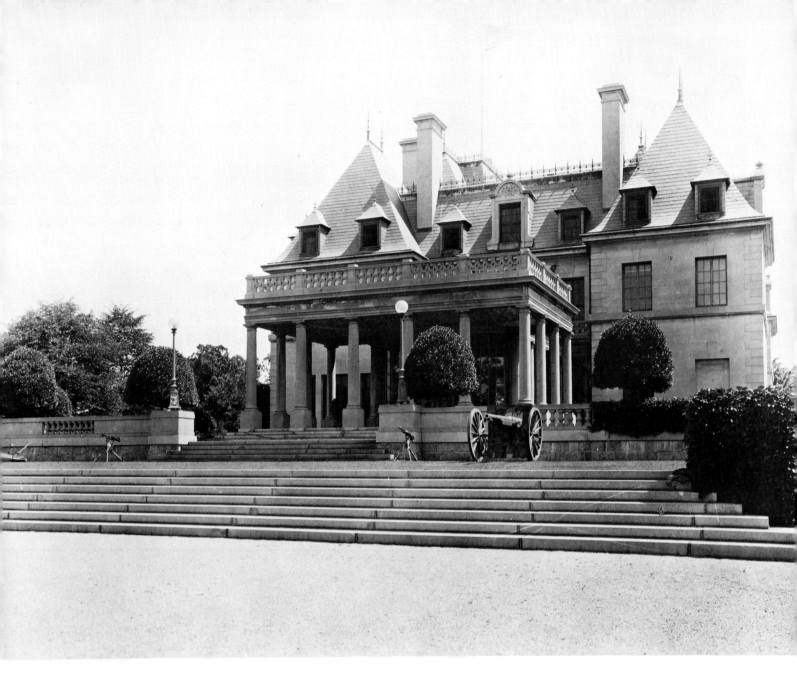

Opposite, top: **14. Italian Family, Roslyn, ca. 1900.** Beginning in the 1870s, large numbers of Italian immigrants crowded the tenements of New York City. Seeking escape from poor living conditions and factory work, some moved to still-rural Glen Cove, Westbury and Roslyn where their gardening and landscaping skills were in demand by wealthy estate owners. Taking a moment from their week's labors, this Italian family expresses the sober pride of hard-working immigrants whose lives were still not easy. To encourage Americanization among the foreign born and to advise on education and employment, the Neighborhood Association was formed in Roslyn in 1915. (*Nassau County Museum, #3618.38; The Sammis Collection.*)

Opposite, bottom: **15. Italian Workmen, Roslyn, ca. 1900.** Road-building and pipeline construction offered other oppportunities for employment among the Italian population. Perhaps some of them were inspired by the success stories of other immigrants, such as John Mackay, an Irishman who made his fortune in Nevada silver mining and spent $5 million to give his son a palatial estate as a wedding present. (*Nassau County Museum, #3618.39, The Sammis Collection.*)

Above: **16. The Mackay Estate, Roslyn, 1935.** Built at the turn of the century, Clarence Mackay's "little summer place" was a prime example of how the wealthy developed Nassau County's open lands into spectacular estates. Set on the highest point in Roslyn (368 feet) with a view of Long Island Sound and the nearby countryside, "Harbor Hill" was intended to rival the neighboring mansions of the Vanderbilts, Astors and Whitneys. It enclosed 650 acres of former wilderness and farmland, including a century-old cemetery belonging to the local black community. Pleasure-seekers could no longer visit the picnicking grounds at Taber's 100-foot-high observatory, nor could local residents gather firewood freely. But Mackay valued the woodlands, spending extra thousands to save a chestnut grove and encase the roots of an old oak. He was equally extravagant in approving the architectural plans of McKim, Mead and White, who modeled his home on a French chateau, Maison Lafitte, using pale gray stone exterior, oak columns, imported choir stalls, marble walkways and graduated plazas. Soon after this photograph was made, the main building was closed. Clarence died in 1938, but his son, John, continued to occupy ten acres of the property until 1958, when the estate was sold for development. The house was torn down in 1961, making way for the comparatively modest "estates" of the upper middle class. (*Nassau County Museum, #3395.*)

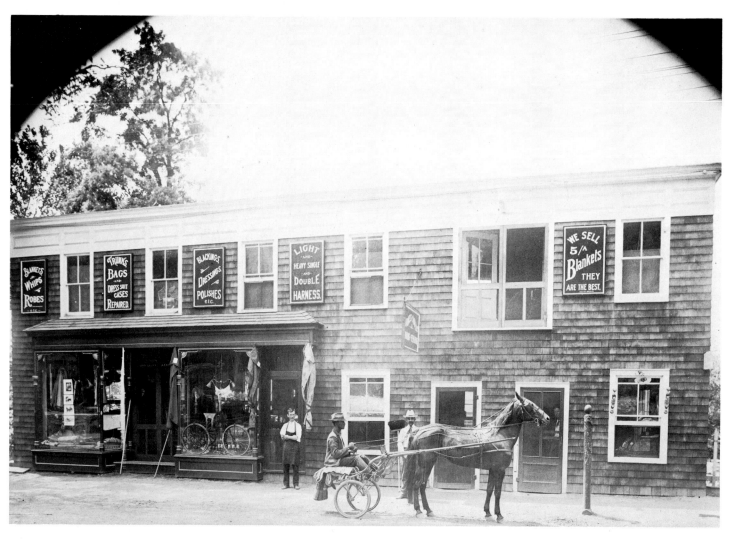

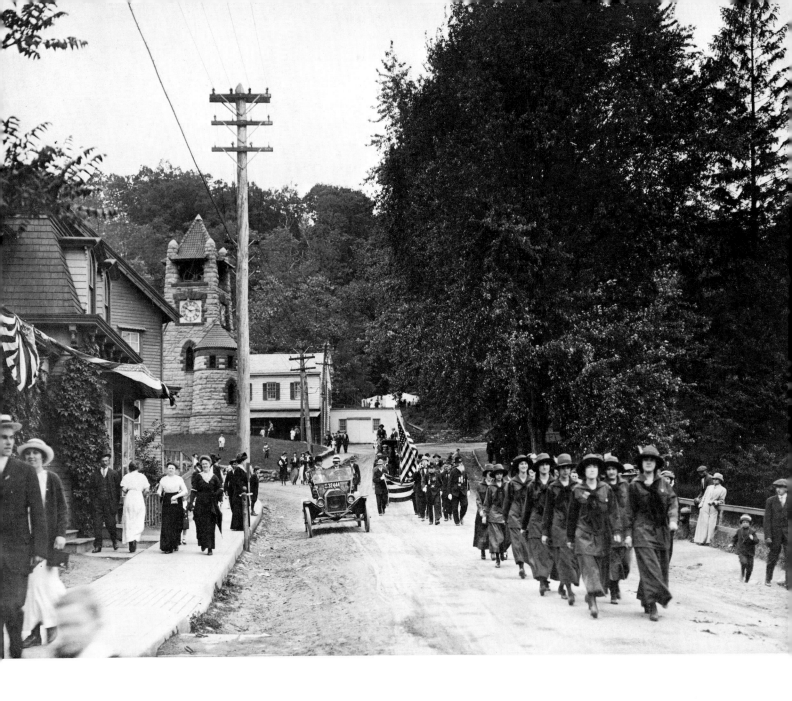

Opposite, top: **17. Remsen's Harness Shop, Roslyn, 1910.** John H. Remsen stands behind the horse as a customer he probably outfitted pauses on old Northern Boulevard. Among the products Remsen offered were blankets, harnesses, whips, robes, trunks, bags and blacking. His carriage trade was declining with the rising availability of the automobile; like the blacksmith, however, his services would be required until about 1927, when machinery replaced the horses used in farm labor and hauling. Behind Remsen's shop was a livery stable where horses and vehicles could be rented by the day, along with the funeral carriages owned by his brother, Cornelius, the town's undertaker. (*Nassau County Museum, #3343.*)

Opposite, bottom: **18. Gristmill, Roslyn, ca. 1890.** Begun in 1701, the Roslyn gristmill was located on the harbor side of the milldam so that boats could tie up alongside to unload grain and load flour. Wagons were able to approach from the milldam road, first built in 1706 and later widened to accommodate two-way traffic. The building in this photograph is the mill as it was rebuilt in 1735. George Washington visited it on his 1790 journey along Long Island's North Shore, commenting on its productiveness in his diary. The mill was owned by a succession of prominent businessmen throughout the nineteenth century, the last of whom, Isaac Hicks, gave it to Roslyn in 1916 to be restored as a museum.

Leased as a teahouse in 1919, and once a gathering place for famous people, it is now closed, awaiting further restoration. Today part of the building still stands along Old Northern Boulevard, now the commercial center of Roslyn. The present, much rebuilt road is considerably higher than the road in the photograph, reaching almost to the doorway where the miller stands. (*Nassau County Museum, #3530.*)

Above: **19. Parade, Roslyn, 1914.** This group of determined women suggests the rising influence of feminism, three years before New York State voted for women's suffrage and six years before final ratification of the Nineteenth Amendment. Unbeknownst to the marchers, who were commemorating the victims of the Spanish-American War, a great conflict is about to engulf Europe. The procession has passed the famous Roslyn Clocktower, erected in 1895 in honor of Ellen E. Ward, widow of Elijah Ward, former Judge-Advocate in New York and member of Congress. Constructed at a cost of $10,000 of Letts Island granite and red sandstone trim, the Egyptian-style tower stands 44 feet high; its bell weighs 2700 pounds; its clockworks are by Seth Thomas. On the lawn is a cannon taken in the Spanish-American War. Today the tower also serves as a memorial for Roslyn soldiers killed in World War II. (*Nassau County Museum, #3353.*)

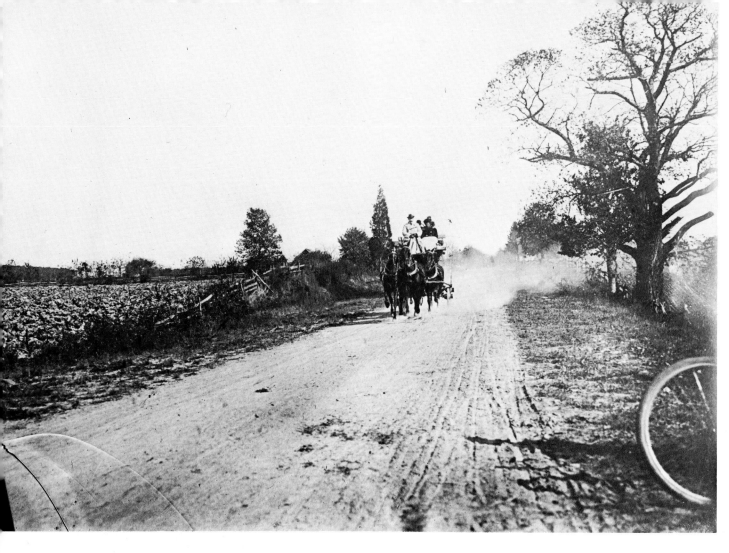

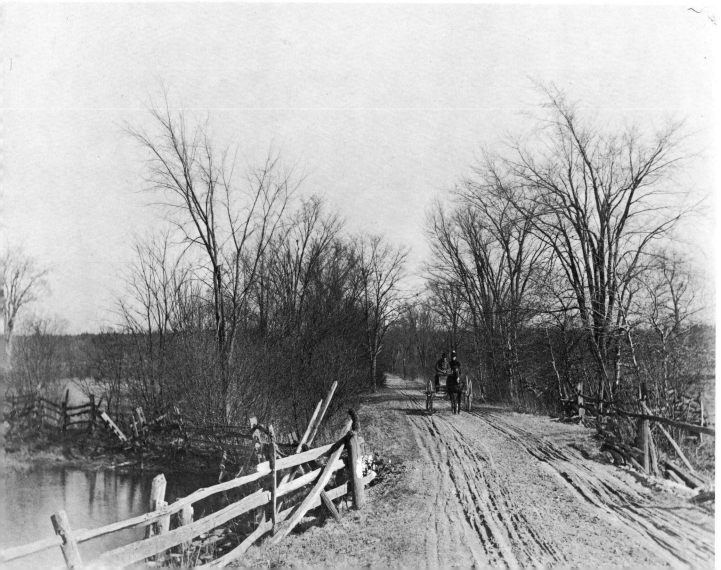

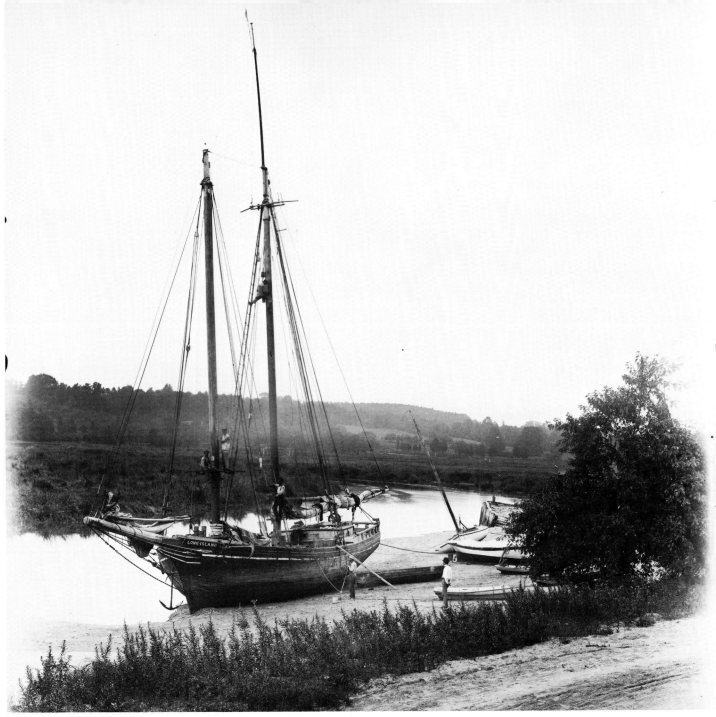

Opposite, top: **20. Coaching on North Country Road, near Roslyn, 1898.** Coaching by stage was the major form of transportation between villages from the colonial period until the turn of the century. These horse-drawn wagons were essentially boxes mounted on springs, providing a tiring and uncomfortable journey over poor roads. The length of the trip required frequent stops for the comfort of both passengers and horses. North Country Road, now known as Northern Boulevard (Route 25A), was originally an Indian path, much traveled in colonial times by settlers along the North Shore. In 1790, George Washington made a famous journey along this road, in a coach drawn by four white horses, stopping in Roslyn to dine in a local tavern and visit the town grist and paper mills. Although North Country Road became the North Hempstead Turnpike toll road in 1835, it was not macadamized until 1880. Still standing in the Roslyn Cemetery is Stephen Speedling's old toll booth, the only surviving structure of its type along Route 25A. (*Photograph by Hal Fullerton; Suffolk County Historical Society, The Fullerton Collection, #1136.*)

Opposite, bottom: **21. Dosoris Lane, Glen Cove, ca. 1900.** This rural lane served as the major north-south route in Glen Cove at the turn of the century; it is seen here at a point near Dosoris Pond and Island. The name "Dosoris" was given to the northern part of the peninsula in 1736 by the Reverend Benjamin Woolsey,

who, on receiving the property as part of his wife's dowry, called it *dos uxoris* (a wife's dowry). Although the southern portion is now a paved suburban street, Dosoris Lane follows the same path to the Sound as it did in the eighteenth century. (*Nassau County Museum, #1944.*)

Above: **22. Schooner *Long Island*, Sea Cliff Inlet, ca. 1890.** Beached at low tide on an inlet of Hempstead Harbor, the two-masted schooner *Long Island* is being readied for another voyage. Perhaps it will carry cordwood or farm products in the coastwise trade; schooners of greater tonnage transported Long Island pine, oak, brick, sand, clay and gravel as far as the Caribbean, Central America and Africa. Small sturdy wooden craft under sail had been a familiar sight on local waterways since the early seventeenth century. The reputation of Long Island captains for shrewdness in trading developed in the ensuing 200 years; some offered farmers a day of shipboard fishing to add to their winter stores in return for barrels of potatoes or cabbages to take on the next sailing voyage. The photographer, Hal Fullerton, preserved a scene that was becoming increasingly rare on Long Island, as almost all freight was finally transferred inland to the railroad and later to the superhighway system. (*Photograph by Hal Fullerton; Suffolk County Historical Society, Fullerton Collection, #L104B.*)

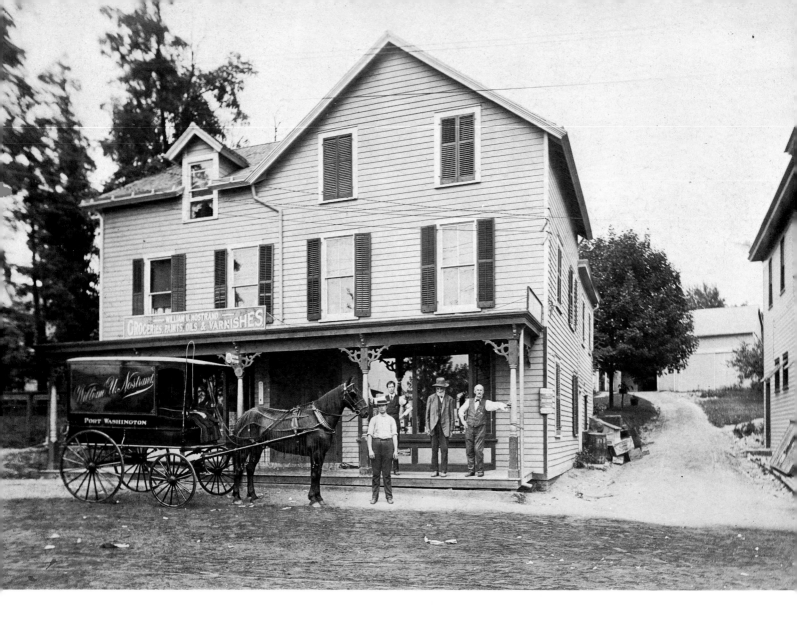

Above: **23. Van Nostrand's General Store, Port Washington, ca. 1900.** William Van Nostrand, owner of one of the first general stores in Port Washington, stands at the corner of his porch at 322 Main Street, then called Flower Hill Avenue. Mr. Van Nostrand shared the building with the postmaster. Today the Main Street of Port Washington is rather narrow, probably because its original structures, built before sidewalks and paving, were set close to the muddy road. This building remained an active commercial space into the 1970s, when it served as a furniture exchange. With a modern sidewalk in front, the old porch, once useful as well as decorative, was enclosed as a display window. (*Port Washington Public Library, Ernie Simon Collection, #N131.*)

Opposite, top: **24. Main Street, Port Washington, ca. 1910.** A new form of horsepower takes its place on unpaved Main Street. The population of Port Washington increased greatly after the town was linked to the Long Island Railroad system on June 23, 1898. A trolley line to Mineola was established by the New York and North Shore Traction Company on February 1, 1908, completing the array of typical early twentieth-century surface transit.

On the right in this view of lower Main Street is the Bank of North Hempstead. Built in 1892, it suggests, by its stone-columned solidity, the movement toward economic development that would soon render obsolete the watering troughs of Cove Inn (visible on the left). The imposing façade did not guarantee the success of the bank, but long glorified the White House Laundry that later occupied the building, which now houses two small businesses. (*Photograph by Henry Otto Korten; Nassau County Museum, #5365.611.*)

Opposite, bottom: **25. Harbor and Public Dock, Port Washington, 1910.** The itinerant photographer, Henry Otto Korten, observed the leisurely quality of a day at the town dock—girls gossiping and families gathered to watch the pleasure craft. At the dockside, Bradley's Restaurant and Hotel offered fine food and accommodation. Swimming was still possible in the unpolluted waters of the Sound. From the 1880s until 1916, a launch service brought day visitors from New York City to Port Washington as an increasingly mobile population discovered the delights of Long Island. (*Photograph by Henry Otto Korten; Nassau County Museum, #5365.673.*)

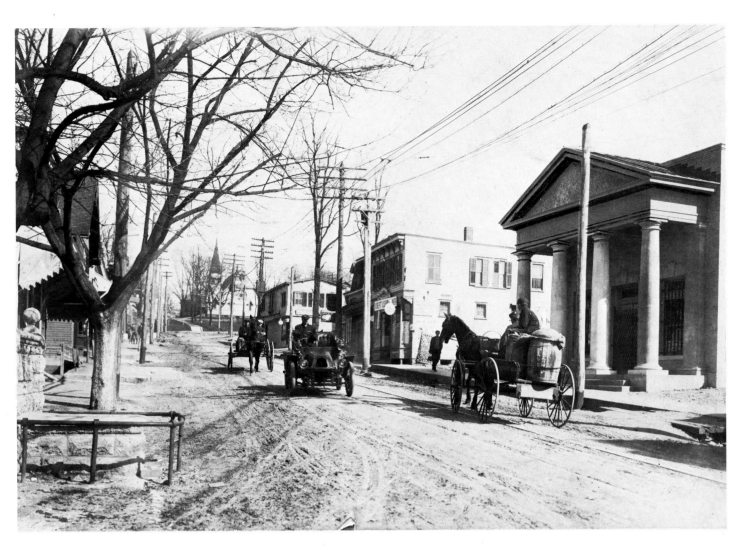

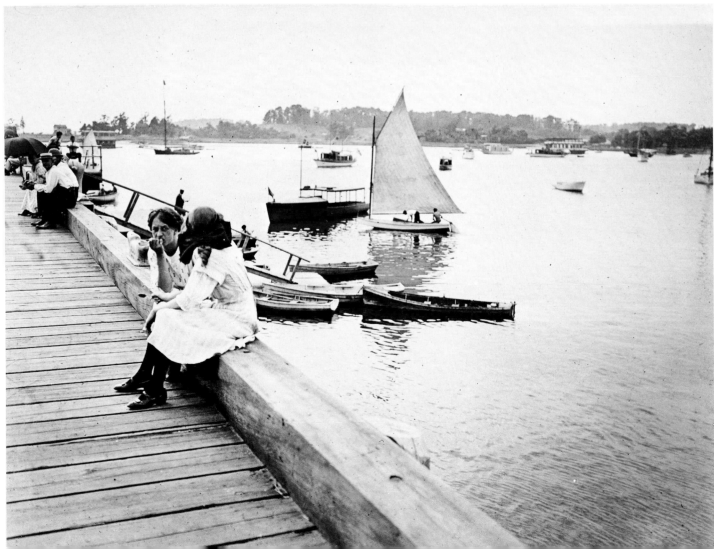

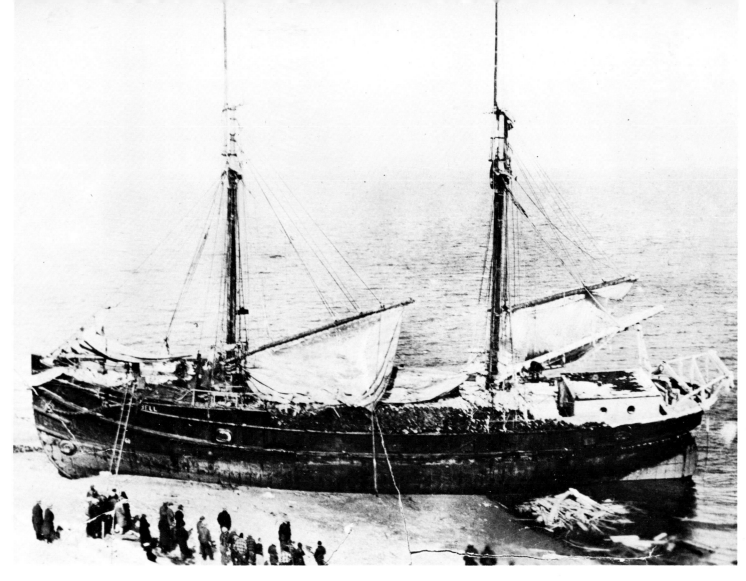

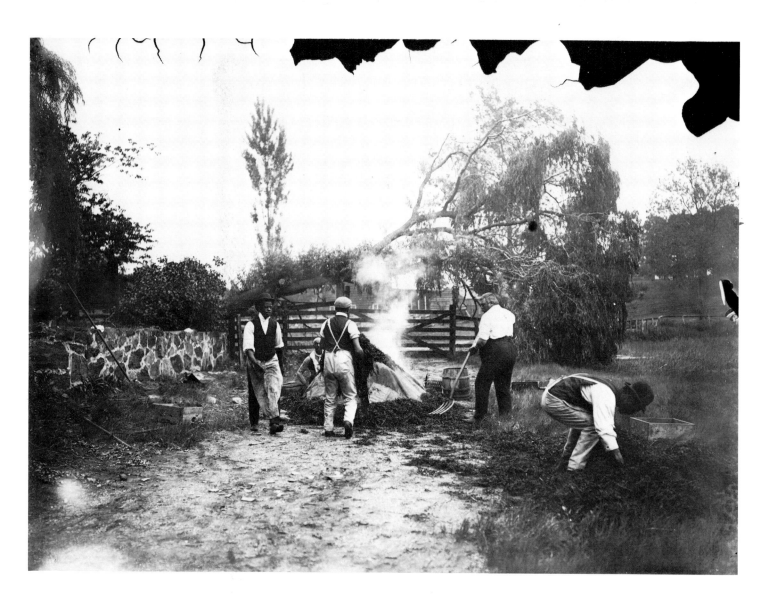

Opposite, top: **26. Wreck of the *William T. Bell*, Bayville, February 19, 1927.** The waters around Long Island were the scene of military and economic activities from the beginning of the colonial period. During the years following the Prohibition Act of 1919, large boats anchored outside the three-mile limit with cargoes of alcohol. Baymen and other local fishermen would use their smaller craft to carry the contraband ashore. The many inlets and bays along the north and south coasts of Nassau County made it a natural center for this illegal activity. One of these "rumrunners" was the *William T. Bell,* shown here, beached at Bayville. (*Nassau County Museum, #1041.*)

Opposite, bottom: **27. Captain Stannard's Junkyard, Port Washington, ca. 1900.** Founded in 1887 by Elbert Stannard, a retired shipmaster, this was one of the largest privately owned junkyards in America. Taking advantage of the deep-water harbor at Port Washington, Captain Stannard bought condemned ships from the U.S. Navy and recycled usable lumber and metal. Many

ships in active service during the Civil War were junked here, including Commodore Perry's *Powhatan,* which had opened Japan to trade in 1856. (*Nassau County Museum, #3187.*)

Above: **28. Clambake, Port Washington, 1897.** At the turn of the century, oysters and clams were plentiful in the waters around Long Island. On the North Shore, where today the name Oyster Bay reminds us of this vulnerable resource, there were unpolluted inlets emptying into Long Island Sound. In the photograph, Fullerton captured a sight that went back to Indian times when the fresh, plump bivalves were roasted underground. Perhaps the rest of the harvest would be used as Whitman remembered:

> The boatmen and clam-diggers arose early and stopt for me,
> I tuck'd my trouser-ends in my boots and went and had a good time;
> You should have been with us that day round the chowder-kettle.

(*Photograph by Hal Fullerton; Suffolk County Historical Society, Fullerton Collection, #2015.*)

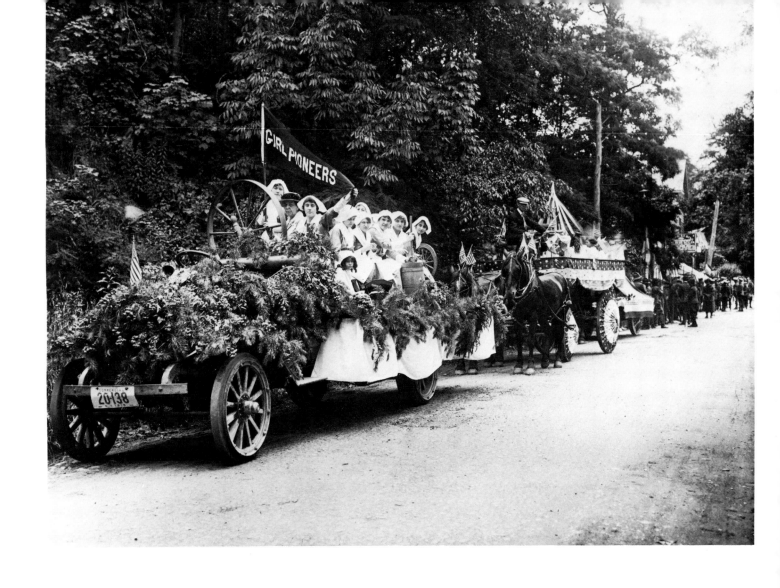

Above: **29. Girl Pioneers, Roslyn, 1910.** Like other enterprising immigrants, William Pickering held a variety of jobs—sailor, post-office employee, track walker for the Southern Pacific Railroad, gardener's assistant on the Mackay estate, coachman, stableboy and general utility man—before he became a professional photographer. He must have dashed out of his studio on East Broadway (in the background) to record this parade with the Girl Pioneers, seen churning butter on their bough-laden float. The Girl Pioneers, who practiced skills ranging from camping to crocheting, were forerunners of the Girl Scouts, which was founded in Savannah, Georgia in 1912. The troop leader, seated under the banner in a black-banded hat, was Mrs. Hicks, who knew the importance of a good photograph. Her aunt, Rachel Hicks, had already preserved rare glass-plate views of agricultural Long Island (see Nos. 100–104). Mrs. Hicks herself consulted her neighbor, Pickering, for advice on making photographs. (*Collection of Lydia Hicks.*)

Opposite, top: **30. Lighthouse, Sands Point, ca. 1880.** Less than 20 years after the ratification of the Constitution, a native Long Islander, Samuel Latham Mitchill, served in Congress and introduced a bill to establish the Sands Point Lighthouse. It was constructed in 1809 on five acres of land purchased from Benjamin Hewlett; there it stood isolated at the tip of a peninsula once used as common grazing land (Cow Neck). The adjacent brick house, with its connecting passage to the tower, was built in 1868. Until 1937 whale oil produced the beacon used to warn sailors of the rocky coast. (*Photograph by George Brainard; Nassau County Museum, #773.3—Brainard Plate #1416.*)

Opposite, bottom: **31. Hearst Castle, Sands Point, ca. 1930.** Begun in 1917 by Mrs. Oliver H. P. Belmont, a wealthy Long Islander politically active in the women's suffrage movement, this estate was originally called "Beacon Towers." Adjacent to the old Sands Point lighthouse, it was designed to resemble a medieval French castle. At its completion in 1929, it had 15 master bedrooms and 12 servants' rooms; Mrs. Belmont spent $25,000 a year simply to maintain the housekeeping staff. The estate was sold in 1927 for $400,000 to William Randolph Hearst (1863–1951), publisher and politician. Hearst's national chain of newspapers, including the New York *Journal*, increased circulation by sensational treatment of reform issues. After serving two terms in Congress, Hearst ran unsuccessfully for Mayor of New York before he purchased Beacon Towers as his "between-seasons home." Mrs. Hearst changed the name of the estate to "St. Joan," added a banquet hall and a movie theater, and in 1933 entertained 2,000 guests at a dinner-dance in the paved courtyard. By the end of the thirties the house was too expensive to maintain. It was leveled at a cost of $10,000; by 1943, ten homes had been built on the property. (*Photograph by U.S. Army Air Services; Nassau County Museum, #4532.*)

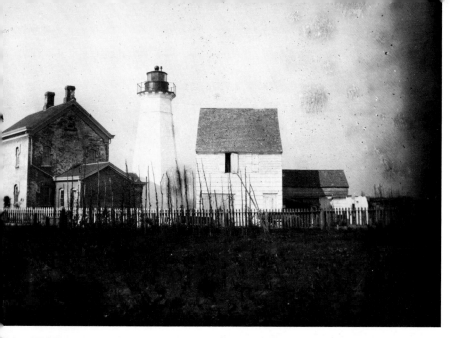

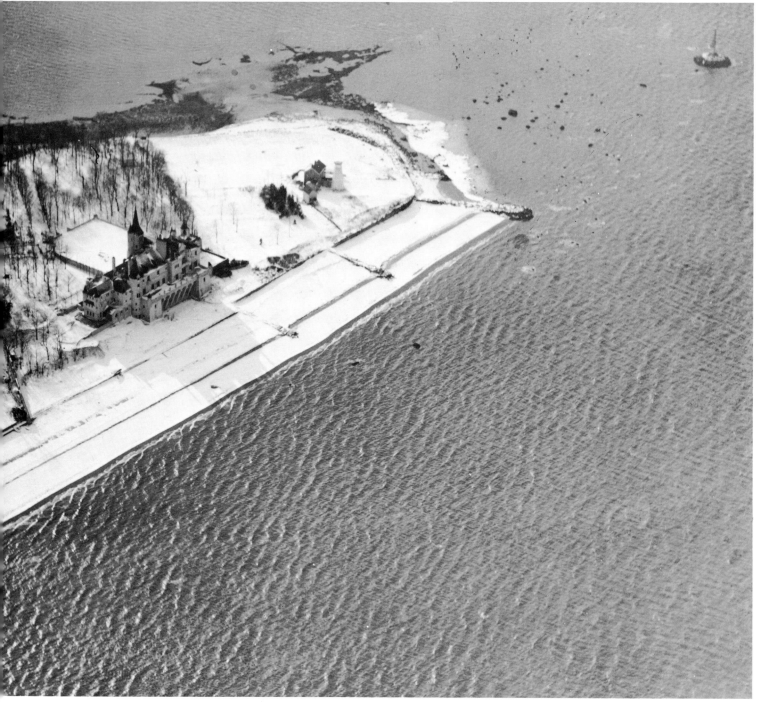

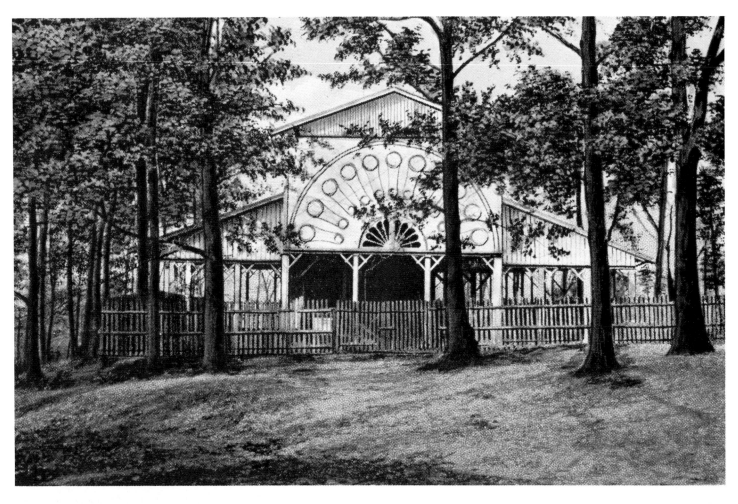

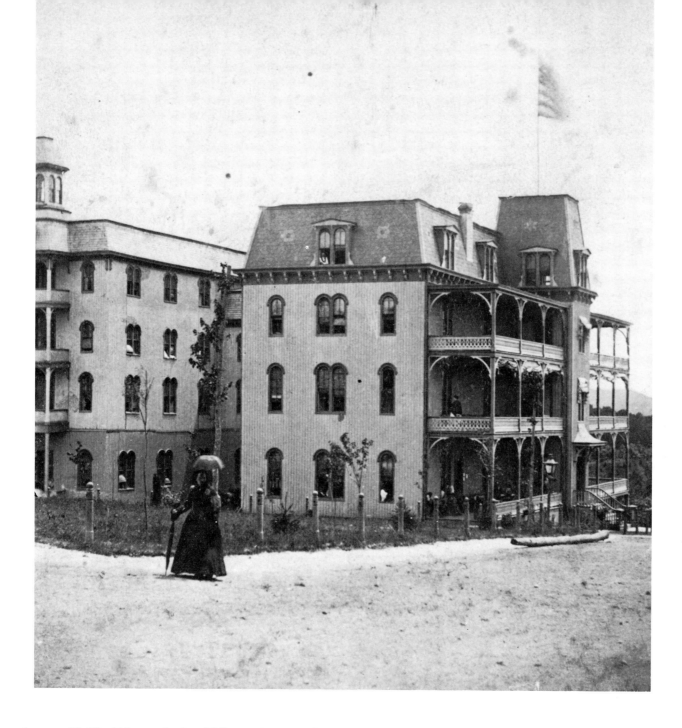

Opposite, top: **32. The Tabernacle, Sea Cliff, ca. 1906.** In 1871, the Metropolitan Camp Ground Association invested more than $270,000 to develop 240 acres of Sea Cliff land as a Methodist settlement. When the campground was opened, thousands came every weekend from New York and the adjacent country, traveling by railroad, horse and buggy or sidewheel steamer. Tents were provided to accommodate the multitudes who flocked here for spiritual enjoyment and public worship. Located on Summit Avenue, the famous Sea Cliff Tabernacle was crammed to its limit during the summer, despite a seating capacity of 5,000. In the 1880s, German Methodists rented space for $10 a year, but ceased to use the campsite in 1890, dividing it into lots. At this time, the old tabernacle was partly dismantled. One portion was moved to the north end of Main Street, where it was used for German Methodist meetings until World War I. (*Postcard Collection of Rikki Sowinski.*)

Opposite, bottom: **33. Camp Meeting, Sea Cliff, 1906.** Camp meetings were only part of the reason for the huge influx of summer visitors to Sea Cliff. Pleasure seekers soon discovered the scenic delights of this wooded bluff, appropriately named because of its commanding overlook on Long Island Sound. The beauty of its location was praised in an early railroad handbook which noted: "The ground shelves down abruptly from the pla-

teau, and the houses and streets rise, terrace on terrace, until they reach and crown the top of the bluff." Visitors to this idyllic spot could enjoy the mile of shorefront on Hempstead Harbor, protected from the sound by a breakwater. Besides a splendid community beach and pavilion, there were miles of shaded walks, nearby country clubs, bridle paths, boating facilities, modest bungalows and palatial villas. It was no surprise that as Sea Cliff's system of leasing property gave way to selling, its summer population swelled dramatically jumping from 554 in 1885 to 1,475 in 1903, and to 8,000 by 1925. (*Postcard Collection of Rikki Sowinski.*)

Above: **34. Hotel at Sea Cliff, ca. 1890.** A summer visitor to Sea Cliff at the turn of the century could enjoy a wide range of accommodations. Tents could be leased at the Methodist campground or, modest cottages rented at reasonable rates to those who preferred bungalow life. As earlier restrictions were abandoned and the size of individual lots increased, wealthier persons were able to build their own elaborate houses on purchased property. Other temporary residents could stay in hotels such as the large Sea Cliff House, whose dining hall seated 1,000, or in smaller places such as the one pictured in this stereoscopic view. A bonneted stroller, parasol in hand, enjoys the summer sun and fresh sea breezes as she strolls past some newly planted trees. (*Lightfoot Collection.*)

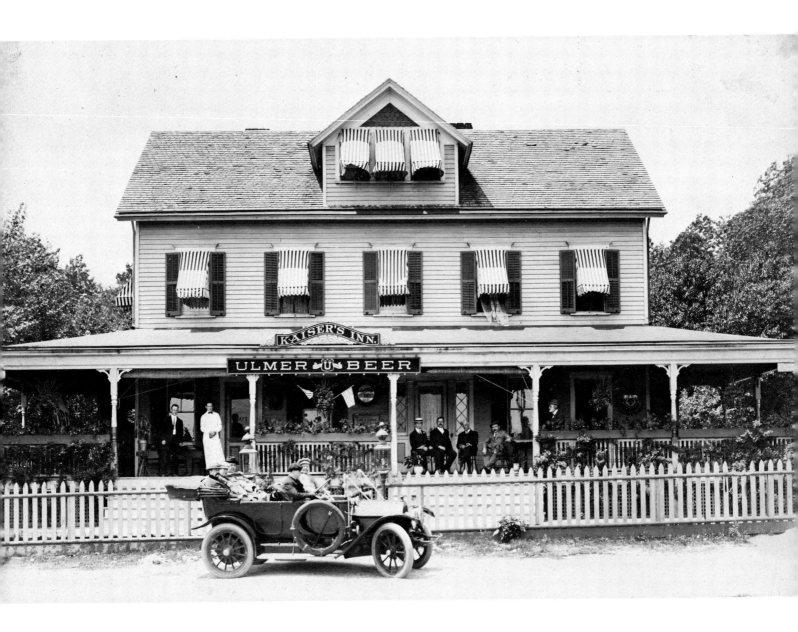

Above: **35. Kaiser's Inn, Sea Cliff, ca. 1910.** This hotel stood across the street from the Sea Cliff Station and the driveway gate to Thompson Park, afterwards replaced by Trousdell Village. As in Hicksville, New Hyde Park, Floral Park and Franklin Square, German immigrants established their prosperity here as farmers, craftsmen, brewers and innkeepers. This neatly painted and awninged hotel welcomed German Methodists who came to worship at the campgrounds. In these years just before World War I, they still unselfconsciously honored the name of the Kaiser; later they would be persecuted as "hyphenated Americans." (*Glen Cove Public Library, Kohler Album.*)

Opposite, top: **36. Barlow Mansion, Glen Cove, ca. 1900.** When Charles A. Dana, owner of the New York *Sun*, bought Dosoris Island as a vacation property in 1873, there were only two other New York City residents with summer homes in the neighborhood. One of these was Samuel Latham Mitchill Barlow, who lived in this mansion, an elaborate blend of Victorian and Carpenter Gothic styles. The house had formerly been owned by a man named Kinnaird, the builder of the Atlantic and Great Western Railroad. When Barlow solved the railroad's financial problems in an antitrust suit, the grateful stockholders not only paid his fee, but gave him the wisteria-bedecked residence. Evidently, commuting did not reduce Barlow's efficiency as an attorney, for it is recorded that he spent between five and six hours a day in travel between Glen Cove and his New York office. (*Glen Cove Public Library, Kohler Album.*)

Opposite, bottom: **37. Nassau Traction Company Trolley at Sea Cliff Station, ca. 1905.** It was a much shorter ride from Glen Cove to neighboring Sea Cliff, where the Glen Cove trolley met the Nassau Traction Company Trolley pictured here. This trolley line connected the Sea Cliff station with the bluff at the water's edge. At the other end, it continued on through Glen Cove and on to the beach at Long Island Sound. (*Glen Cove Public Library, Kohler Album.*)

Over: **38. Steamboat Landing, Glen Cove, ca. 1890.** Late in a summer afternoon a steamer returns Glen Cove passengers from their activities in New York City. Steamer service to New York was new along the North Shore when, in 1829, William M. Weeks, later proprietor of the dockside Pavilion Hotel, persuaded Captain Elijah Peck to add Glen Cove to the run. The town was then known as Musquito Cove, meaning "cove of the grassy flats" in the local Indian language. Hotel and boardinghouse owners, fearing the negative effect of the name on their summer visitors, voted, in 1834, to change it to Glen Cove, a corruption of the Scots "Glen Coe." The favorable location of the town on Hempstead Harbor contributed to its steady growth; in 1918, 250 years after the first settlement, Glen Cove was incorporated as a city. (*Glen Cove Public Library, Kohler Album.*)

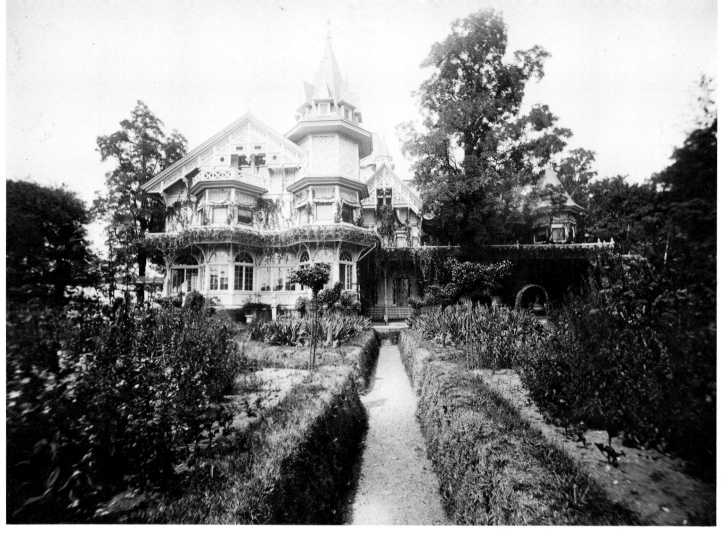

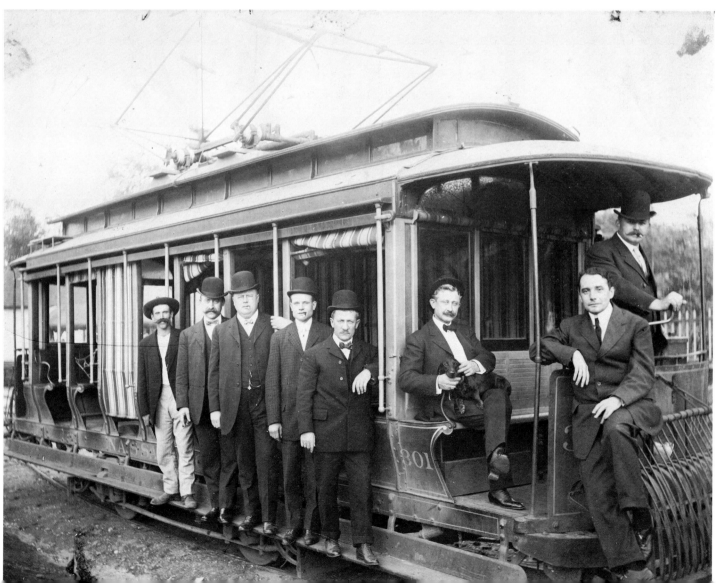

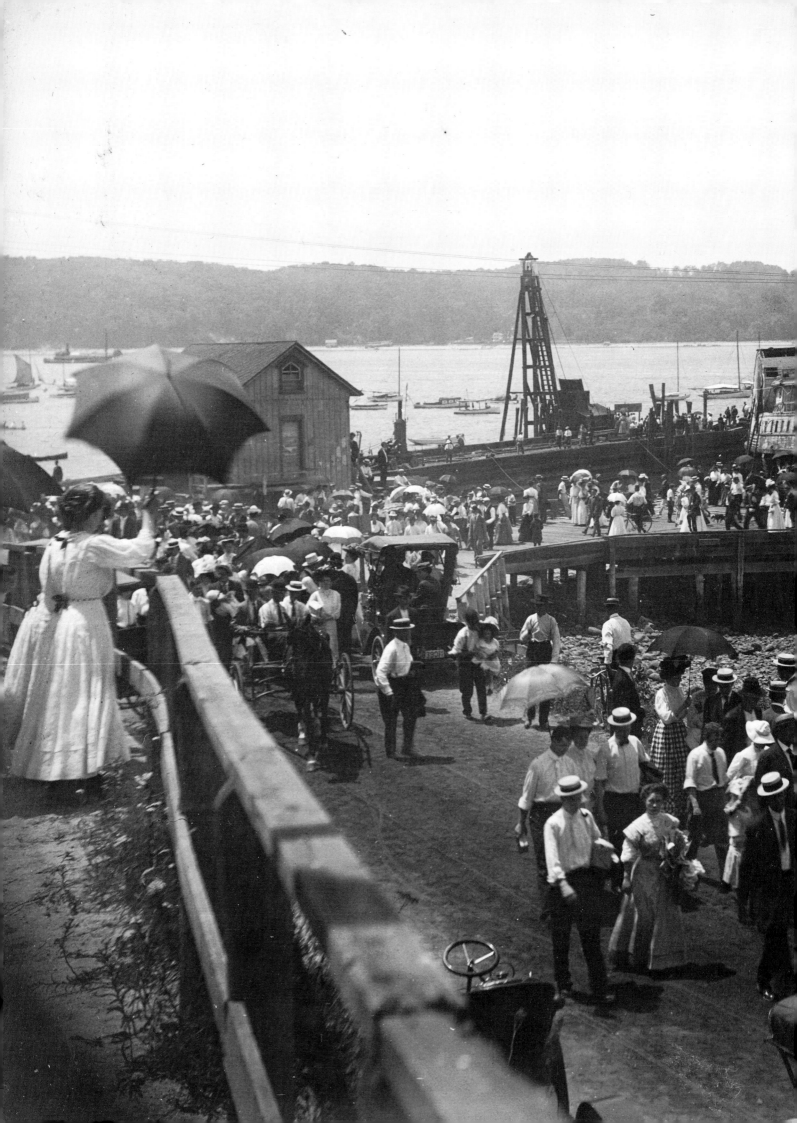

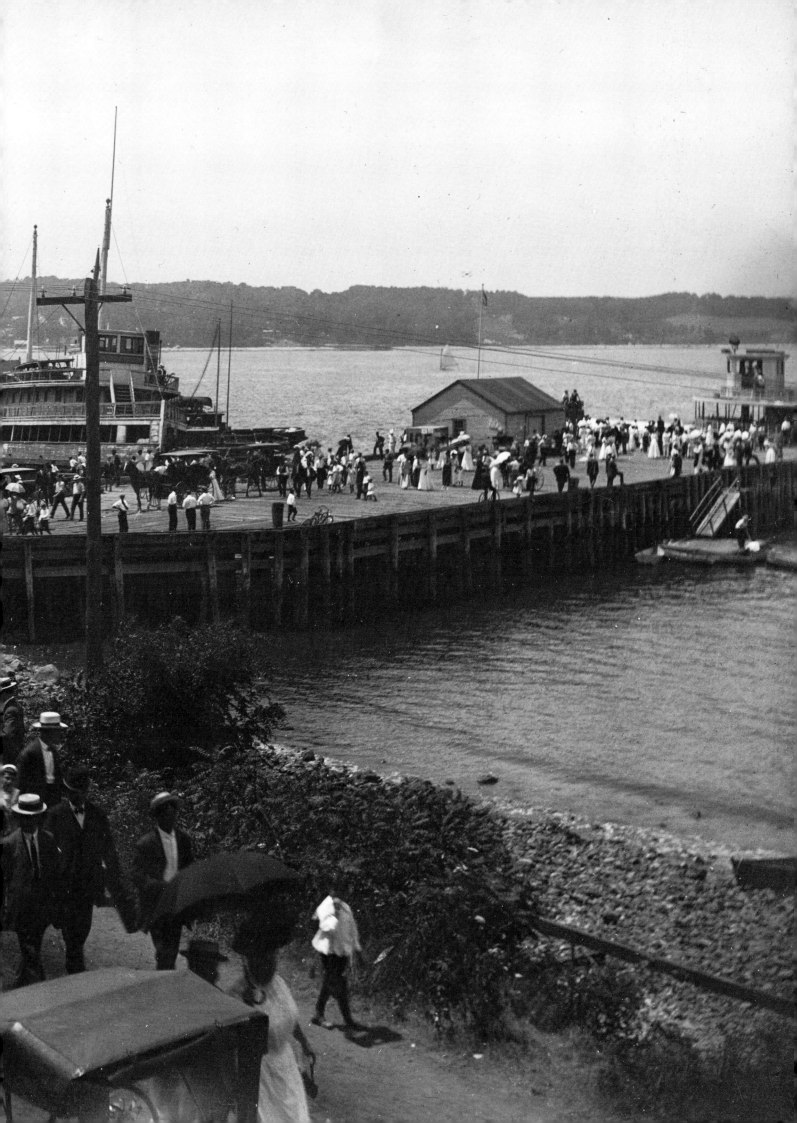

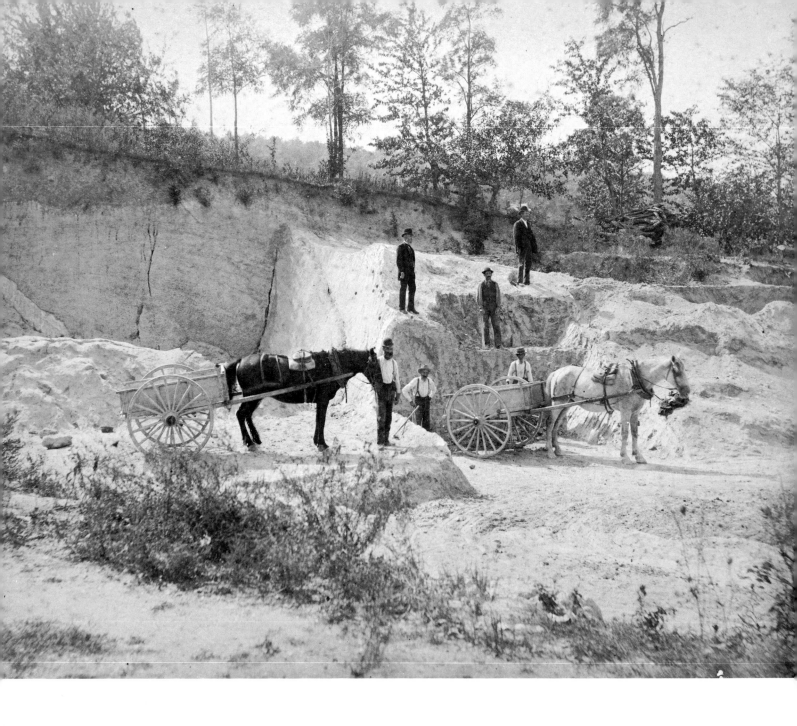

Above: **39. Garvie's Point Clay Pits, Glen Cove, 1885.** Originally used by Matinecock Indians (whose village here has been excavated), the clay beds at Garvie's Point are part of a glacial deposit that stretches along the North Shore of Long Island. Most of the unfired Indian vessels did not survive intact, but the high quality of the clay was appreciated by Dr. Thomas Garvie, who sold a superior quality of pipe clay at $1.25 per 12 bushels. At the time of the photograph, the clay pits were being mined by the doctor's heirs. The ancient multicolored cliffs of clay at Garvie's Point are still a temptation to visitors, who are now asked by the County to resist carrying samples home. (*Nassau County Museum, #1974.*)

Opposite, top: **40. Garvie Farm, Glen Cove, ca. 1898.** August Flittner tends the sheep on the Garvie Farm on land known in colonial times as Sheeps Pen Point, common grazing ground. Jesse Coles developed a thriving "plantation" here, which was purchased by a Scots physisican, Dr. Thomas Garvie, in the early 1800s. One of two medical men practicing in Glen Cove at the

time, the well-educated Dr. Garvie was a trustee of the local common school district and a man of many scientific interests. Eventually the property was inherited by his granddaughter, Mary Helen Bailey, who died in 1944, leaving the estate subject to conflicting claims. In 1961, Nassau County bought 62 acres for the Garvies Point Museum and Preserve, using it to display the geologic formation of Long Island. (*Photograph by M. J. Donohue; Nassau County Museum, #1943.*).

Opposite, bottom: **41. Ladew Leatherworks, Glen Cove, ca. 1915.** The Ladew Leatherworks manufactured leather belting for heavy industry, including the world's largest belt, over 12 feet wide. Their products were important to the operation of steam engines. By 1925, Ladew was the principal industry in Glen Cove, employing nearly 1,000 people, among them many Irish and Italian immigrants. The glum-faced workers seen here suggest that conditions were less than desirable. (*Glen Cove Public Library.*)

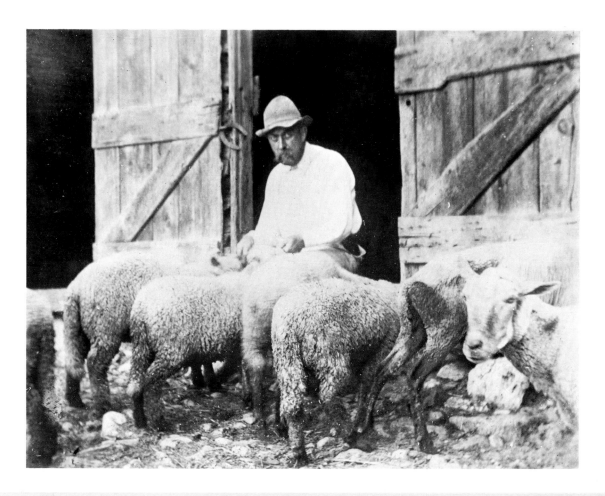

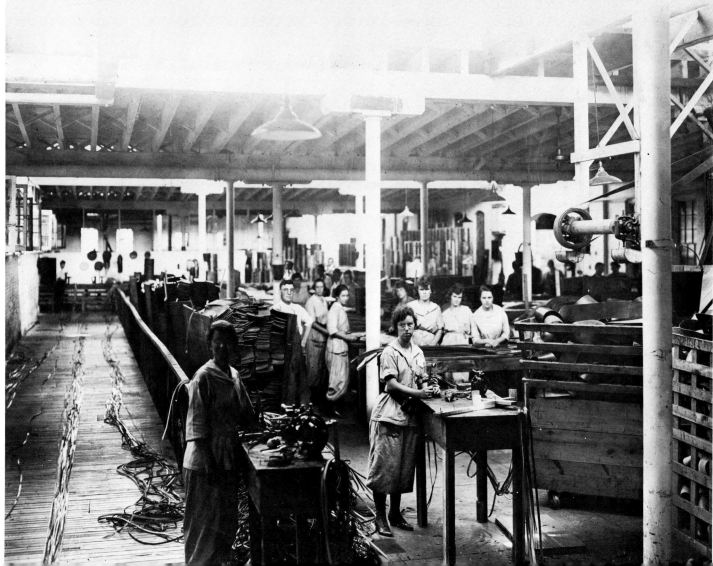

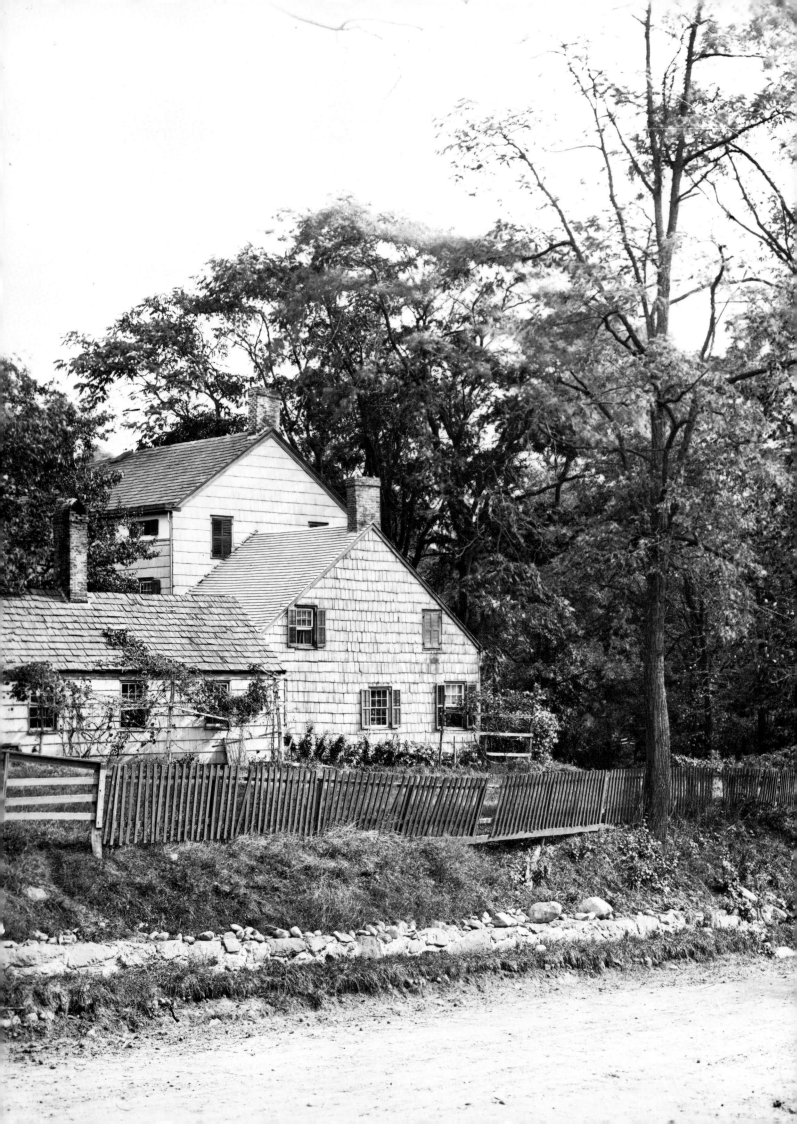

42. Old Quaker School, Locust Valley, October 1900.
In the early nineteenth century Quakers had a long-standing settlement at Jerusalem, now north Wantagh and Levittown. As the soil's fertility declined, they relocated around the rich farmlands of Westbury, Jericho, Bethpage, Hicksville, Oyster Bay and Locust Valley. This photograph of the old school at Locust Valley is a reminder of the importance Quakers placed upon education; their interest dated back to the seventeenth century when, influenced by George Fox, they set up 46 Quaker schools in England. Since English universities barred their teachers, Quakers developed their own educational priorities, turning away from classical Latin to English readers, and pioneering in useful training for such trades as carpentry, clock-making, spinning and needlework. Today there is still a large Friends Academy at Locust Valley and, as at William Penn's original school in Philadelphia, non-Quakers are welcome. (*Photograph by Hal Fullerton; Suffolk County Historical Society, Fullerton Collection, #L45.*)

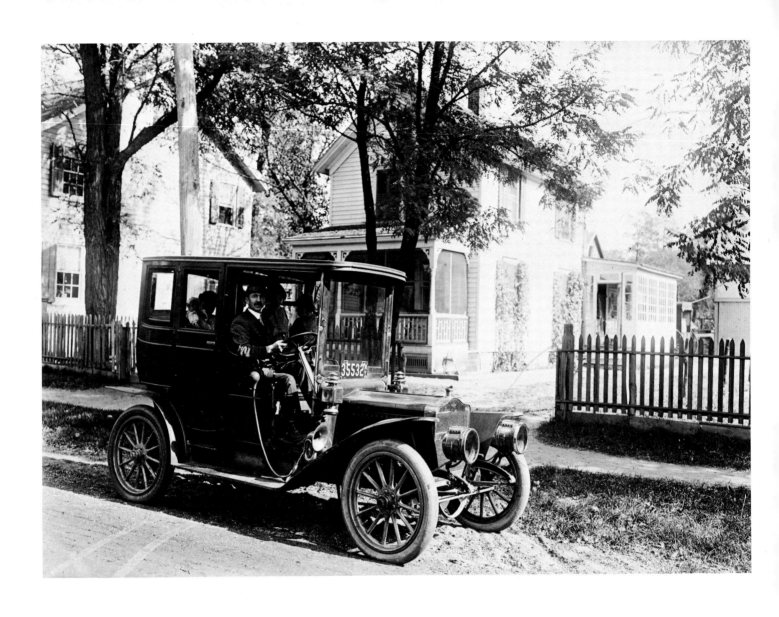

Above: **43. East Norwich Street, ca. 1910.** One of the pleasures of a summer Sunday was a drive through the small villages of Nassau County. There was not likely to be much traffic on the then-unpaved roads; automobiles were reserved for the rich or the determinedly footloose. Here Henry Otto Korten, who took glass-plate photographs for postcard reproduction all over picturesque Long Island, is seen in his Reo Roundabout. Before 1907 he had to use the railroad and a rented horse and wagon to make his picture-taking journeys. (*Photograph by Henry Otto Korten; Nassau County Museum, #5365.176.*)

Opposite, top: **44. The Jericho–Oyster Bay Road, East Norwich, ca. 1910.** By 1910, East Norwich had evolved from a small agricultural comunity to a typical New England–style town, with its spacious Victorian houses, general stores and white steepled church. People once congregated here to exchange goods and information, perhaps to discuss the freshness of John M. Layton's eggs, or to buy molasses and lamp oil at the Luyster store. Though the church still stands to remind us of times past, the town is now virtually gone; a victim of road improvements and commercial development. To preserve a record of Long Island life, Nassau County moved the Layton and Luyster stores to a permanent home in the Old Bethpage Village Restoration. (*Photograph by Henry Otto Korten; Nassau County Museum, #5365.178.*)

Opposite, bottom: **45. East Norwich Junction, ca. 1910.** This photograph is one of the few records of a town center obliterated by road widening. Wiped out in the 1950s by an eight-lane highway, the intersection of North Hempstead Turnpike (Route 25A) and the Jericho–Oyster Bay Road (106) was the place where Vanderbilt Cup Racers once made their reckless turns. The East Norwich Inn, a favorite watering place for the racers and their audience, can be seen in the left rear. (*Photograph by Henry Otto Korten; Nassau County Museum, #5365.182.*)

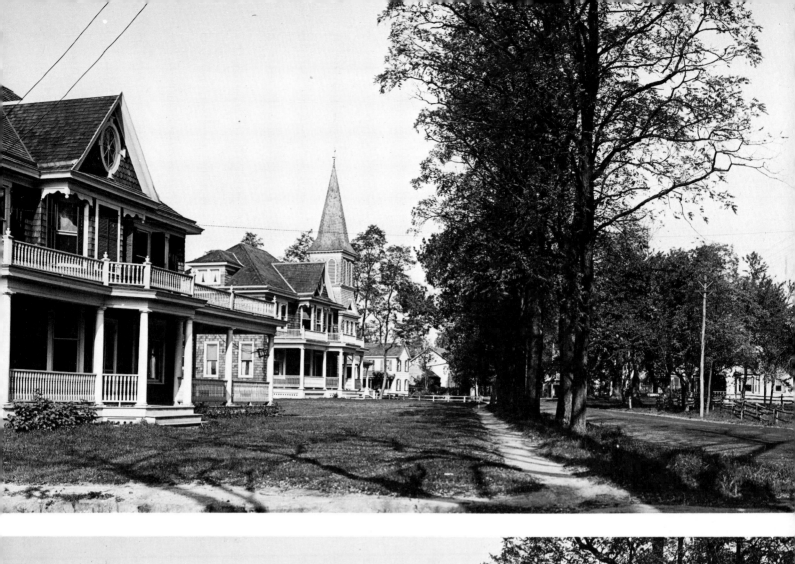

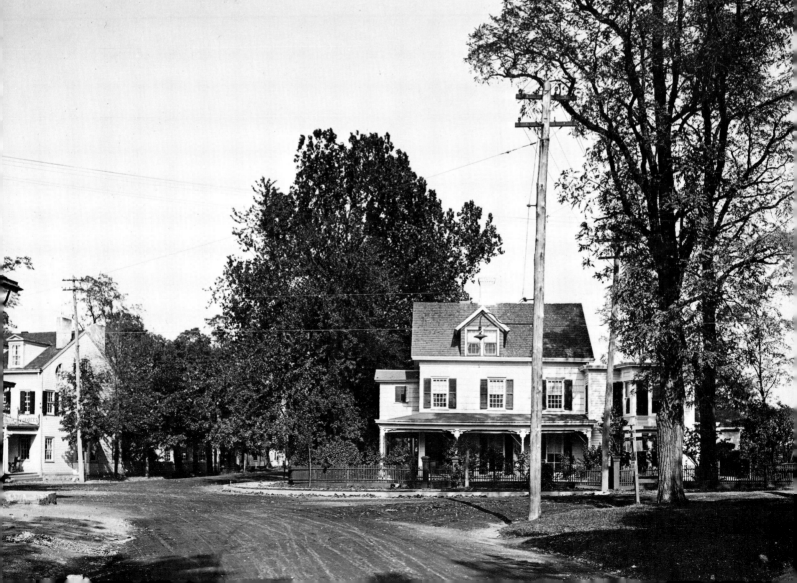

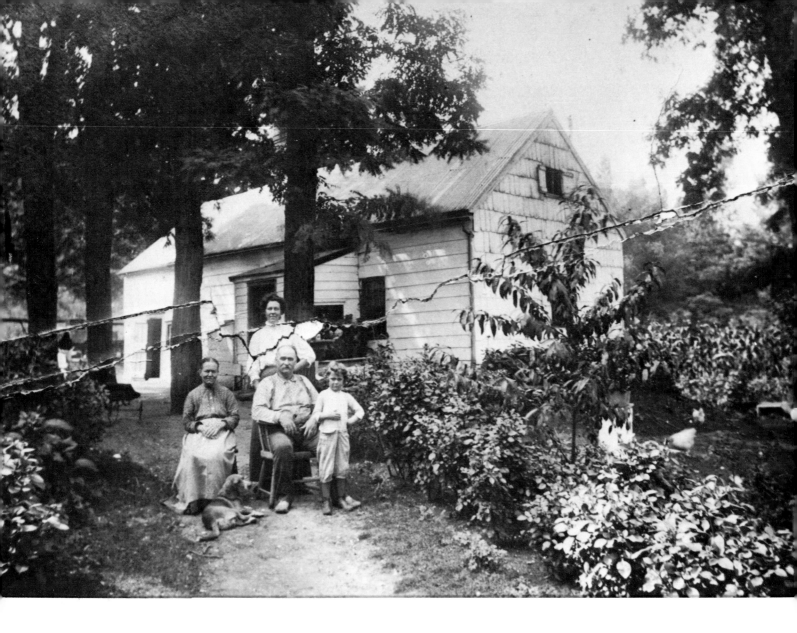

Above: **46. Miller John Townsend's House, Oyster Bay, ca. 1880.** Among the earliest grants of land in Oyster Bay was that made in 1661 to Henry Townsend, of Jamaica, West Indies, "for the purpose of having a mill erected on the stream called Mill River." The Townsend name remained prominent in Oyster Bay, often associated with the milling trade, which required both mercantile and mechanical ability. Miller John Townsend, seen in this photograph, was related to the Henry Townsend, who, in 1810, manufactured at his Oyster Bay ironworks the first "blistered steel" in the United States and, in 1816, made New York State's first cannon. Another noted member of the family, the merchant Samuel Townsend, occupied Raynham Hall at the time of the Revolution. Before the Revolution, shipping had been the major economic resource of Oyster Bay, named for its fine oysters. After the war destroyed sea trading, agriculture became Oyster Bay's chief resource; the primary crops were asparagus, a variety of apples bred by a local farmer named McCoun and apple cider. (*Oyster Bay Historical Society Library.*)

Opposite, top: **47. Old Mill at Mill Neck, ca. 1880.** Once there were more than 200 mills on the creeks and inlets of Long Island; a principal industry licensed by the towns, it is always mentioned in old records. The mill, positioned to be accessible by road and by water, was a center of social and commercial activity. Among the many types were grist, paper, silk, woolen and bone. Samp mills, for the grinding of Indian corn, were so numerous on the Long Island shore that boats guided through the fog by the regular sound of their grinding. The photograph shows an old sawmill, where planks, porch columns, broom handles and picket fences were turned out until its demolition in 1890. Gristmills were fading from the Long Island landscape at this time, too, as the Midwest granaries replaced local wheat and new roller mills rendered stone mills obsolete. (*Oyster Bay Historical Society Library.*)

Opposite, bottom: **48. Arnold Fleet's Mill, Oyster Bay Cove, ca. 1890.** To turn the wooden wheel and harness the energy of changing tides required a delicate balance between machinery and natural forces. The millwright had to be capable of invention, adjustment and repair, in a situation more complex than windmilling. On Long Island, where water resources were ample, tide or "undershot" mills greatly outnumbered windmills, testifying to the presence of skilled millers, such as Arnold Fleet. His gristmill was located east of the town of Oyster Bay at Oyster Bay Cove, a short distance from the steamboat landing. Operating in the 1870s, it turned 60 pounds of wheat into 42.5 pounds of superfine flour, 5.5 pounds of second-grade flour, 2 pounds of third-grade flour, 8.8 pounds of bran and 1.2 pounds of waste. (*Oyster Bay Historical Society Library.*)

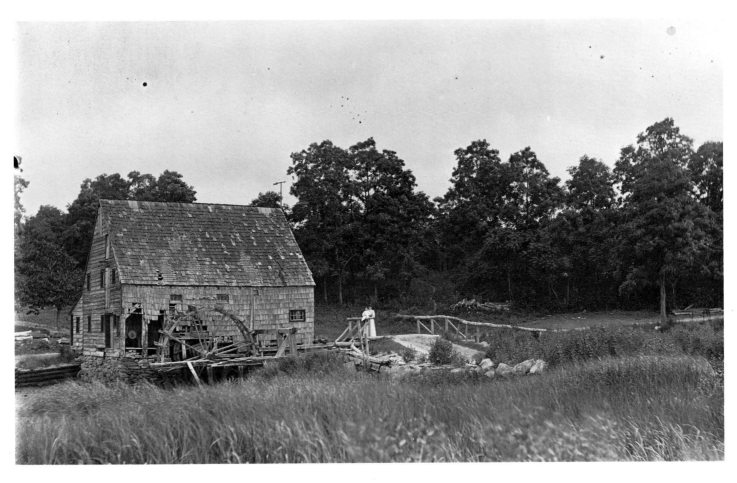

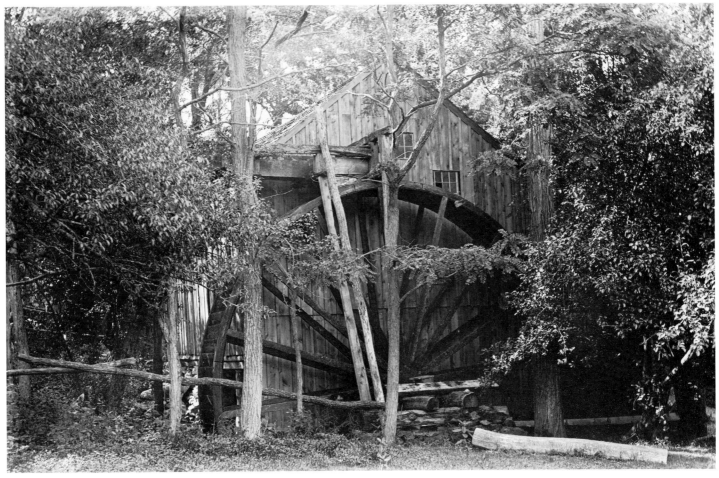

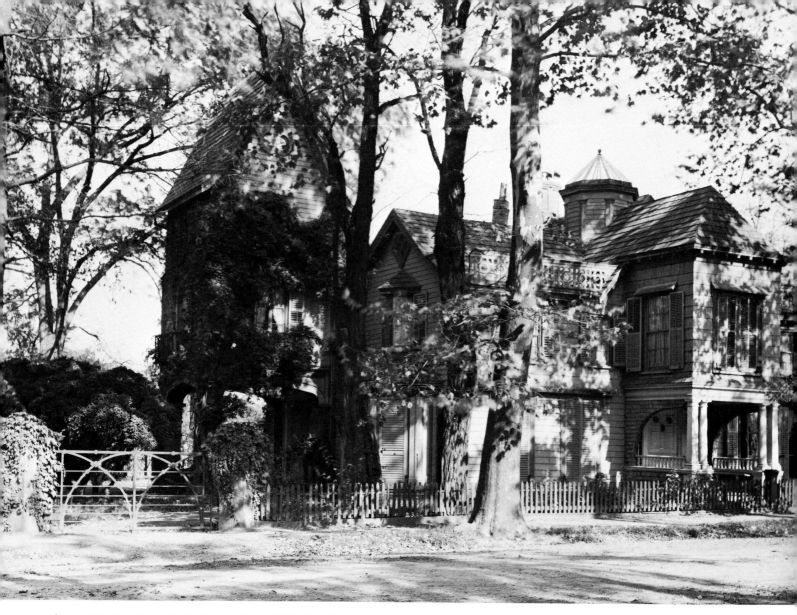

Above: **49. Raynham Hall, Oyster Bay, 1902.** Raynham Hall, first built as a one-room cottage in the eighteenth century by Thomas Weeden, is here seen with its nineteenth-century Victorian additions, including tower and skylight. It has since been restored to its appearance as it was during the Revolution, when it served as British headquarters in Oyster Bay. At this time the house was owned by Samuel Townsend, merchant and importer, whose son Robert secretly served as George Washington's chief intelligence agent in New York. Even while his father's home was occupied as winter headquarters by British Colonel John Graves Simcoe, Robert Townsend (alias Culper, Jr.) masqueraded as a journalist and merchant in Manhattan, sending messages on British troop movements to Colonel Benjamin Tallmage in Connecticut. Robert Townsend's role remained a mystery for 150 years, until historian Morton Pennypacker discovered his identity through a comparison of handwriting. Raynham Hall, named by the Townsends for their English "river home" at Fakenham, Norfolk, was given to the town of Oyster Bay in 1947 and is now open as a museum. (*Suffolk County Historical Society, Fullerton Collection, #L173.*)

Opposite, top: **50. Sewanhaka-Corinthian Yacht Club, Centre Island, 1910.** Located on a peninsula surrounded by the waters of Cold Spring Harbor, Oyster Bay Harbor and Long Island Sound, 600-acre Centre Island was formerly called Hog Island. On the southwest tip, Smith Brothers Steam Brickworks made three million bricks in 1860, using the clay deposits found there, as elsewhere on the North Shore. The name "Brickyard Point" still identifies that location. A combination of country landscape, beach and accessibility to the deep waters of the Sound also made Centre Island desirable to the rich, who built homes in this private enclave. Their sporting pleasure soon led to the formation of the famous Sewanhaka-Corinthian Yacht Club, founded in 1871 and one of the two oldest clubs having headquarters on Long Island Sound (the other being the New York Yacht Club). "Seawanhaka," also the name of a famous steamboat that served this area from 1866, is an Indian name meaning "place of the conch-shell beads." "Corinthian," meaning a wealthy amateur sportsman, referred to the chief purpose of the club: to return the sport of yacht racing to amateurs. In 1872, the club held its first regatta, an international competition which soon became famous as "America's Cup of Small Yacht Racing." Ten Roosevelts belonged to the club in 1877, including Teddy Roosevelt, whose home at Sagamore Hill can be seen across the inlet. Still in operation, the Sewanhaka Yacht Club has always held as its motto, "Put no duffer at the helm." (*Photograph by Henry Otto Korten; Nassau County Museum, #5365.97.*)

Opposite, bottom: **51. Davenport's Octagon Hotel, Oyster Bay, ca. 1910.** This hotel appears in the 1873 *Long Island Atlas* as Nassau House, A. A. Reed, proprietor, located at the corner of Spring and Main Streets. A curiosity of the mid-nineteenth century, such houses were inspired by Orson Fowler's book, *A Home for All*, which praised the octagon as "the ideal shape." There were at least two other such buildings on Long Island at Mattituck and Huntington. On Roosevelt (then Blackwell's) Island, the Octagon Tower (1839) served as the New York City Lunatic Asylum. Long Islanders, partial to George Washington since his 1790 visit, may have associated the octagon shape with The Octagon in Washington, D.C. Completed in 1801, this building was designed by Dr. William Thornton (who also drew up the plans for the Capitol) and was owned by Colonel John Tayloe, close friend of George Washington. (*Photograph by Henry Otto Korten; Nassau County Museum, #5365.51.*)

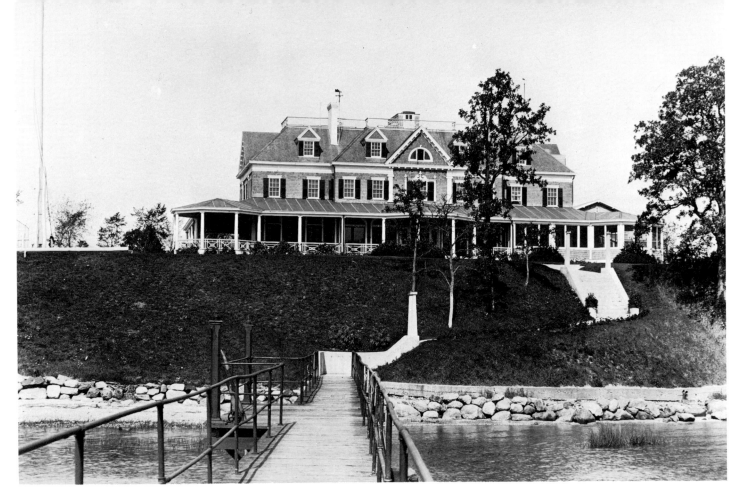

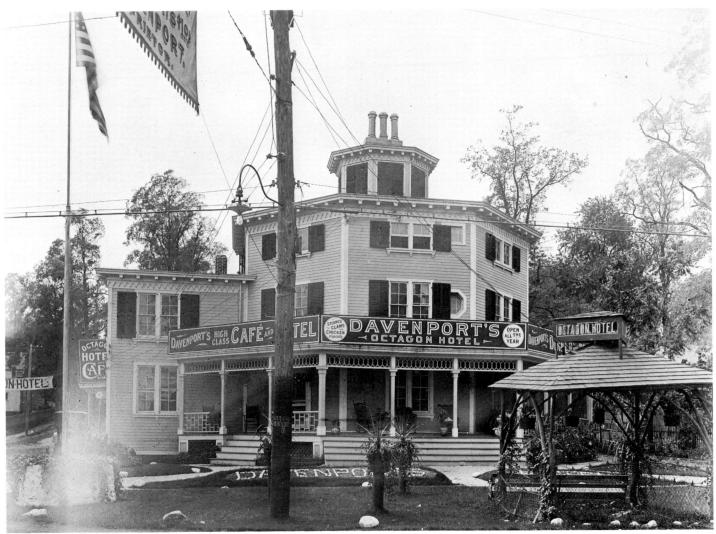

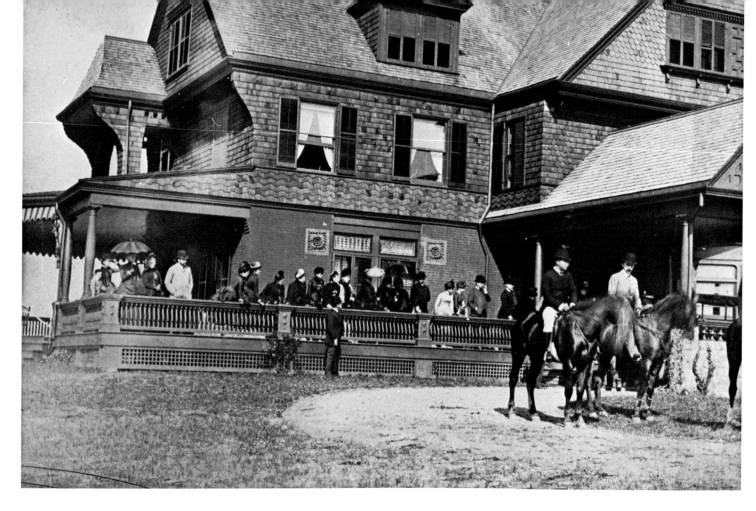

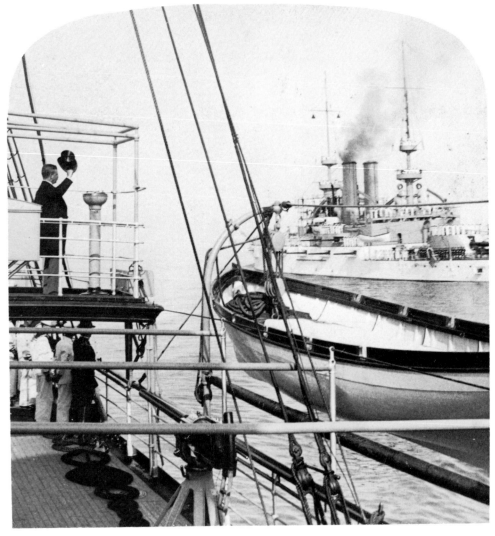

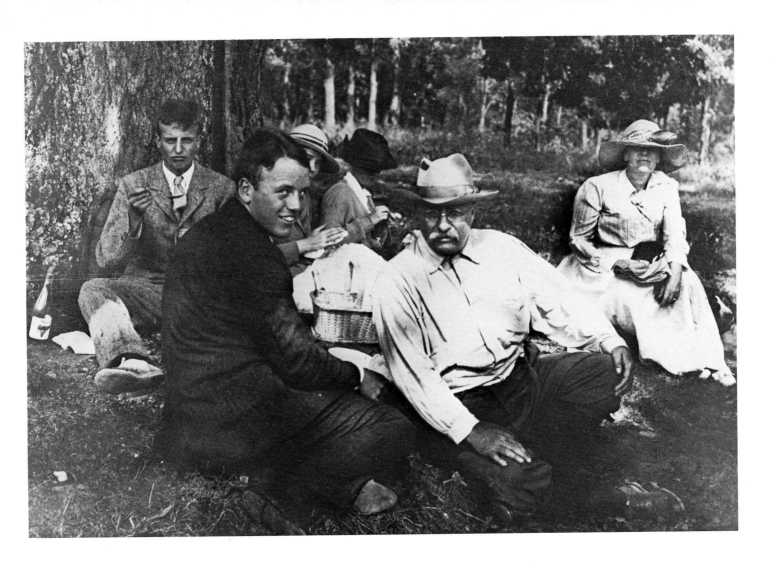

Opposite, top: **52. Sagamore Hill, Spring 1886.** Completed in 1885 for $16,975, Sagamore Hill was the residence for more than 30 years of Theodore Roosevelt (1858–1919). On the shores of Oyster Bay at wooded Cove Neck, the substantial Queen Anne–style house was constructed of brick and frame, with a wide piazza around two sides. Unlike the pretentious Gold Coast estates, modeled after fortresses and French chateaux, Sagamore Hill possessed a rustic informality as a book-filled, many-windowed family home. Despite his reputation for flamboyance and "rough-riding," Theodore Roosevelt was capable of appreciating the beauty of Long Island's meadows, woodlands and marshes. Today, visitors are guided by the National Park Service through Sagamore Hill, where they can enjoy the outdoors and see the many trophies of Roosevelt's career. (*Sagamore Hill Research Library.*)

Opposite, bottom: **53. President Roosevelt Reviews a Naval Parade off Long Island, 1903.** Roosevelt's interest in naval power was shown during his Harvard days, when he completed his first book, *The Naval War of 1812*, and in his service as Assistant Secretary of the Navy. During his Presidency, he advocated greater prepared-

ness on the part of the United States Navy, believing in the deterrent effect of power display. For this reason, in 1907 he sent the "Great White Fleet" around the world. In the years when he was President, Long Island Sound was the scene of naval displays, like the one recorded in this stereograph of Roosevelt standing on the *Mayflower* and saluting the fleet. (*Lightfoot Collection.*)

Above: **54. Theodore Roosevelt and Family, 1916.** Following an unsuccessful campaign in 1912 on the Bull Moose ticket, former President Roosevelt led an expedition to South America before returning home to his beloved Sagamore Hill. In a peaceful moment, before the entrance of the United States into World War I, Roosevelt joins in a family picture. Right of him is his wife, Edith Kermit Roosevelt; left is Quentin, one of the first group of aviators trained on the Hempstead Plains, who died in combat over France in 1918. Behind Quentin is Archie, his sister Ethel, and Archie's wife. Theodore Roosevelt's daughter, Alice, is not pictured here, nor are two other sons, Kermit and Theodore, Jr., both of whom were killed in active service. Roosevelt himself died at Sagamore Hill in January, 1919. (*Sagamore Hill Research Library.*)

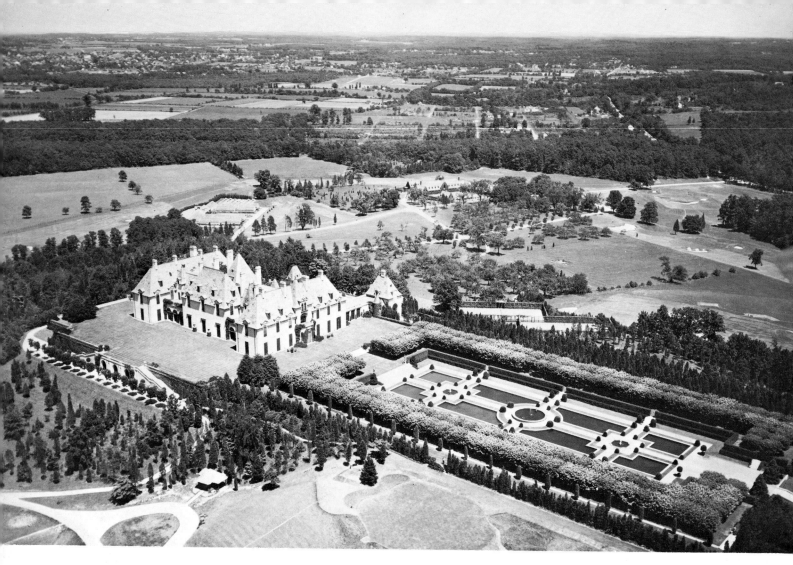

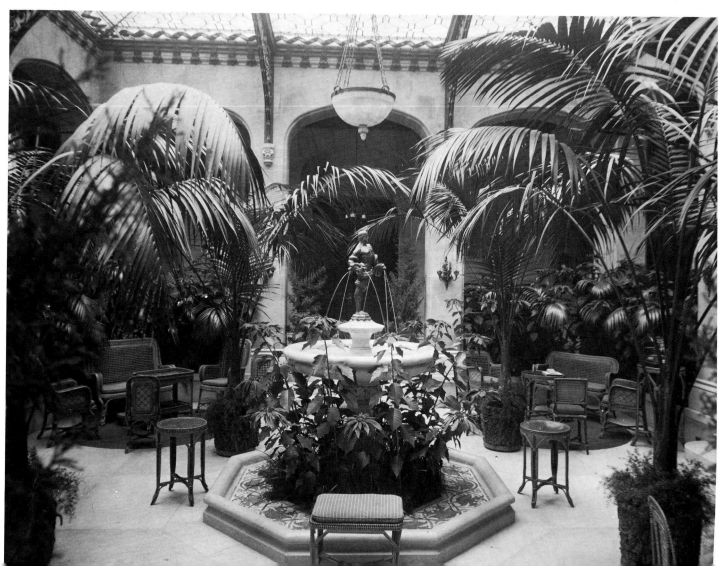

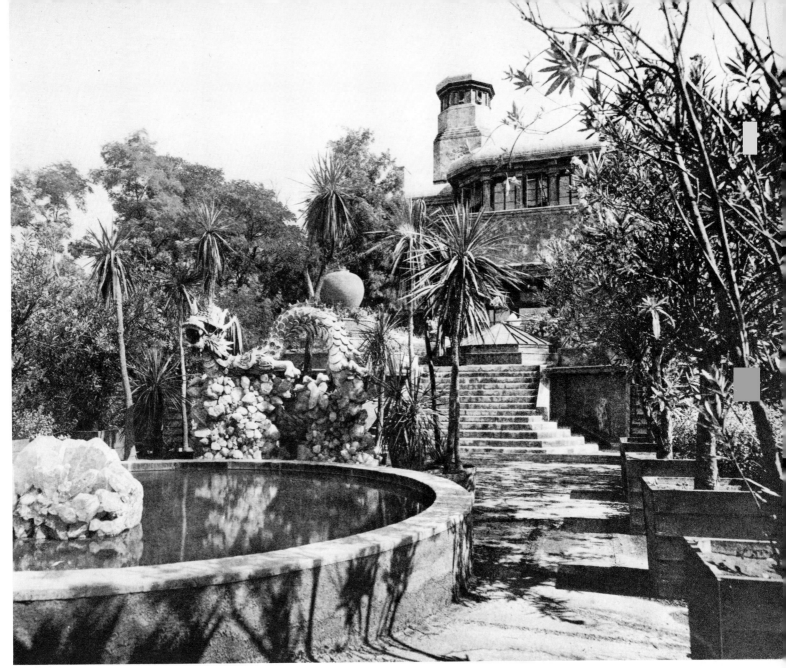

Opposite, top: **55. Otto Kahn Estate, Cold Spring Harbor, ca. 1930.** One of the grandest of the North Shore estates, this was the extravagant 126-room home of Otto H. Kahn (1867–1934), railroad financier, authority on practical economics and taxation, patron of the arts. Designed by William Adams Delano as an H-shaped Norman-style chateau with formal gardens, the estate, situated on 350 acres, took four years to build. At its completion in 1921, it employed a staff of 200 servants. The dining room could seat 200 people, but the Kahns usually kept the guest list to a modest 50 or 60. Believing that material success should be repaid by serving others, Kahn was active in community affairs; he was one of the principal supporters of the New Theatre to develop American drama, chairman of the Metropolitan Opera Company, vice-president of the New York Philharmonic, honorary director of the Royal Opera House, Covent Garden. After his death, the house was occupied by the Department of Sanitation as a rest home for its employees, and was later used to house the Eastern Military Academy. The original building is still standing. (*Nassau County Museum, #1077.*)

Opposite, bottom: **56. Palm Room, Hempstead House, Sands Point, ca. 1917.** Hempstead House was built at a cost of over $500,000 on the Howard Gould property at Sands Point. Gould, son of railroad magnate Jay Gould, planned the English-manor-style residence with his architects Hunt and Hunt, but never lived there; he and his wife, a wild-West performer, separated in 1907 before the completion of the building in 1910. At the time of this photograph, it was the home of Daniel Guggenheim. Castlegould,

servants' quarters and stables were modeled after those at Castle Kilkenny in Ireland. In 1923, Harry Guggenheim inherited part of the property and added a third mansion, Falaise, a French chateau. After her husband's death in 1930, Mrs. Daniel Guggenheim built an adjacent smaller estate, Mille Fleurs, the fourth major structure on the site. These buildings, which transplanted European styles and original architectural fragments to the North Shore Gold Coast, still stand on the 209-acre Gould-Guggenheim property, willed by Harry Guggenheim to Nassau County. (*Nassau County Museum, #4327.*)

Above: **57. Louis C. Tiffany Estate, Laurel Hollow, 1940.** Among the splendid estates along the North Shore was Laurelton Hall, the Moorish-Mission style home designed and built in 1905 by Louis Comfort Tiffany (1848–1933). Son of Charles Louis Tiffany, founder of Tiffany & Company, jewellers, Louis was a painter, craftsman, and decorator who became famous for "favrile" glass. His iridescent and freely shaped glass was popular from 1890 to 1915; the recent interest in art nouveau has brought it back into fashion. The $2 million estate was sold in 1946, with part of the proceeds going to establish scholarships for young artists, under the auspices of the Louis Comfort Tiffany Foundation. When the house was dismantled in the 1950s, a collector saved the entranceway, a stone, glass and ceramic *loggia* which is now exhibited at the Metropolitan Museum of Art. Other relics of the Tiffany era on Long Island are the handsome windows in churches, including those at Far Rockaway and Cold Spring Harbor. (*Nassau County Museum, #6315.*)

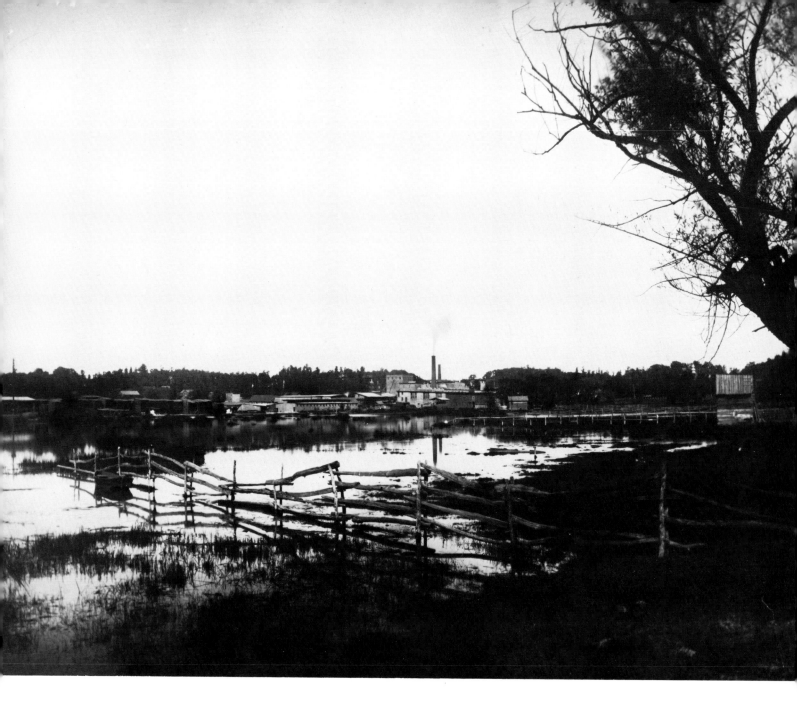

Above: **58. Duryea Starch Works, Glen Cove, ca. 1880.** The extensive pond-and-creek network in Glen Cove, which attracted the earliest settlers, made it a center for all kinds of water-powered milling industries. Foremost among them was the Glen Cove Starch Manufacturing Company. Established in the early 1850s on the south shore of Glen Cove Creek, it was the largest business of its kind in the world. Winner of gold medals for their cornstarch, the Duryeas brought over large numbers of Irish immigrants, increasing the population and stimulating industrial expansion. Owning the major stores and newspaper, they made Glen Cove into a company town. The factory was destroyed by fire shortly after this, the only surviving photograph of it, was taken by George Brainard. (*Photograph by George Brainard; Nassau County Museum, #773.92—Brainard #1458.*)

Opposite, top: **59. Woolen Mill, Cold Spring Harbor, 1900.** Since 1700, mills had been operating in Cold Spring Harbor, fulling and weaving the wool brought by neighboring farmers. When the War of 1812 stimulated local industry and greater numbers of Merino sheep were raised, John and Walter Jones invested $12,000 in two new mills. This photograph shows their Lower Factory, which produced broadcloth, kerseymeres, satinets, flannels, blankets and carpeting. In 1821, a year after opening, the Jones factories won several prizes at New York City fairs, including one for their blue-and-white patterned coverlets. By 1827 cheaper im-

ports were threatening their prosperity; Jones joined "Friends of the American System" to lobby for higher tariffs. This effort failed. The Jones brothers turned to whaling, and, by the Civil War, the Cold Spring Harbor woolen industry came to an end. (*Photograph by Hal Fullerton; Suffolk County Historical Society, Fullerton Collection, #L82A.*)

Opposite, bottom: **60. The *Hope* on the Beach, Cold Spring Harbor, October 1903.** On the easternmost border of Nassau County, Hal Fullerton paused to photograph the beached schooner *Hope* and a small child looking across the peaceful inlet. She is sitting near the site of the Brooklyn Biological Laboratory, now the Cold Spring Harbor Laboratory, made famous by Dr. James Watson. This part of Cold Spring Harbor, where whaleships were fitted for their dangerous voyages, had been known as "Bungtown." The eastern side of the harbor, once even more boisterous, was known as "Bedlam"; there sailors caroused and spent their profits. John H. Jones, great-grandson of Thomas Jones (after whom Jones Beach is named), founded the busy Cold Spring Whaling Company here in 1837. His ship, the *Sheffield*, returned in 1849 with 200 barrels of sperm oil, 4,000 barrels of whale oil, and 22,000 pounds of whalebone. The peak years of whaling in Cold Spring Harbor were 1850 to 1854, after which the industry declined, ceasing in 1860. (*Photograph by Hal Fullerton; Suffolk County Historical Society, Fullerton Collection, #L261B.*)

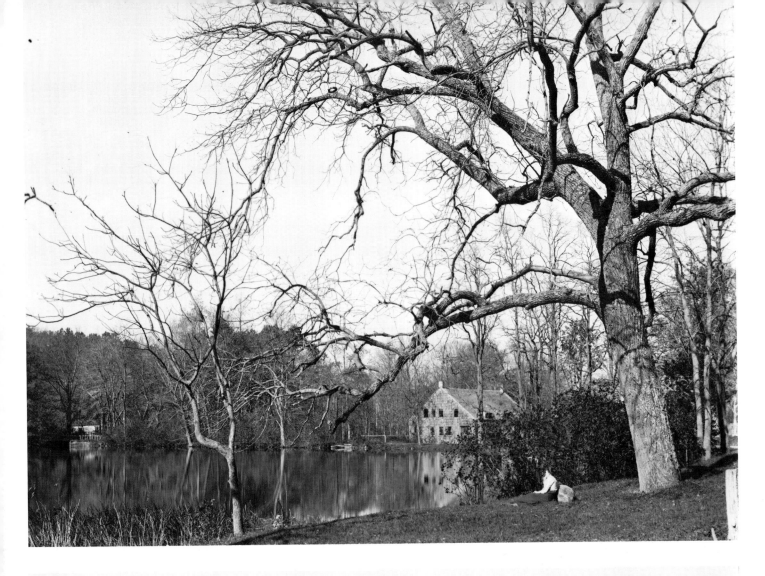

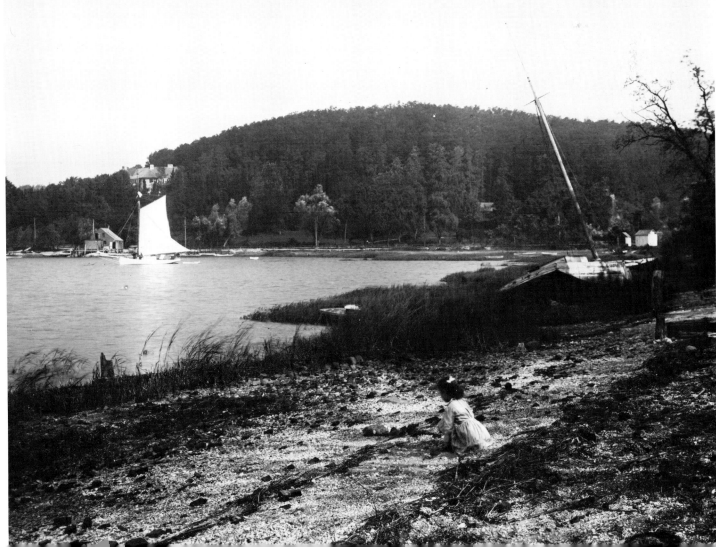

61. St. John's Church, Cold Spring Harbor, September 29, 1903. The Protestant Episcopal Congregation of Cold Spring Harbor, formed in 1831, met in the red schoolhouse on the millpond until 1835, when they acquired a nearby tract of land from John H. Jones for their colonial style, white clapboard church. The cost of building the church, $8,279, was subscribed by 68 people. A single, unpretentious structure, it had separate doors for ladies and gentlemen. It was later renovated to include stained glass windows and dark oak paneling. In the 1920s the church was returned to its earlier style and in 1952, when a portion of the millpond was filled in, it was expanded to hold 300 people. There are now three Tiffany windows on the east side and a locally made George Earle organ. The unpaved road in this photograph is the old Route 25A, passing across the dam that separated the harbor from the millpond. A New York State Fish Hatchery was established in 1881 on the right side of this road. Widened and redirected, Route 25A now skirts the harbor, leaving St. John's and the Fish Hatchery on the same side. (*Photograph by Hal Fullerton; Suffolk County Historical Society, Fullerton Collection, #L264A.*)

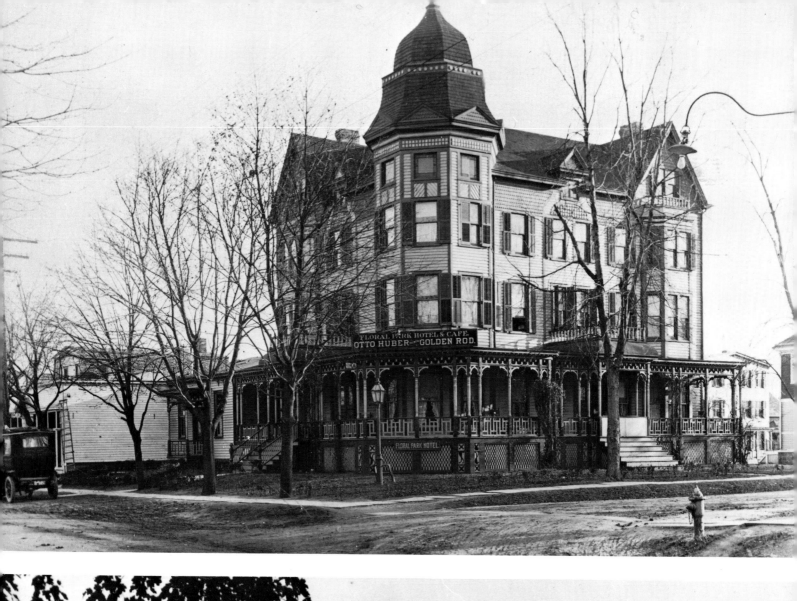

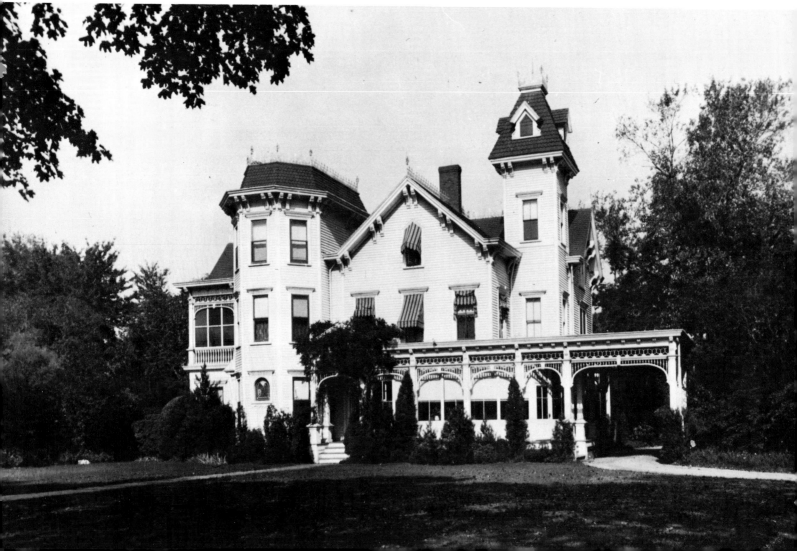

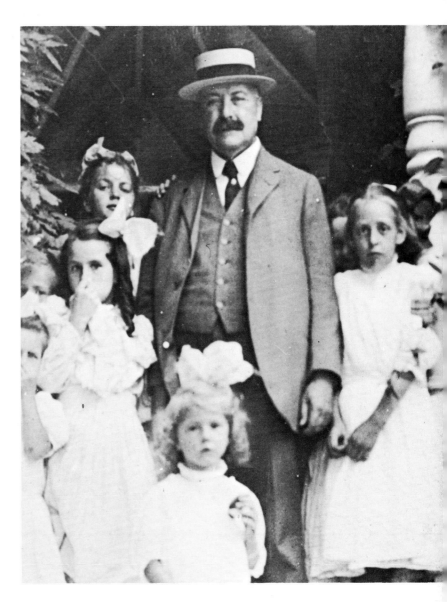

Opposite, top: **62. Floral Park Hotel and Café, 1918.** When John Lewis Childs (1856–1921) came to Long Island from Maine in 1874, Floral Park, called East Hinsdale, was a farming community located between Flushing and the town of Hempstead. Some florists had already established nurseries in the area, which had the advantage of being at a railroad junction. Childs shaped the future of the town, renamed Floral Park, by developing a large-scale operation and taking a paternalistic role toward his workers and their families. Built in 1890 at the corner of Tulip and Violet Avenues, this hotel was originally called the Park House and served as a residence for the Childs employees. By the time of this photograph, it was known as the Floral Park Hotel and Café. (*Cohen Collection, Floral Park Public Library.*)

Opposite, bottom: **63. Home of John Lewis Childs, Floral Park, ca. 1915.** Childs' own home, a handsome Victorian mansion, built in 1882, with its many wings, arched portico, bracketed cornices and high square tower, exhibited the influence of the Gothic Revival and the Italianate styles. Originally including 11 rooms on a three-acre plot a few hundred feet north of the railroad tracks, the house grew to 30 rooms by the time of Childs' death. It is a good example of a successful businessman's residence, its architecture showing his prosperity without being extreme. From his tower, Childs could survey acres of carefully landscaped grounds and see the fields of gladioli, lilies, and tulips. The Childs home was torn down in 1950 to make room for a $3.5 million development of garden apartments. Childs was responsible for more than 20 buildings in Floral Park, including hotels, lumber and planing mills and his own printing press. (*Cohen Collection, Floral Park Public Library.*)

Right, top: **64. John Lewis Childs and Young Guests, ca. 1915.** Childs beautified the community by providing a public park. He also participated freely in its political and social life. In 1894 he was elected New York State Senator, and put through the bill establishing a State Normal School at Jamaica. Twice he ran unsuccessfully for Congress on the Republican ticket and in 1912 he energetically supported the Presidential campaign of Theodore Roosevelt. Childs was also a friend of the naturalist John Burroughs. Here, at his annual lawn party for local children, Childs poses among the young ladies enjoying the special treat of ice cream. (*Cohen Collection, Floral Park Public Library.*)

Right, bottom: **65. John Lewis Childs' Seed Building, ca. 1915.** The ivy-covered brick seed warehouse was built in 1890, the greenhouse to the right in 1915. Childs' seed business was the largest on Long Island; he made it known throughout the world by distributing 500,000 semiannual catalogues printed at his own Mayflower Press. His business grew to include 1,000 acres at Flowerfield, St. James, in eastern Long Island, where he developed the finest collection of gladioli in the country. (*Cohen Collection, Floral Park Public Library.*)

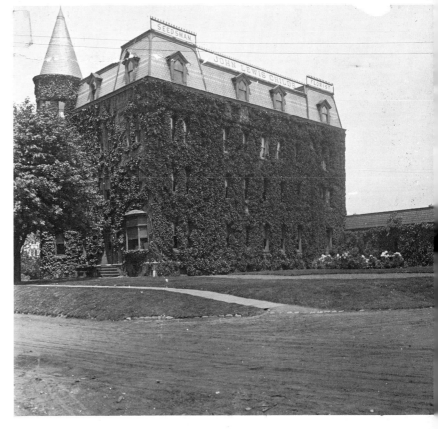

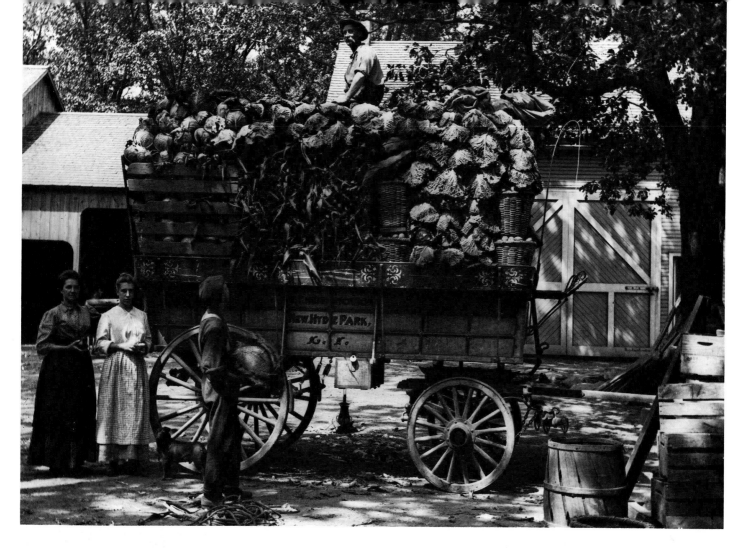

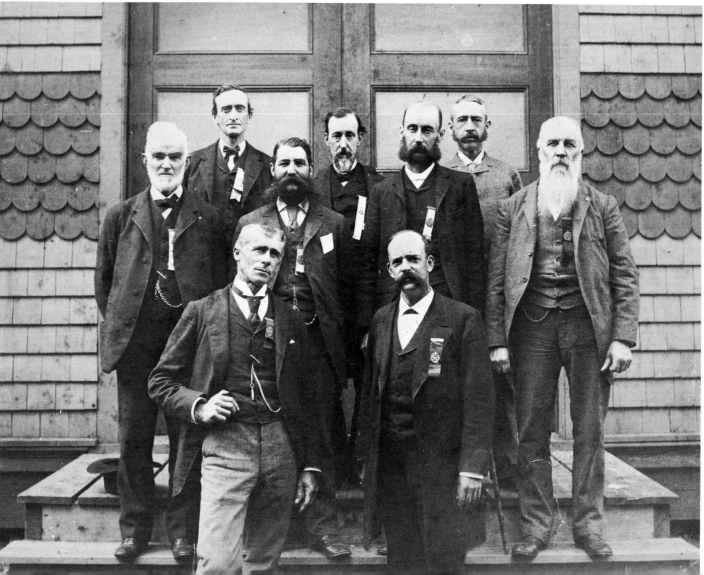

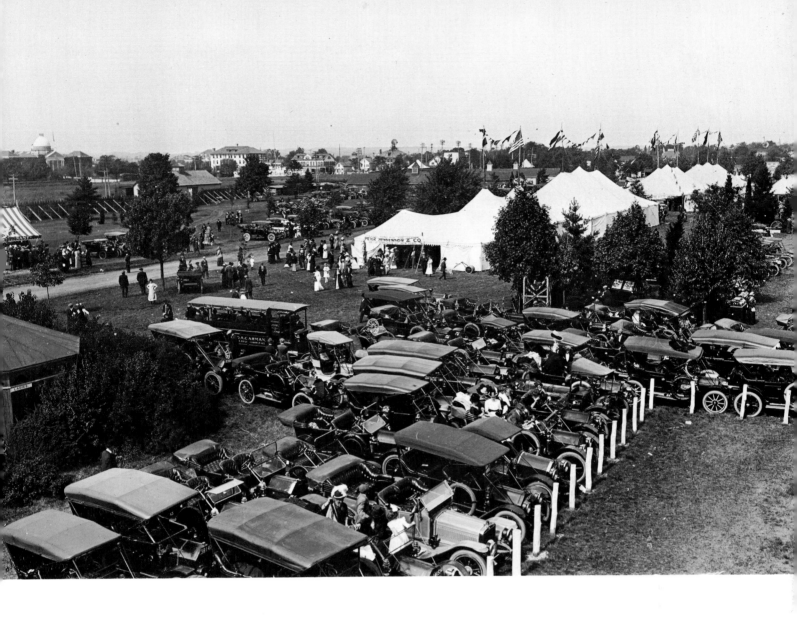

Opposite, top: **66. Cabbage Wagon, New Hyde Park, 1905.** Originally part of a manorial domain awarded in 1683 to Thomas Dongan, fourth Royal Governor of New York and later Earl of Limerick, New Hyde Park was first called "Dongan's Farm." It included 800 acres of land with dwelling houses, cattle and slaves. When Dongan died in 1715, his estate was divided. George Clarke, Secretary of the Province of New York, built a new house on the site, but when he became Lieutenant Governor in 1783, he sold the property. Although it remained a Tory stronghold, "Hyde Park," as it was then called, lost its elegant mansions and was described in a nineteenth-century Long Island Railroad manual as "a scattered village, extending over a rich agricultural district." In the photograph, Wilbur T. Hendrickson proudly displays his surplus cabbages as he gets ready to join a farmer's "right guard" parade. By this time the town had been renamed "New Hyde Park" to avoid confusion with Hyde Park on the Hudson. (*Nassau County Museum, #6281.19.*)

Opposite, bottom: **67. Queens County Agricultural Society Judges at the Mineola Fair, ca. 1895.** The tradition of English country fairs was transplanted to Long Island as early as 1693, developing around sheepshearing day and the semiannual sale of horses and cattle. In 1817 the Queens County Agricultural Society was formed at the old Queens County Courthouse. With Rufus King as president in 1819, it worked to improve methods of farming and stock raising, and toward every "mutual improvement in rural econ-

omy." Other fairs were patterned after those sponsored by this society as the influence of pioneers from Long Island spread to developing farming areas of the West in Ohio, Indiana, Illinois and Missouri. After a temporary flagging of interest beginning in 1822, a new Queens County Agricultural Society was established in 1841. In 1860 a prize was offered for the best essay on the potato and its diseases; the following year, officers began to wear badges similar to those seen in the photograph. In 1866 the Society purchased a 40-acre tract in Mineola for permanent fairgrounds. In 1899, when the new county was formed, the influential organization was renamed the Agricultural Society of Queens and Nassau Counties. (*Nassau County Museum, #5361.*)

Above: **68. Mineola Fair, 1910.** By the turn of the century Mineola was given new prominence, both by its role as county seat and by its annual fair. Prizes of $13,000 were awarded each year, not only for livestock and horticultural exhibits, but also for art displays, women's handiwork, cheese, preserves and bread. With restaurants, grandstand, trotting track, poultry and cattle shed, stables and a ladies' building, fairs were much-anticipated events on Long Island. The photographer must have been standing on a nearby roof to take this view of Model T's and other horseless carriages crowding the fairgrounds. In 1954 the fair moved to Roosevelt Raceway. After that, state law required that it be held every two years. (*Photograph by Henry Otto Korten; Nassau County Museum, #5365.500.*)

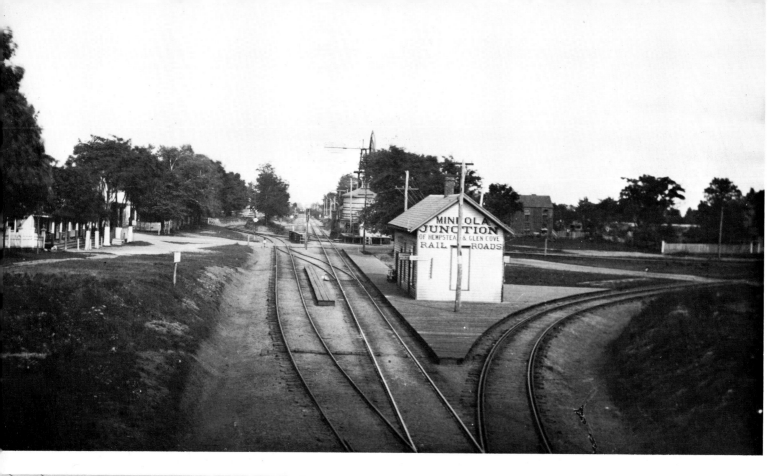

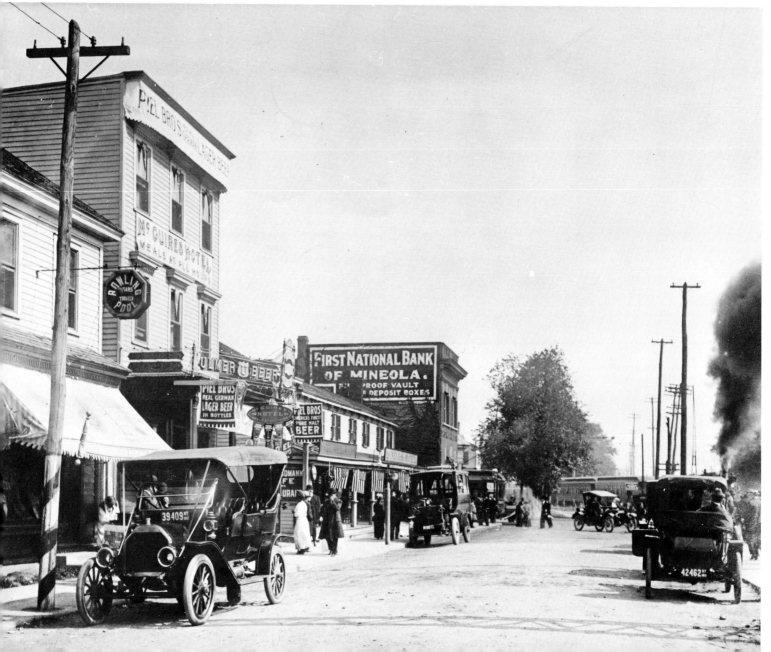

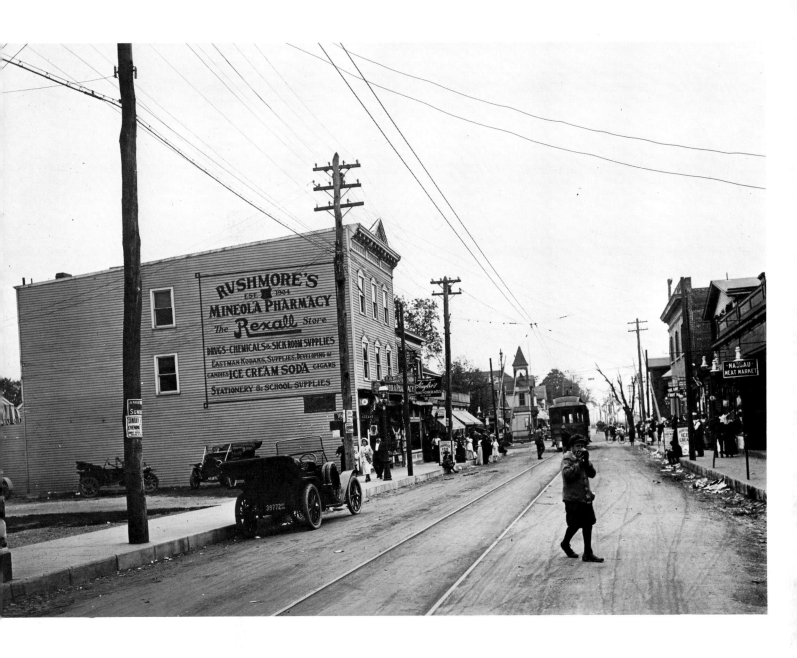

Opposite, top: **69. Mineola Station, ca. 1880.** At about the time Brainard took this photograph, a Long Island Railroad handbook described Mineola as "an important junction and the centre of the transportation of farming products." The track on the right curved south toward Hempstead and that in the left rear went north to Glen Cove. Notice the windmill down the track. The main line continued down Front Street, just as it does today, toward Westbury and Hicksville. (*Photograph by George Brainard; Nassau County Museum, #773.105—Brainard Plate #23.*)

Opposite, bottom: **70. Main Street, Mineola, 1913.** As the seat of county government, Mineola developed into a bustling place with its hotels, saloons, banks and railroad station all clustered near the town center. On the far right, a plume of smoke can be seen from the locomotive chugging down Front Street. Most of the buildings along this typical commercial street are of frame construction, but the First National Bank is built solidly of brick. Major traffic congestion had not yet come to Mineola, but it would soon follow thanks to Henry Ford's new assembly-line procedure which turned out 300,000 cars in 1914 and 500,000 in 1915. (*Nassau County Museum, #2757.*)

Above: **71. Rushmore's Pharmacy, Mineola, 1913.** Korten chose this angle to include a clear view of the advertisement for Rushmore's Mineola Pharmacy. Rushmore was typical of the many druggists who supported the itinerant photographer's postcard trade by paying for the publication of prints to be sold at their store. In this way, not only did they advertise their business, but they preserved an invaluable historic record of Long Island's main streets in the early twentieth century. (*Photograph by Henry Otto Korten; Nassau County Museum, #2741.*)

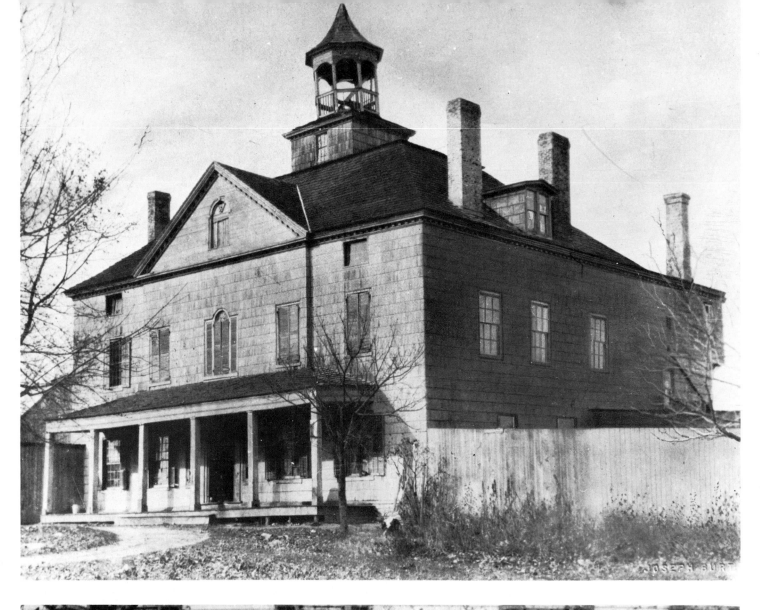

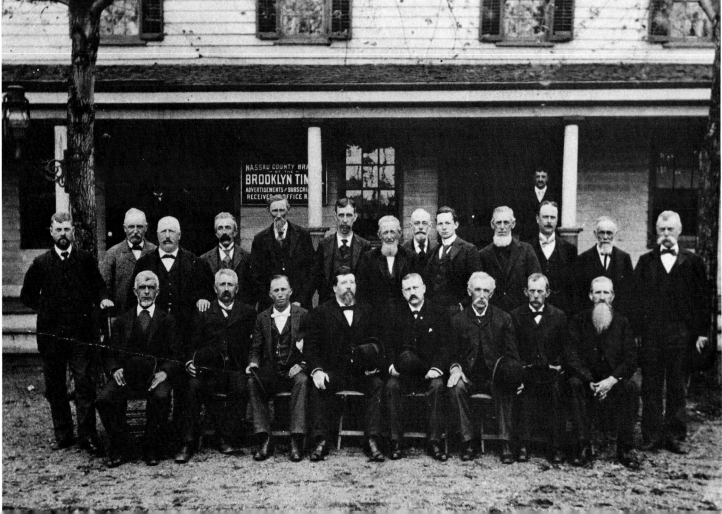

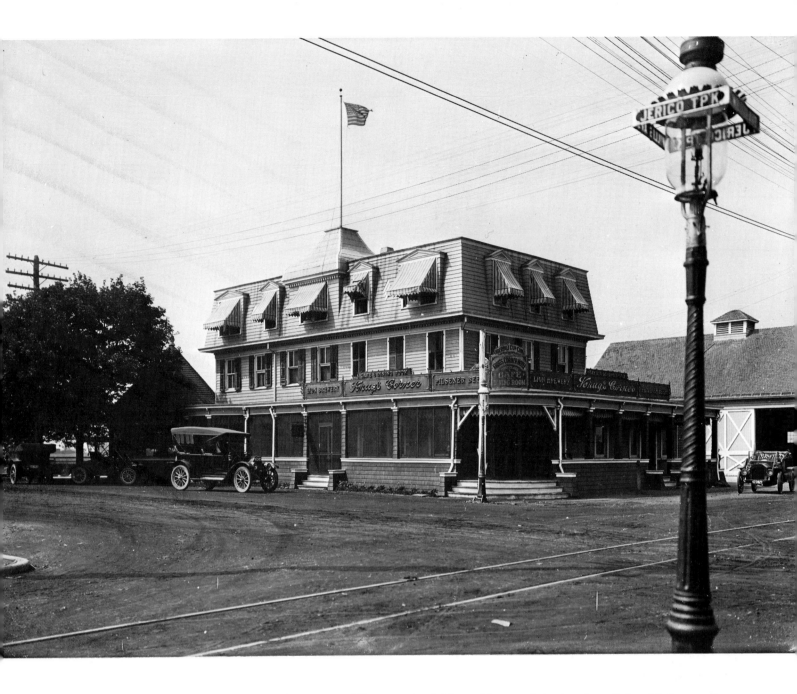

Opposite, top: **72. Old Queens County Courthouse near Mineola, ca. 1890.** For more than three-quarters of a century this was the Queens County Courthouse, serving the whole area from western Queens to the Suffolk border. The first public building for this widely dispersed population, erected in Jamaica in 1683, had been used as a combination courthouse, prison and church. In 1785 the New York State Legislature shifted the county seat to Hempstead and, in 1786, built this courthouse near the intersection of Herricks Road and Jericho Turnpike, the geographical center of what was then Queens County. They set aside £2,000 for a courthouse and jail "within a mile of the 'Windmill [now Herricks] Pond' at or near the house of Benjamin Cheeseman." During its early years, courts here often meted out corporal punishment for petty crimes, the last public whipping occurring in 1810. In 1872, responding to pressure from western Queens, the main court moved to a building in Long Island City; the structure pictured here continued to be used as a local court building until 1877. (*Nassau County Museum, #901.*)

Opposite, bottom: **73. Nassau County Jury, Mineola, ca. 1899.** Nassau County came into existence on January 1, 1899. This resolved a long-standing dispute among those who felt that the 274-square-mile area should remain a part of Queens and Greater New York, attach itself to Suffolk or become a new political entity. Central location of public buildings had always been an insoluble problem, and the location of the old Queens County Courthouse had never pleased those who lived in the western sections. When the seat of the new county was finally chosen, Mineola triumphed over Hempstead and Hicksville; courthouse functions moved from the old building, on the outskirts of town, to new temporary headquarters at the Mineola Hook and Ladder Company firehouse. The permanent Nassau County Courthouse, still standing in Mineola, was dedicated in 1901. This photograph shows the first Nassau County Supreme Court Grand Jury assembled before Allen's Hotel, Main Street, Mineola. In the front row, fourth and fifth from the left, are William G. Miller, district attorney, and James R. Neimann, county clerk. While the court functions were carried on in the firehouse, the old courthouse building was used as additional space for the State Insane Asylum. Old Courthouse Road, today running from Herricks Road to Marcus Avenue, is the only reminder of this venerable building, which burned in 1910. (*Nassau County Museum, #4072.*)

Above: **74. Krug's Corner Hotel, Mineola, ca. 1910.** The old courthouse was still standing across the way when Korten took this photograph at the intersection of Jericho Turnpike and Denton Avenue (Main Street). The turnpike location was ideal for a typical small traveler's hotel. Business was stimulated by the Vanderbilt Cup Motor Car Races, which passed Krug's corner. (*Photograph by Henry Otto Korten; Nassau County Museum, #5365.431.*)

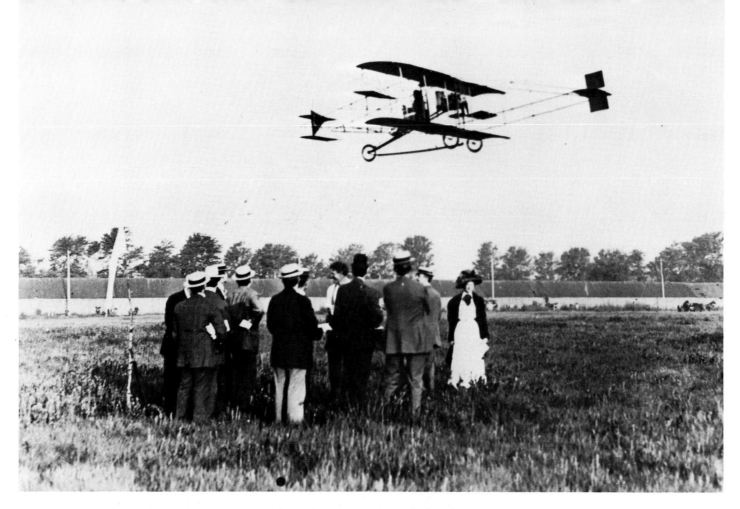

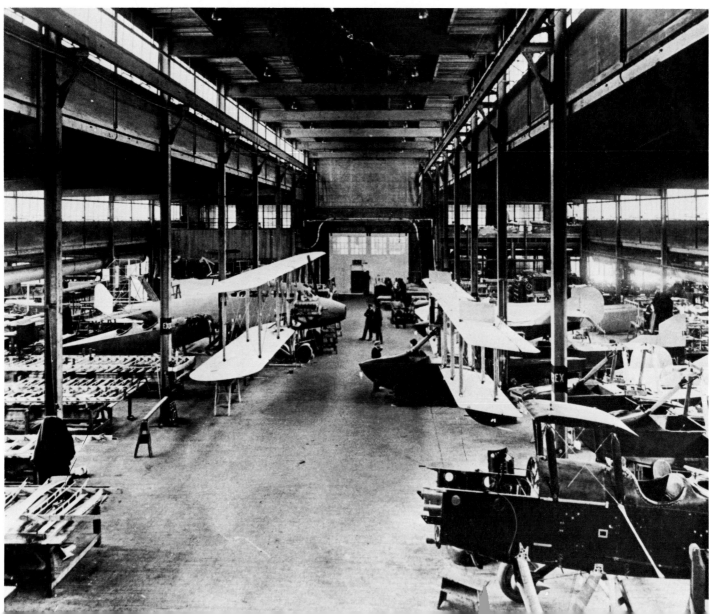

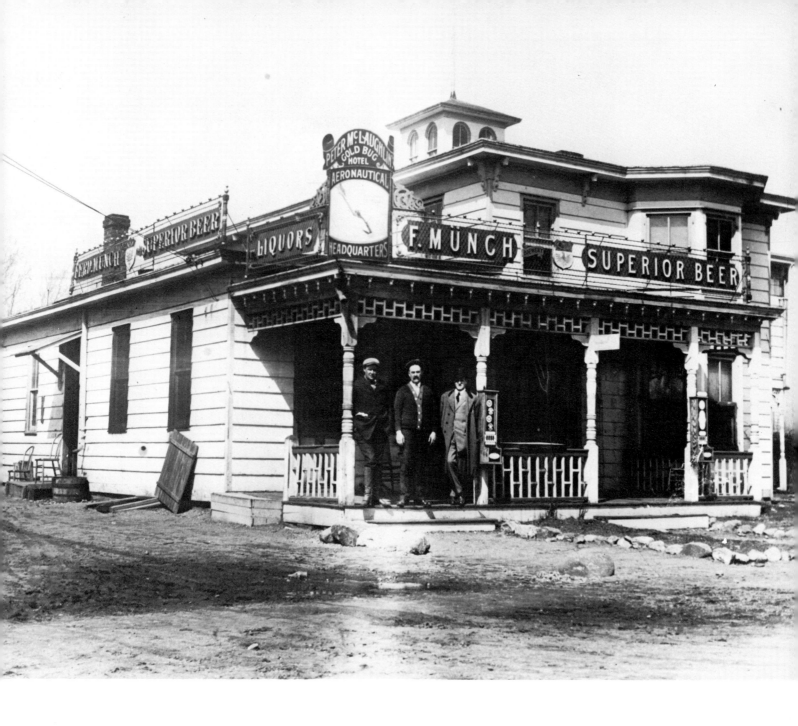

Opposite, top: **75. Glenn Hammond Curtiss in** *Gold Bug* **(Golden Flyer,), 1909.** On a tract of flat land between Old Country Road and Washington Avenue, adjacent to the carriage sheds of the Mineola Fair, the New York Aeronautic Society experimented with flight. Here Glenn Curtiss managed to keep his *Gold Bug* aloft for 15½ miles on July 17, 1909. This feat won the pilot $10,000 and a trophy from the *Scientific American*. Curtiss gave ground instruction and practiced flying at this location. (*Garden City Archives.*)

Opposite, bottom: **76. Curtiss Engineering Plant, Garden City, 1919.** During World War I, as airplane technology grew, the Curtiss Engineering Corp., at Clinton Road north of the railroad, supported the war effort. Engineers designed, as a secret navy weapon, large trimotor seaplanes powerful enough to cross the Atlantic Ocean. Though not used in the war, later one of the "flying boats," the NC 4, completed the transatlantic journey with only two stops. In this view we can see a tandem-wheeled trimotor

Eagle (left center), the fuselage of a "Jenny," with uncovered wing frames beside it (far left) and an F-boat, with wing-top stabilizers and a pusher engine (right). During the 1920s Curtiss Engineering specialized in pursuit and racing planes, winning many prizes; in 1931 it closed this large brick plant, transferring operations to a tract in Valley Stream. (*Garden City Archives.*)

Above: **77. Gold Bug Hotel, Garden City, 1909.** At the Washington Avenue flying field, the Gold Bug Hotel (Peter McLaughlin, proprietor, at the center) served as aeronautical headquarters. The *Gold Bug* was reassembled in a large tent beside the hotel. "Superior beer" heartened the aviators, who worked at unraveling the mysteries of flying. Perhaps Poe's famous story "The Gold Bug" inspired experimenters to hope that at the end of this puzzle they, too, would find treasure. Their courageous and imaginative work had enormous military, industrial and social consequences. (*Garden City Archives.*)

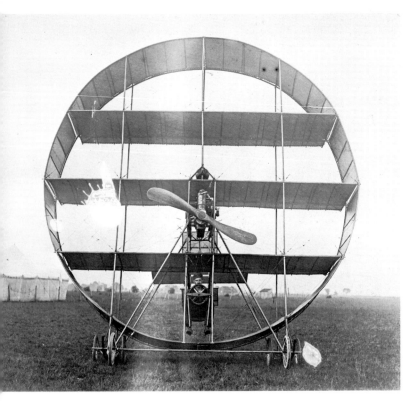

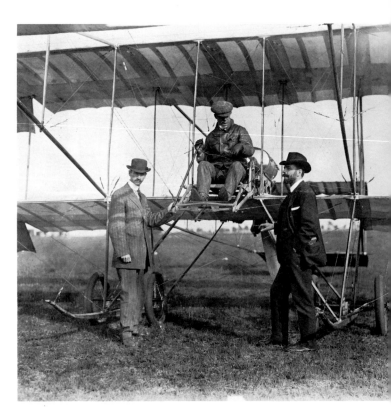

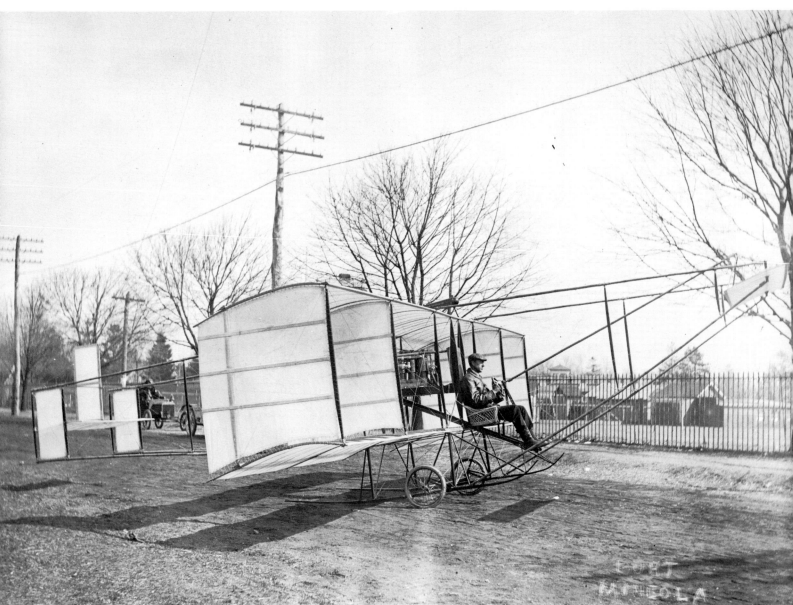

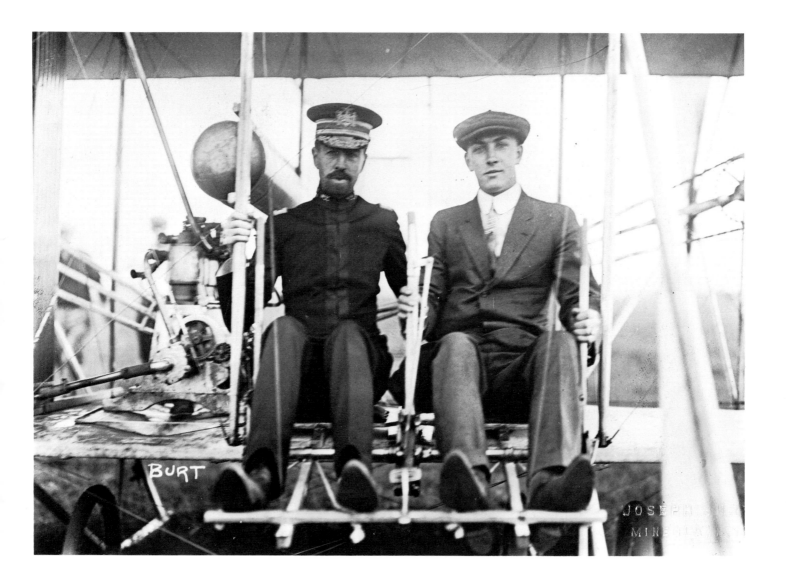

Opposite, top left: **78. Experimental Plane, Mineola, August 17, 1911.** From 1909 to 1929, the activities of experimental fliers on Long Island fields made Nassau County world famous as "the cradle of aviation." Along with the educated scientists were many who seemed to ignore the established principles of physics in favor of bizarre flying machines. This circular experimental plane was doomed to failure, as were the multiwinged and bird-winged planes, favorites of the nonprofessionals. Even the successful flights were not without their problems, as Calbraith Rogers showed exactly one month after this picture was taken. It took Rogers 82 flying hours and 49 days, including 19 crashes en route, to complete the first transcontinental flight from Long Island to Long Beach, California. (*Nassau County Museum, #4042.*)

Opposite, bottom: **79. Experimental Plane, Mineola, ca. 1910.** Flying over the flat Hempstead plains, both amateur and expert inventors attracted as many as 10,000 people to exhibitions of their latest aerial accomplishments. In its early days aviation was considered more a sport and entertainment than a commercially viable pursuit. In 1910 the second United States Aviation Tournament was held at Belmont Park, where speed and altitude records were set. (*Nassau County Museum, #3822.*)

Opposite, top right: **80. Glenn Hammond Curtiss, 1912.** Curtiss (left) is standing with Augustus Post, Jr. (right) in front of a French Farman biplane. Before Curtiss turned his interests to aviation, he had been considered "the fastest man on earth" for his motorcycle speed records. Alexander Graham Bell, searching for a way to power the giant kites which he had been testing, recruited Curtiss for flight experiments. This led to the first official public flight in the United States on July 4, 1908, at Hammondsport, New York, where Curtiss stayed aloft for nearly a mile. A. M. Herring of Freeport was present on this occasion and brought Curtiss to Long Island where together they built the prizewinning *Gold Bug* in 1909, six years after the Wright Brothers had mastered powered flight in Kitty Hawk. A bitter fight ensued between Curtiss and the Wrights, culminating in a jointly patented Curtiss-Wright engine. Eventually personal tragedy caused the Wright Brothers to drop out of aviation, but Curtiss went on to develop the military applications of aircraft at the Curtiss Engineering Corp. in Garden City. (*Nassau County Museum, #4077.*)

Above: **81. Cornelius Vanderbilt and George Beatty in Wright Plane, ca. 1910.** To those who did not envision the commercial potential of aviation, the airplane was merely a dangerous toy of the rich. Yet these wealthy investors stimulated interest in flight by purchasing planes for their private pleasure and offering prizes for aerial design and competition. Among the financial backers was William Randolph Hearst, who owned the first flying machine on Long Island and offered $50,000 for the first transcontinental flight to be completed in 30 days. Other supporters included Clarence Mackay and Cornelius Vanderbilt, seen here on the left beside George Beatty, an early pilot. In the years after this photograph was taken, many "firsts" were accomplished by Long Island aviators: Harriet Quimby was the first woman to earn a flying license; Earle Ovington first piloted an airmail flight from Garden City to Mineola; Charles Lindbergh became famous for the first nonstop solo flight from Roosevelt Field to Paris. Elinor Smith was the first female to fly commercially. (*Nassau County Museum, #4093.*)

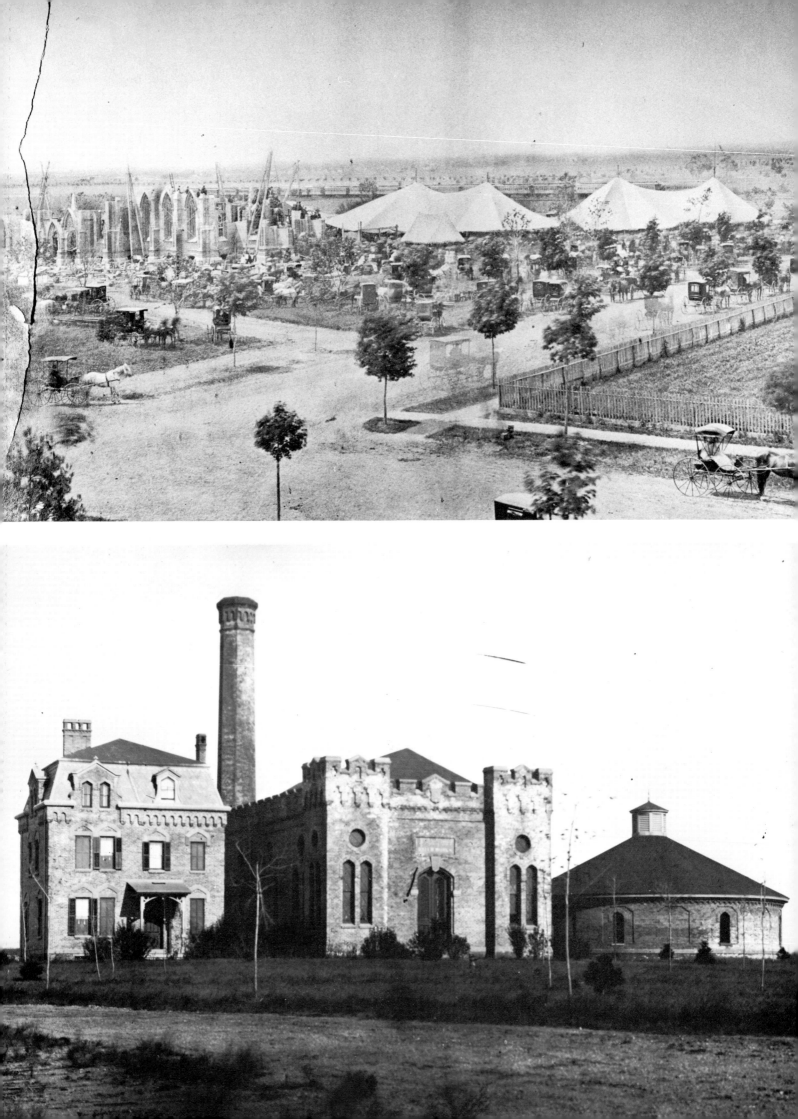

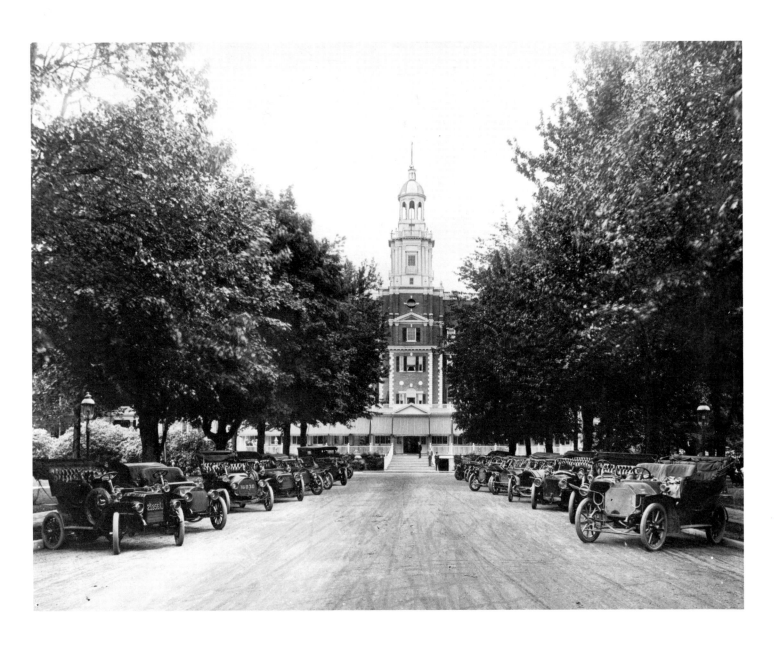

Opposite, top: **82. Construction of Garden City Cathedral, June 28, 1877.** One of the oldest surviving glass-plate photographs of Nassau County, this view of laying the cornerstone at the Cathedral of the Incarnation was found in the Deanery attic. It shows the Gothic cruciform church, its walls rising 30 feet above the Hempstead Plains. The supply tents on the right stored Belleville stone, marble and English glass windows. Still an imposing landmark, the Episcopal church was planned in 1876 as a memorial to Garden City's founder, Alexander Turney Stewart, by his widow; the architect was Henry G. Harrison, the builder James l'Hommedieu. When the Cathedral was completed on June 2, 1885 by 240 workmen, Garden City had a total population of only 550 and was mocked as "Stewart's Folly." A prosperous New York drygoods merchant, Stewart had purchased 7,170 acres of barren land in 1869 for $55 an acre. He envisioned a planned community where the desert would be "made to blossom as the rose," but he was buried in the Cathedral crypt before his $394,350 investment began to flourish. (*Garden City Archives.*)

Opposite, bottom: **83. Garden City Waterworks, 1876.** For 20 years, the Great Well on the right was Garden City's only water source. Designed in 1876 by Henry W. Lewis, and built at Cherry Valley and Hilton Avenues by James l'Hommedieu, the well was 45 feet in diameter and 40 feet deep. It was considered a wonder for its time, when 14-foot wells were sufficient to draw potable water. The middle building housed the boilers which produced steam heat and the pumps which filled seven miles of mains. The brick house on the left provided living quarters for three engineers. Until 1956, when it was filled in, the Great Well served as a storage reservoir. (*Photograph by George Brainard; Nassau County Museum, #773.126—Brainard Plate #33.*)

Above: **84. Garden City Hotel, ca. 1907.** The original Garden City Hotel was planned as the center of Stewart's community. Built in 1874 by John Kellum for $150,000, the square four-story brick-and-stone structure had a mansard roof and 25 rooms. After Garden City prospered in the 1880s as a sportsman's resort, the building was ambitiously redesigned by McKim, Mead and White; it grew to 100 rooms, where guests paid $3.50 per day, American plan. A fire gutted the building in 1899, leaving only the shell, and in 1900, McKim, Mead and White completed a fireproof brick and marble restoration, with two additional wings. This photograph shows the main entrance of the rebuilt hotel in its heyday, when guests included the Astors, Belmonts, Morgans and William K. Vanderbilt, the millionaire industrialist who planned the Vanderbilt Cup Race here. The Georgian Revival building dominated Garden City until 1973, when it was bulldozed by real-estate developers who failed to appreciate its architectural significance. They also failed financially. After several years of neglect, the site is again being used for a new luxury hotel. (*Garden City Archives.*)

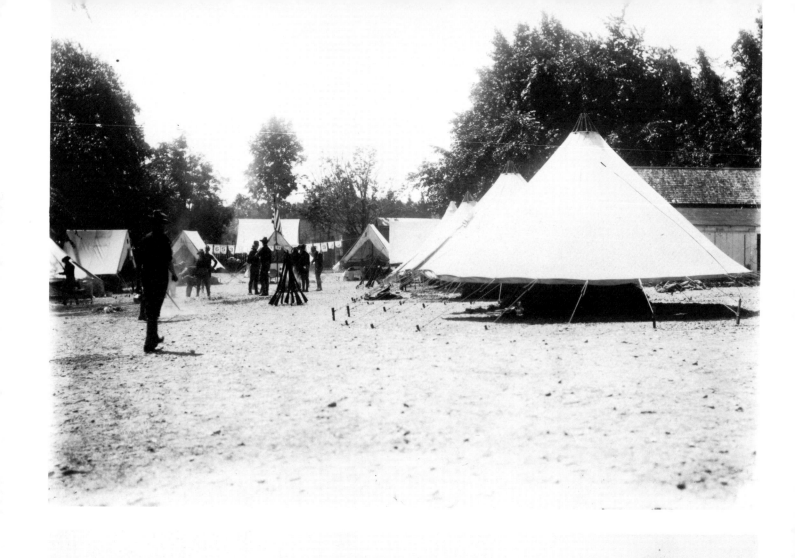

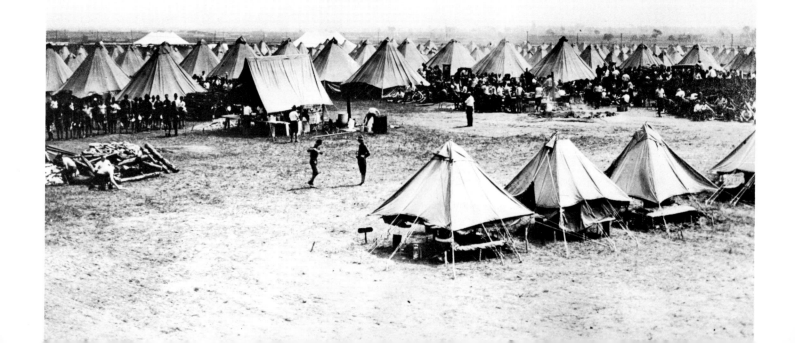

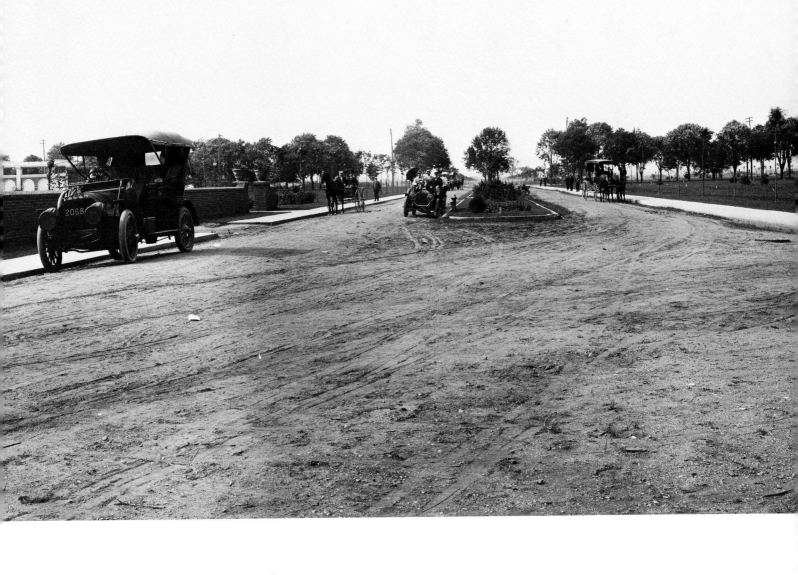

Opposite, top: **85. Camp Black, Hempstead, 1897.** The Hempstead Plains had been used for the training of troops in the Revolution, the War of 1812 and the Civil War. In 1897 Camp Black became the principal recruiting station for the Army's Department of the East and housed volunteers on their way to fight the Spanish-American War. It was named after Governor Frank S. Black, who two years later signed the bill creating Nassau County. Perhaps some of the men gathered here supported Teddy Roosevelt's "roughriders" in their famous charge on San Juan Hill. (*Photograph by Hal Fullerton; Suffolk County Historical Society, Fullerton Collection, #1007A.*)

Opposite, bottom: **86. Camp Mills, Garden City, 1917.** During World War I this large tract of land east of Clinton Road was chosen as a training camp for soldiers preparing for overseas duty. Named for Brigadier General Albert L. Mills, Chief of the Militia Bureau, it was selected for its nearness to New York City, its abundant water supply and varied rail connections. This photograph shows the 42nd or Rainbow Division, assembled from the

National Guard Regiments of every state in the Union. Its thousands of men lived in floorless tents. As many as 50,000 visitors added to the excitement in Garden City on the autumn Sundays before October 1917, when the Division sailed for Europe. When news came of the large number of dead (2,950) and wounded (13,290), local residents erected a monument on Clinton Road. Camp Mills was reactivated in 1918 for the Sunset Division and closed in 1919. (*Nassau County Museum, #1443.*)

Above: **87. Nassau Boulevard, Looking North, Garden City Estates, ca. 1907.** The original trees brought to this "garden city" from Prince's Nursery in Flushing today form a green arch over the now-paved road adjacent to the train station. Carrying out Stewart's plan for a geometric pattern of wide streets, Nassau Boulevard, despite heavy traffic, still offers the luxury of a planted center island. Electrification of the railroad in 1908 stimulated the development of Garden City Estates, where large houses now line the Boulevard. (*Garden City Archives.*)

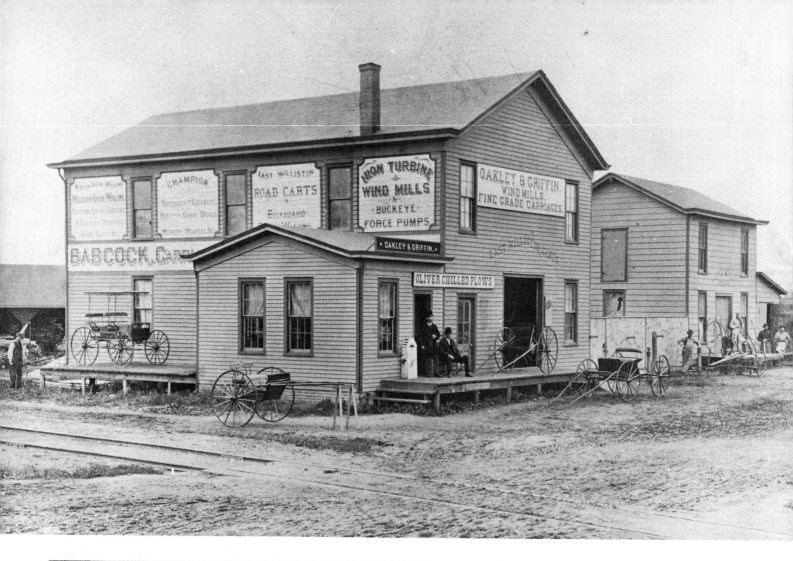

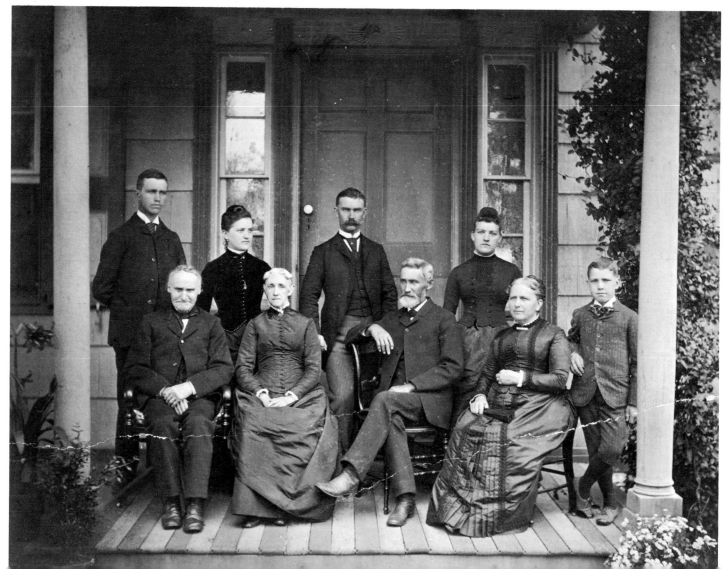

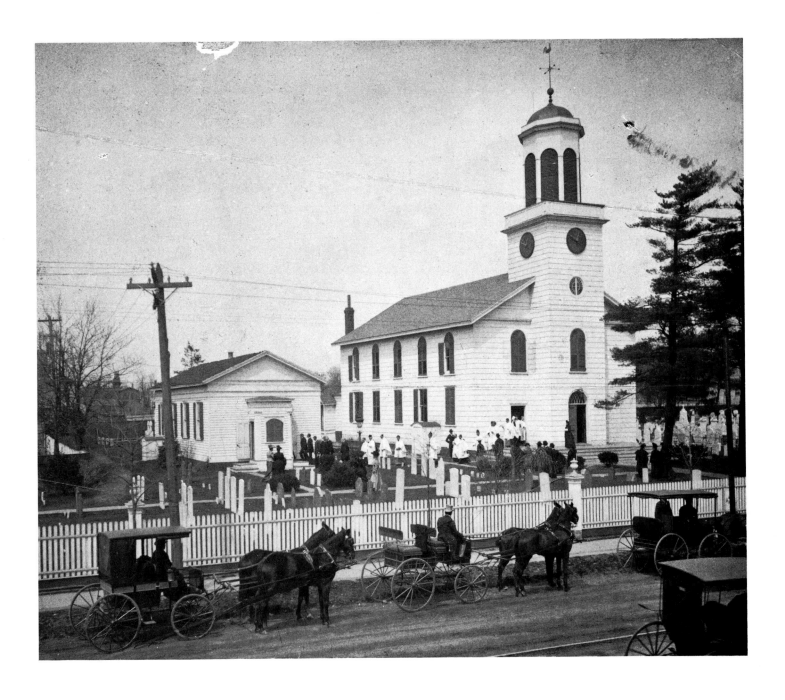

Opposite, top: **88. Oakley and Griffin Cart Company, East Williston, 1890.** Built by Henry M. Willis before 1880, this two-story factory for the production of windmills and carriages was located on the south side of East Williston Avenue (Hillside Avenue), then Main Street, just west of the railroad. Mr. Willis, one of the family for whom the town was named, was a practical inventor, registering 20 patents between 1878 and 1916 for such devices as a lifting jack, a bundle-carrier, a combined inkstand-penrack and a cigar perforator. Most successful of these was his East Williston Road Cart, patented in 1891, a two-wheeled horse-drawn vehicle that offered a smooth, stable, springy ride over Long Island's rutted unpaved roads. An example of the East Williston cart can be seen in the left center of this photograph. (*Photograph by B. Smith of Brooklyn; Nassau County Museum, #799.*)

Opposite, bottom: **89. The Oakley Family, East Williston, ca. 1890.** At the center of this formidable family group stands Foster Lincoln Oakley, the prototype of an enterprising nineteenth-century businessman. Standing left of him are Charles, Jr. and

Martha Jane; to the right, Phebe Luan. Seated in the front row are: left to right, Israel, his wife Phebe Bennet, Charles, Sr., his wife Lydia Ludlam, and George Israel Oakley. In addition to his partnership in Oakley and Griffin, Foster L. Oakley owned an agricultural-supply business, located across the street from the carriage works; farm tools and machinery were sold there until the early 1940s. (*Nassau County Museum, #2952.*)

Above: **90. St. George's Episcopal Church, Hempstead, April 23, 1904.** Founded in 1702, the church erected its first building in 1733. The present structure, built in 1822 on Front Street, is a fine example of Georgian architecture. Its steeple still displays the old golden weathercock, pierced by 16 bullets in target practice by Revolutionary soldiers. The 1793 Rectory on Prospect Street is the oldest residence on Long Island in continuous use. Still treasured in the church collection are the gifts offered by the Royal Governor at the dedication on St. George's Day, 1735, and the chalice and Bible sent by Queen Anne at the founding. (*Long Island Picture Collection, Hempstead Public Library.*)

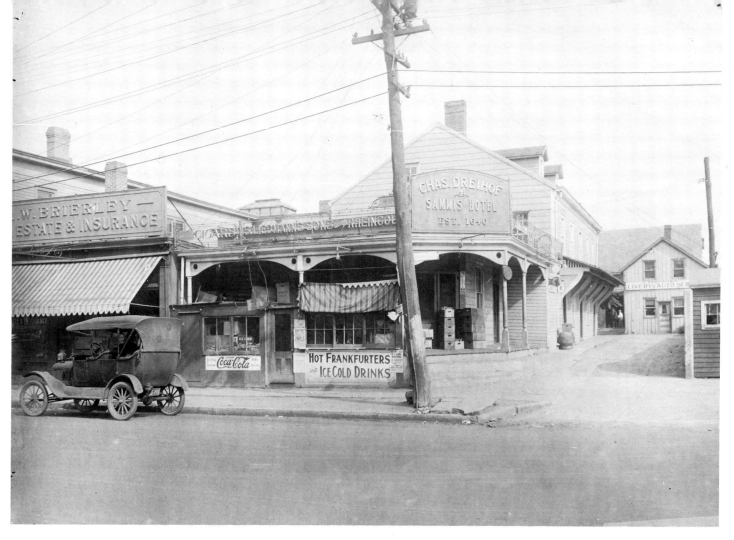

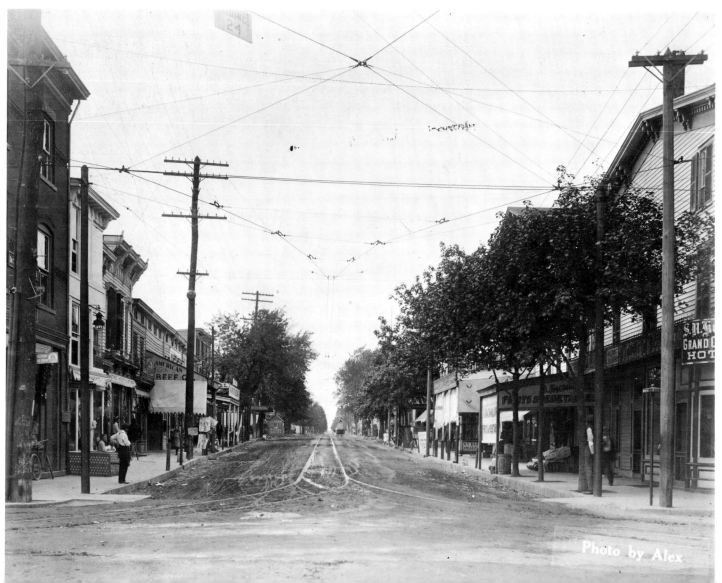

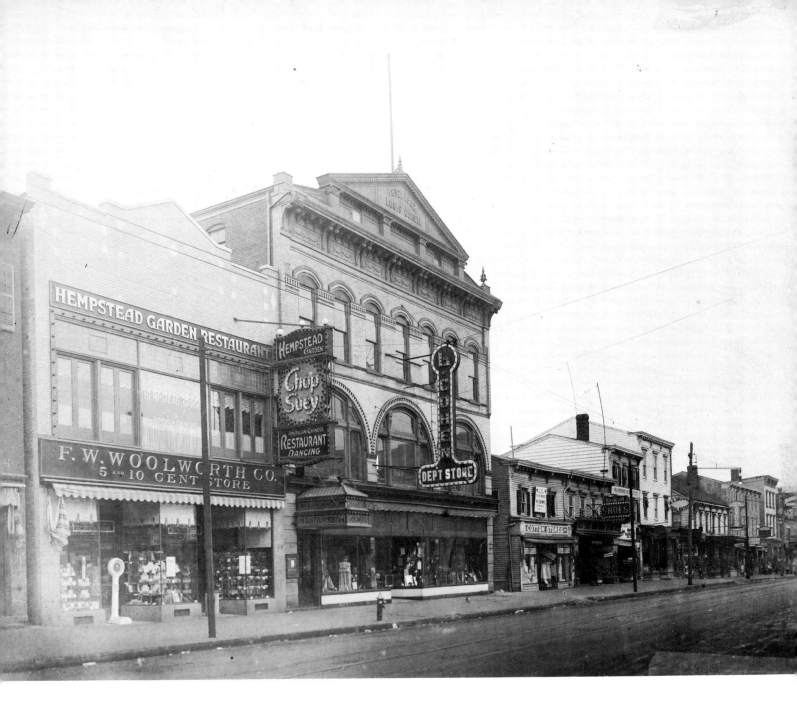

Opposite, top: **91. Sammis Hotel, Hempstead, ca. 1920.** When it was dismantled in the early 1920s, the Sammis Tavern, built in 1680, was the oldest inn in the United States. Located on Fulton Avenue along the main coaching road between New York and the eastern end of Long Island, the inn was run for 223 years by the Sammis family, until Seaman Birdsall assumed management on January 1, 1903. The tavern was used as British headquarters during the Revolution, when Nehemiah Sammis hid under the stairway to avoid conscription. George Washington, who was a guest in 1788 and 1790, remarked, "The inn was a hospitable place and filled with good cheer." The inn's records were complete for over 200 years, serving as an unofficial town history. (*Long Island Picture Collection, Hempstead Public Library.*)

Opposite, bottom: **92. Main Street Looking North, Hempstead, 1900.** Settled in 1643, Hempstead was the oldest village and principal commercial center of Nassau County. Its founders were John Carman and Robert Fordham, Englishmen from Stamford, Connecticut. Some historians derive the town name from the old En-

glish words "Hem," meaning "town," and "sted," meaning "spot." Others find the origin in Hemel-Hempstead, an English market town, or in the Dutch name "Heemstede." By the early 1800s, Hempstead had become a thriving community. Electricity came here in 1886, but the roads and transportation were still uncertain enough to require numerous inns and hotels, such as the Grand Central. Many small businesses lined Main Street at the turn of the century before the development of department stores and supermarkets. (*Long Island Picture Collection, Hempstead Public Library.*)

Above: **93. East Side of Main Street, between Fulton and Front Streets, Hempstead, ca. 1920.** The photograph shows a new exotic attraction on Main Street—a Chinese restaurant advertising chop suey and dancing. Some stores are still specialized, like the cotton and shoe shops, but Woolworth's and Cohen's Department Store show the movement toward consolidation. Later, shopping centers further developed this commercial trend, undermining the business of Main Street. (*Long Island Picture Collection, Hempstead Public Library.*)

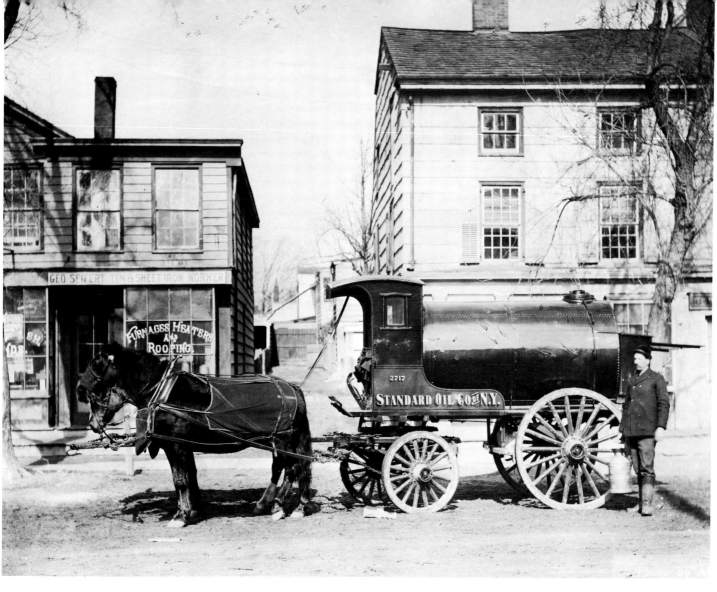

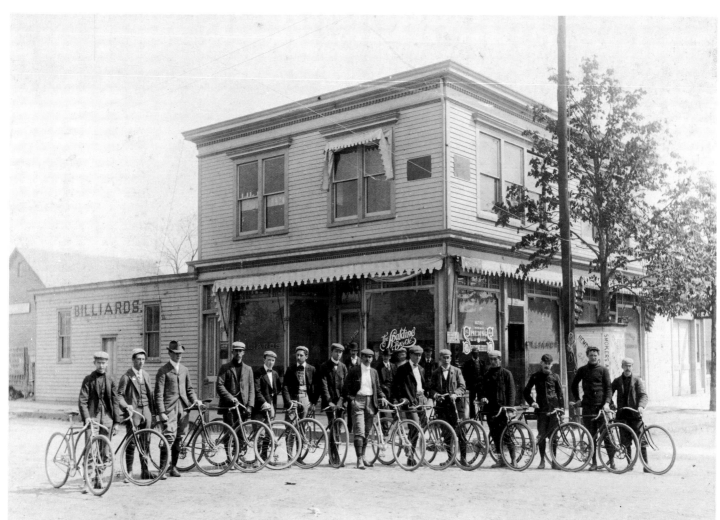

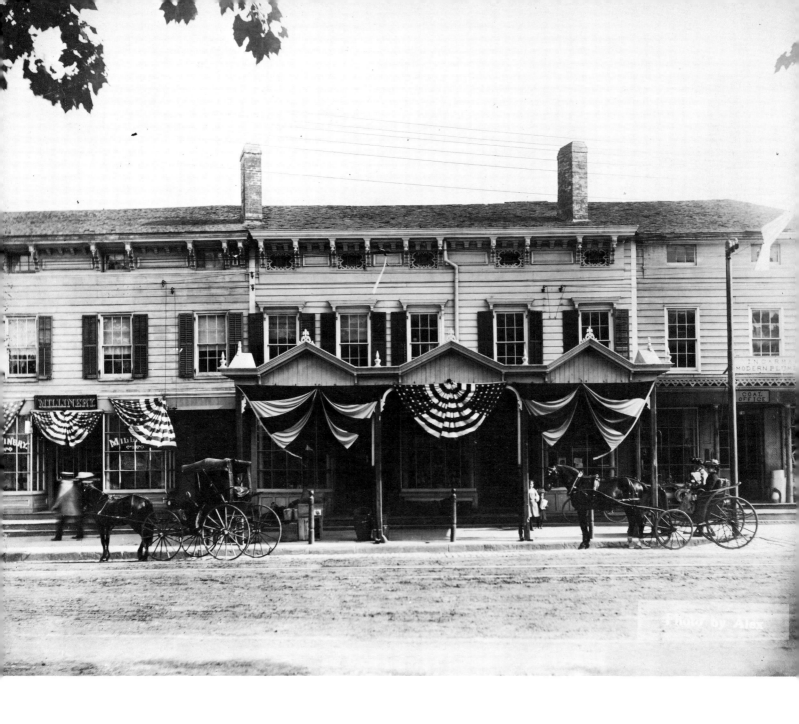

Opposite, top: **94. Standard Oil Co. Delivery Wagon, Hempstead, ca. 1890.** Perhaps today's oil shortages may yet bring back these diminutive tanks! Incorporated in 1870 by John D. Rockefeller, Standard Oil Company soon became the largest single oil manufacturer in the world, producing 10,000 barrels a day by 1872. An underground pipeline from Bayonne brought crude oil to Long Island refineries. Even in the early days there were violent fluctuations in prices and supply. In the two years between 1862 and 1864, the price of oil jumped from $4 to $12 a barrel. The story of oil consumption may be summed up in a maxim taught young Rockefeller by his mother: "Willful waste makes woeful want." (*Long Island Picture Collection, Hempstead Public Library.*)

Opposite, bottom: **95. Main and Fulton Streets, Hempstead, 1899.** The first usable bicycle was made in 1839 by Kirkpatrick Macmillan in Scotland, but it was not until the 1888 development of a pneumatic tire that bicycling became popular. In the decade that followed, club cycling on Sundays was so much in vogue that ministers, fearing their authority slipping, warned "You cannot serve God and skylark on a bicycle." (*Long Island Picture Collection, Hempstead Public Library.*)

Above: **96. Cooper and Powell's Store, Front Street, Hempstead, ca. 1890.** In the center of this frame block stood Cooper and Powell's store, at the time the largest general mercantile business in Hempstead. As a youth, Edward Cooper had been a $40-a-year clerk, but the habit of thrift enabled him to save $400, which he invested in a business with his brother Elbert. After Elbert's death, Cooper formed a partnership with Henry Powell; in 1861, they opened the store shown in the photograph. In addition to selling flour, sugar and other staples, Cooper served as vice-president of the Hempstead Bank and as president of the Queens County Agricultural Society. An 1896 biographical record numbers him among "the progressive men who have contributed to the growth and prosperity of Hempstead." (*Long Island Picture Collection, Hempstead Public Library.*)

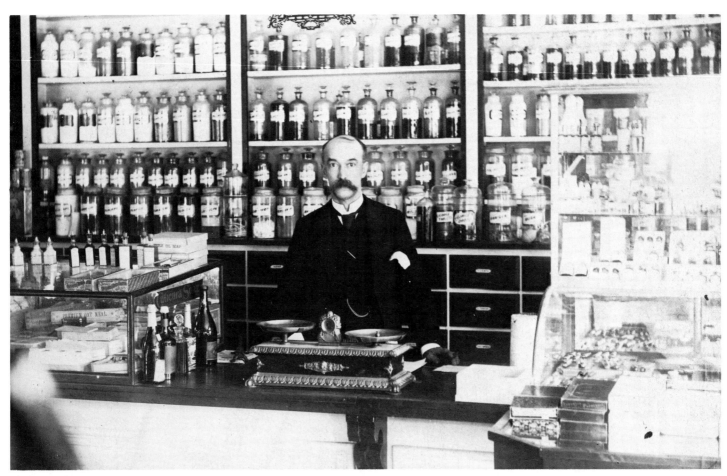

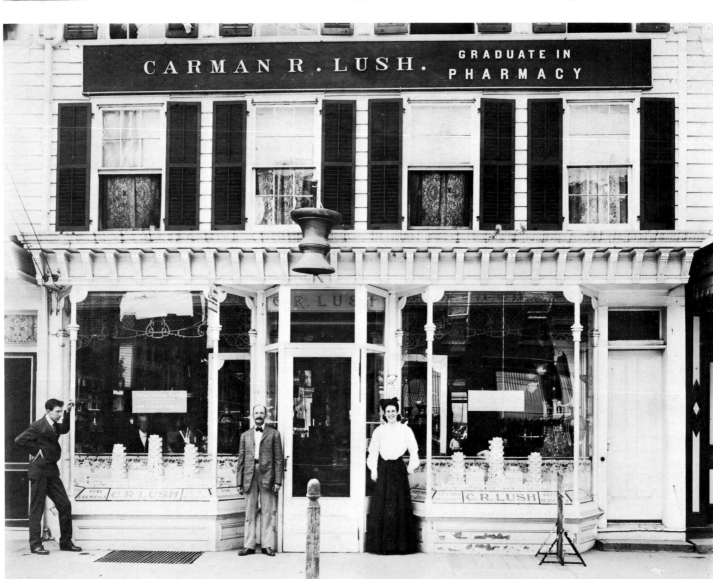

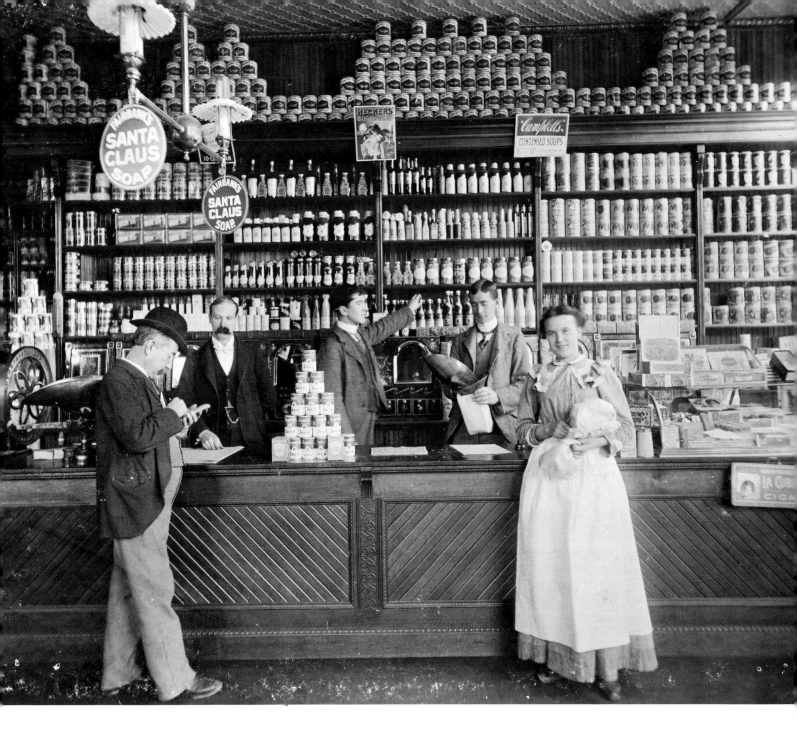

Opposite, top: **97. Interior, Carman R. Lush Pharmacy, Front Street, Hempstead, ca. 1880.** Doctors were expensive and advertising seemed convincing to rural Long Islanders who shopped at such drugstores as Carman R. Lush's Pharmacy. Among the neat rows of medicine bottles now prized as antiques, a Hempstead sufferer might find the most popular panaceas of the day: Hood's Sarsaparilla, Ayer's Cherry Pectoral, Carter's Little Liver Pills, Pierce's Pleasant Pellets, Hale's Honey of Horehound, Fulford's Pink Pills for Pale People, Green's August Flower for Dyspepsia. (*Photograph by De Mott Studios; Long Island Picture Collection, Hempstead Public Library.*)

Opposite, bottom: **98. Exterior, Lush Pharmacy, ca. 1880.** Like other Americans in the post–Civil War period, residents of Nassau County believed in the powers of patent medicines. However it was

the exterior of the bottle, its labie and design, which was patented, rather than the "infallible, speedy and permanent" contents. Perhaps the "Graduate in Pharmacy" inspired more confidence than a street corner peddler, when buyers sought his nerve tonics, blood purifiers, and remedies for indigestion and "female disorders". (*Long Island Picture Collection, Hempstead Public Library.*)

Above: **99. Interior, Grocery Store, Corner of Main and Front Streets, Hempstead, ca. 1885.** You can no longer get a bar of Santa Claus soap, but you can still buy the red-and-white-labeled cans of the Campbell Soup Company, founded in 1869 and incorporated in 1881. The arrangement of goods behind the wooden counter represents a transition between the old-fashioned general store, which relied on delivery, and the modern, self-service supermarket. (*Long Island Picture Collection, Hempstead Public Library.*)

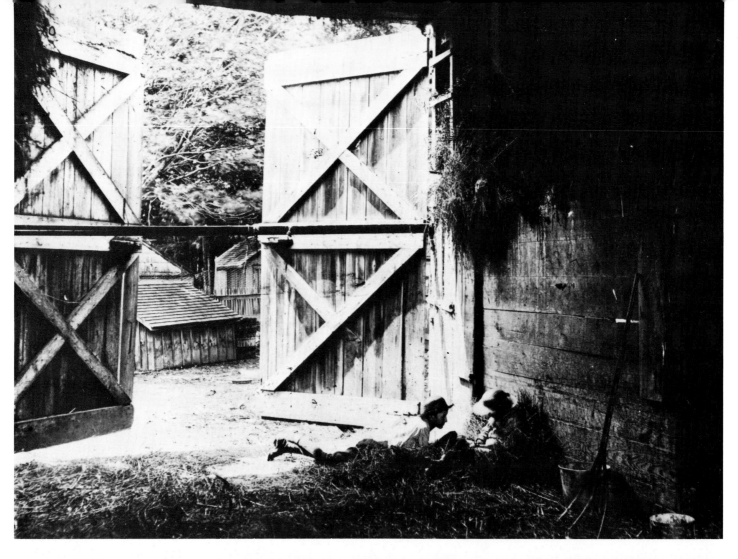

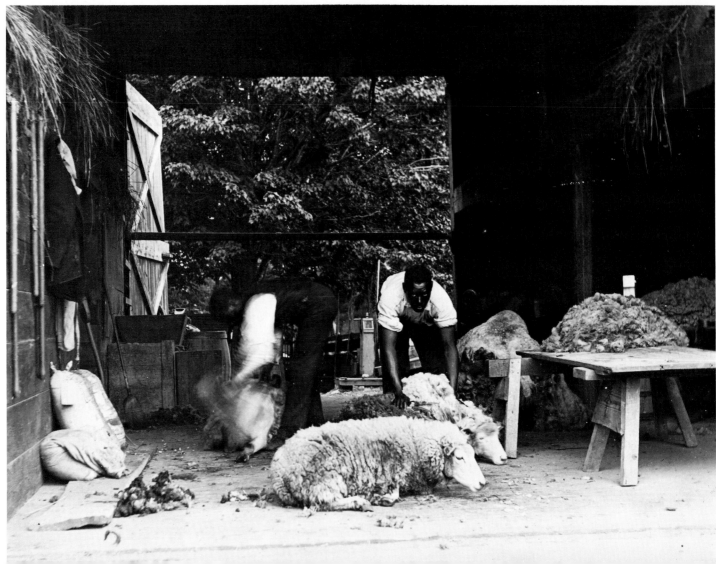

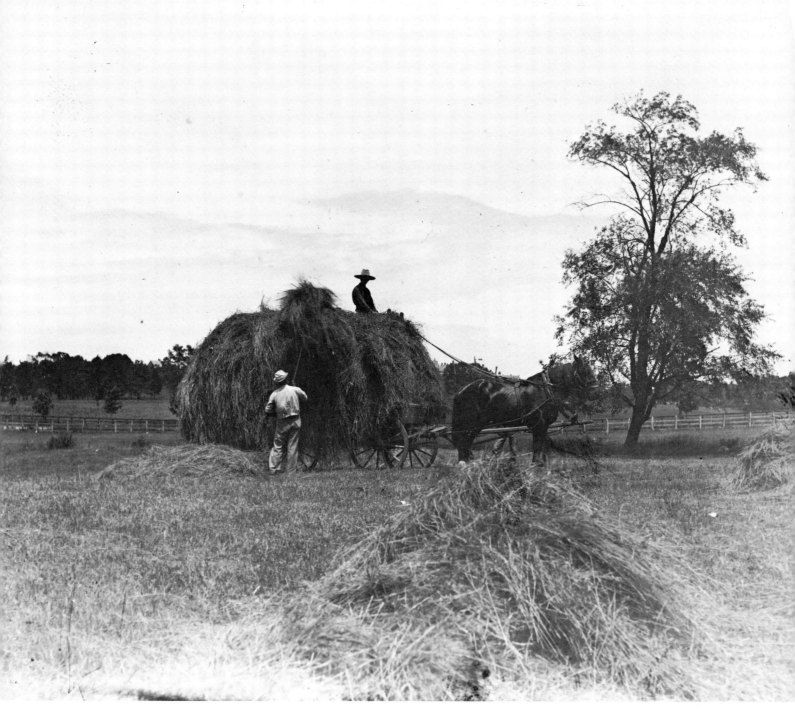

Opposite, top: **100. In the Barn, "Old Place," Westbury, ca. 1885.** Looking down from the hayloft inside the cool, dark barn, photographer Rachel Hicks achieved a painterly quality in this view of her two brothers, Albertson and Ralph. The boys are resting from their chores on the farm known as "Old Place," where their family had lived since the seventeenth century. The last member of this Quaker family to reside here until the farm was sold in 1900, Rachel Hicks was not only a photographer, but a painter, suffragette, local historian and community leader. (*Photograph by Rachel Hicks; Seaman Collection, Nassau County Museum, #2108.109.*)

Opposite, bottom: **101. Sheepshearing, Westbury, ca. 1885.** Sheep had always been an important part of the Long Island agricultural economy. In colonial times, water-surrounded necks of land such as Far Rockaway and Great Neck were fenced for commonly held grazing ground. The "fence-viewer" was a respected town officer in the seventeenth century, when sheep-parting (the separation of herds after a summer in common pasturage) became the basis for an annual autumn festival. During the eighteenth century, woolen mills at Cold Spring Harbor processed the wool of local sheep, spinning, fulling and weaving prize-winning cloth; a factory at Millburn (Baldwin) was established in the following century. When cheaper English imports flooded the market, Long Island woolen mills were closed and sheep herds were diminished by the time of the Civil War. Here at the Hicks homestead, however, the annual farm chores proceeded in the traditional self-contained economy. Late spring was the time for sheepshearing when, as Robert Frost said, "One had to be versed in country things." (*Photograph by Rachel Hicks; Seaman Collection, Nassau County Museum, #2108.148.*)

Above: **102. Haycutting, Westbury, ca. 1885.** Long Island farmers continued into the twentieth century to use the simple techniques developed by their predecessors. On farms averaging 150 acres, they rotated the crops divided in fields of ten to 20 acres. Wheat was followed by timothy hay and red clover; after hay was cut for three years, the field was returned to pasture. Corn was next in sequence, then oats, followed by a return to wheat. By the time of this photograph, wheat growing in Nassau County had declined with the development of Midwest granaries. Local farmers turned to market gardening, dairy production and sheep raising. Between 1875 and 1930 farm acreage dropped from 90,738 to 23,477 as speculators subdivided the land and the wealthy acquired large tracts for estates. (*Photograph by Rachel Hicks; Seaman Collection, Nassau County Museum, #2108.58.*)

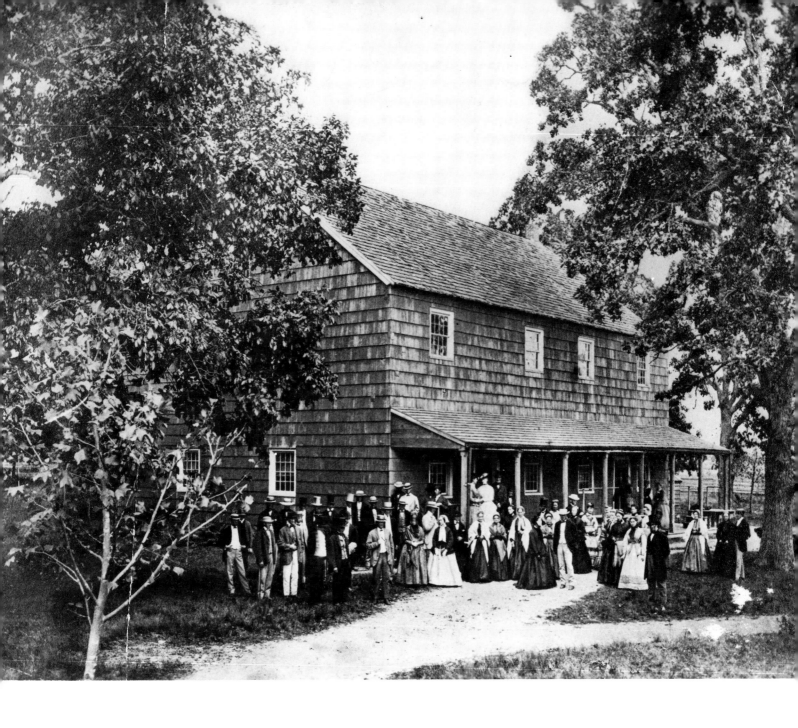

Above: **103. Friends Meetinghouse, Westbury, 1869.** Established in Nassau County since colonial times, the Society of Friends held meetings in Jericho, Hicksville, Roslyn, Locust Valley, Oyster Bay and Westbury. Opposed to luxury, the Quakers advocated "plainness of speech, behavior and apparel," and maintained two central principles: religious tolerance and pacificism. Survivors of ruthless persecution themselves, they were leaders in the antislavery movement. Though the Westbury Friends had been meeting since 1671, their first meetinghouse was constructed on this site, at the intersection of Post Avenue and Jericho Turnpike, in 1701; the building in the photograph replaced it in 1800. In the present 1901 building, third on the site, Westbury Quakers are still honoring William Penn's teaching: "The Best Recreation is to do Good." (*Nassau County Museum, #2823.*)

Opposite, top: **104. Priscilla Pearsall and Friend, Westbury, ca. 1885.** The fields between Westbury and Roslyn, which these rural Long Islanders are crossing, provided rich pasturage for dairy cattle. Milk, together with wheat, oats and hay, was a principal agricultural product in nineteenth-century Westbury. The area, settled by Quakers around 1675, was named after Westbury, Wiltshire, England, the birthplace of its founders, Henry Willis and Edward Titus. These pioneers found no springs here, but located their farms upon kettlehole ponds, cut by the glacier, which held water during the winter and part of the summer. Few photographs survive, in Nassau County collections, of members of the black community, whose history on Long Island goes back to colonial times. (*See also* Nos. 2 and 113). (*Photograph by Rachel Hicks; Seaman Collection, Nassau County Museum, #2108.130.*)

Opposite, bottom: **105. Soap Works, Hicksville, ca. 1880.** The photographs of George Brainard preserved many of Long Island's now vanished industries and public works. Here, on one glass plate, he captured both L. E. Koch's Soap and Candle Factory (left) and an early county records building (right), located on East John Street. The county building dates from the period prior to the January 1, 1899 division of Queens County into Nassau and Queens. In the absence of water resources, German immigrants knew how to substitute wind power. The Old World craft of gold and silver beating was another industry the Germans introduced to Hicksville. A more famous German specialty became established here in 1898, when the H. J. Heinz Company opened a large factory to process pickles, ketchup, vinegar and sauerkraut. (*Photograph by George Brainard; Nassau County Museum, #773.57—Brainard Plate #570.*)

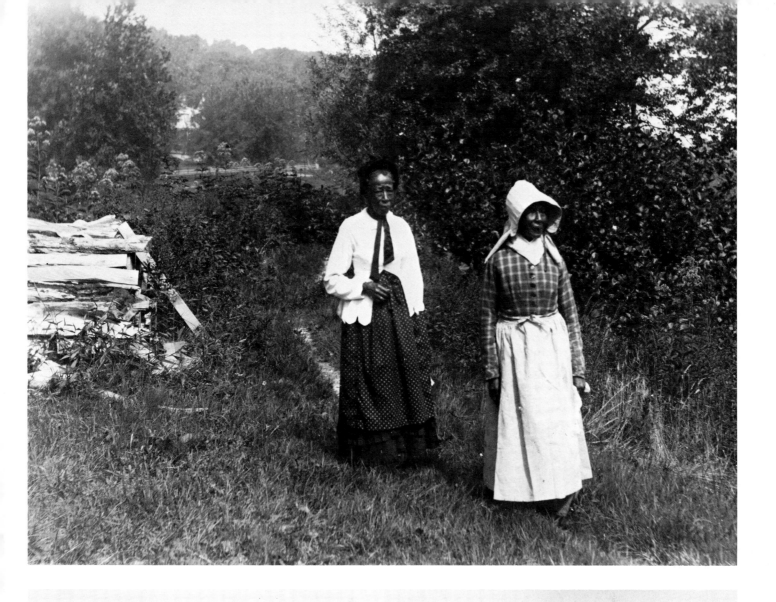

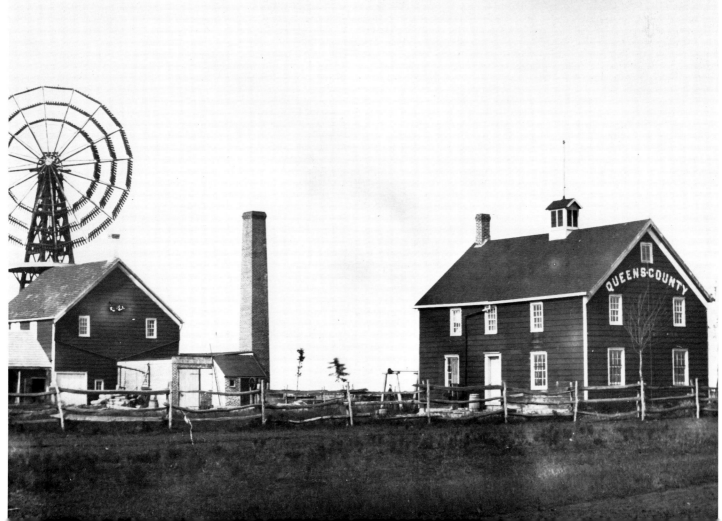

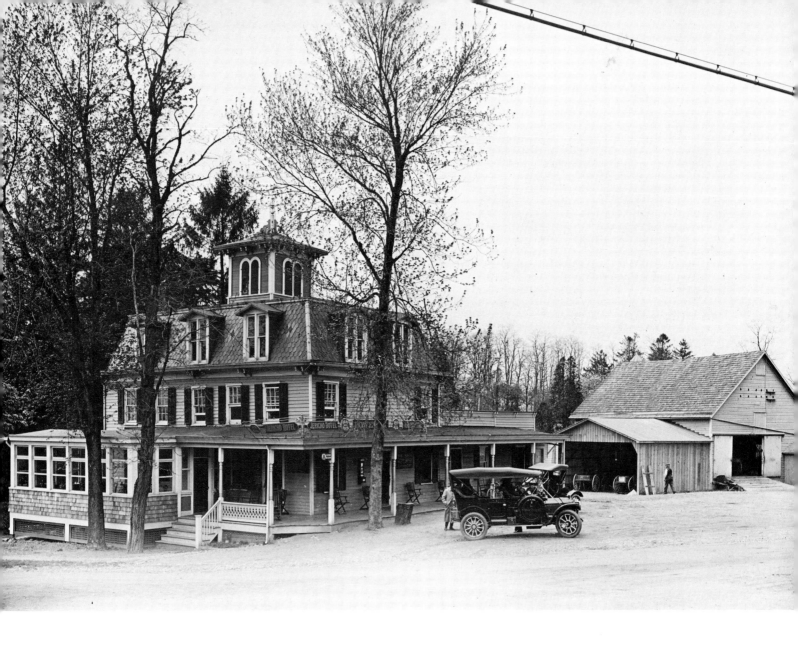

Above: **106. Jericho Hotel, 1912.** Founded by Bible-reading Quakers in 1653, Jericho, first known as The Farms or Springfield, remained a peaceful agricultural community until the twentieth century. Its chief citizen in the Revolutionary period was Elias Hicks, whose devotion to temperance led him to forestall groghouses by opening his own home to travelers free of charge. He used their voluntary contributions to build Quaker meetinghouses. In 1851, the Jericho-Jamaica Turnpike Company brought increasing numbers of travelers through the countryside; this route was improved as a private plank road in the 1880s. After a brief prosperity encouraged by the Vanderbilt Cup Races, the community returned to its quiet life as a country resort until 1938, when Robert Moses built the Northern State Parkway through local farms. In 1960, traffic engineers designed a cloverleaf which reshaped the town, obliterating old landmarks and making way for office buildings and light industry. The old walls of Jericho came tumbling down as the new glass structures rose. (*Photograph by Henry Otto Korten; Nassau County Museum, #5365.74.*)

Opposite, top: **107. Spectators and Autos at Jericho Hotel, First Vanderbilt Cup Race, 1904.** Here is the same corner eight years earlier, on the day of the first Vanderbilt Cup Race, October 8, 1904. The event was started by William K. Vanderbilt, Jr. whose father had introduced the automobile to Long Island society. Young Vanderbilt, who had raced fine cars in Europe, was determined to bring racing to the United States to improve domestic production of automobiles. He set out a 30-mile course of public roads, including this intersection of Jericho Turnpike and Route

106. Racers from many countries competed for the $2,000 ten-and-a-half- gallon silver loving cup designed by Louis Comfort Tiffany. (*Photograph by Hal Fullerton; Suffolk County Historical Society, Fullerton Collection, #1739A.*)

Opposite, bottom: **108. Vanderbilt Cup Race, Westbury, October 8, 1904.** Every fall from 1904 to 1910 as many as 250,000 spectators jammed the sides of the road to catch a glimpse of the cars speeding past them. Some people camped along the roadside; others stood dangerously close to the course, only moving out of the way at the shout of "car coming!" Several deaths associated with the races made it clear that Long Island's unimproved roads were inadequate for high-speed travel. In 1906, Vanderbilt proposed to solve this problem by the construction of the Long Island Motor Parkway, a 45-mile toll road to be used exclusively as a raceway. The first nine-mile section was completed from Westbury to Bethpage in 1908, the year George Robertson was the first American to win on the 258.06-mile course. Much of the excitement of this highway declined after 1910 when the State Legislature enacted a law prohibiting auto racing on public highways. Though motorists still paid tolls on the parkway, it was a financial loss; in 1938 Vanderbilt gave rights of way to the Long Island Park Commission. Today residential and commercial development leave only fragments of the original route that stretched from Springfield Boulevard to Lake Ronkonkoma. (*Photograph by Hal Fullerton; Suffolk County Historical Society, The Fullerton Collection, #5371B.*)

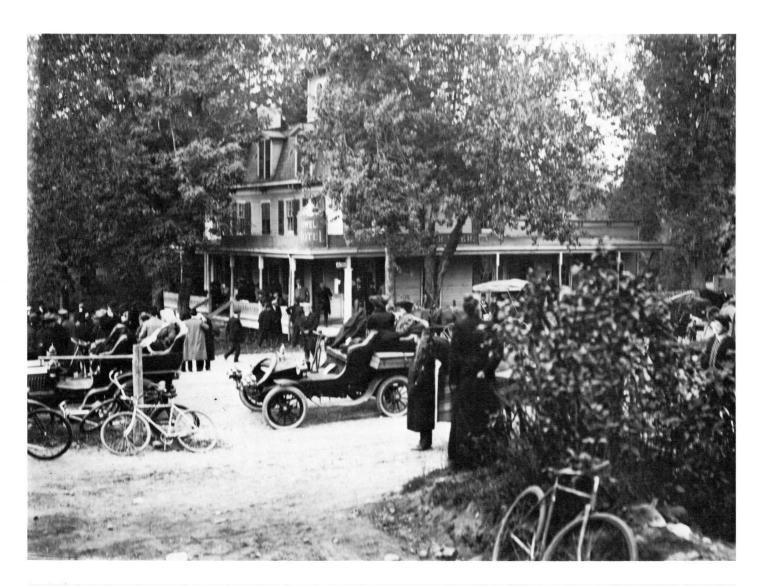

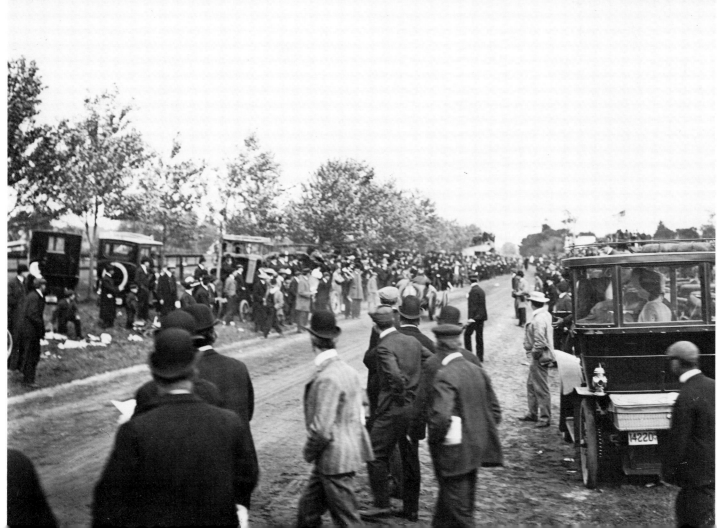

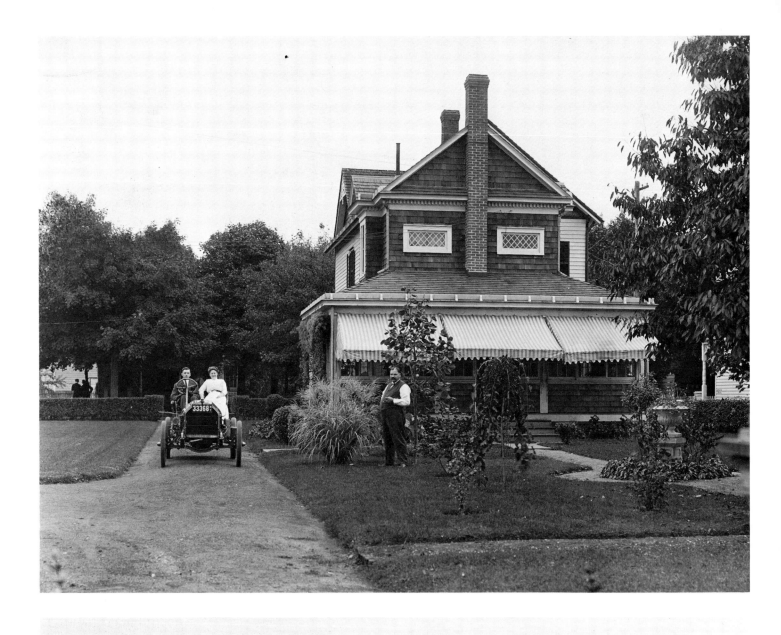

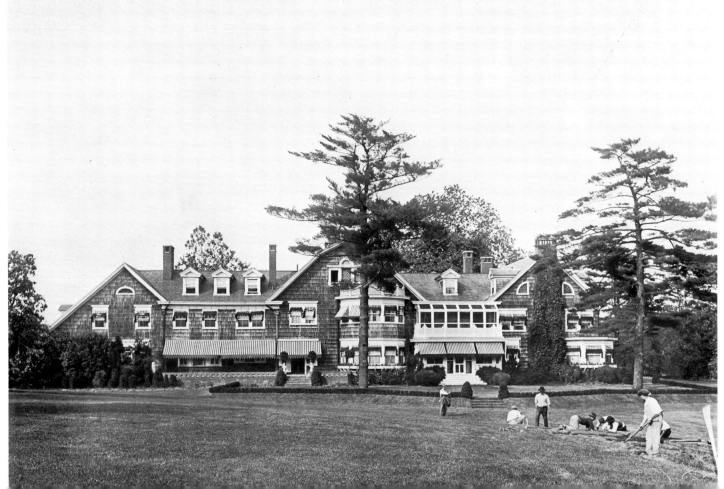

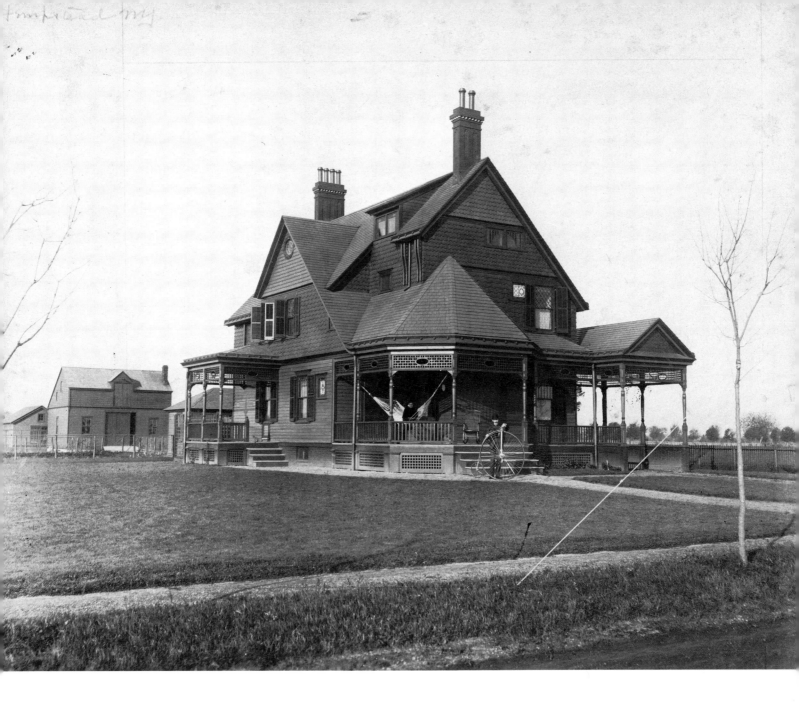

Opposite, top: **109. Residence of W. M. Simonson, Hicksville, ca. 1915.** The photographer caught the essence of an ordinary man's prosperity: a comfortable frame house with gaily striped awnings, a neatly planted and carefully tended lawn, a newfangled automobile in the driveway. Korten must have been confident that other viewers would also find in this Jerusalem Avenue scene a fulfillment of the American dream, for he ordered 1,000 brown-on-buff postcards to be made from his print and sold at the Broadway shop of Frank Marrs. (*Photograph by Henry Otto Korten; Nassau County Museum, #5365.110.*)

Opposite, bottom: **110. Willard D. Straight Estate, Old Westbury, ca. 1910.** "Elmhurst," located near Wheatley Road in Old Westbury, was the home of Willard Straight, diplomat and financier. In his early childhood, at a time when interest in the Orient was just developing, Straight was brought to Japan by his widowed mother, a teacher. This early experience probably influenced him in his choice of career, for though he earned a degree in architecture, he devoted most of his short life to Oriental affairs, as Korean correspondent for Reuters, Consul-General in China, representative of an international banking group, and founder of the magazine *Asia*. Straight's interests expanded to include real-estate development of Long Beach after his marraige to Dorothy Whitney, daughter of W. C. Whitney, whose wedding present to the couple was this spacious shingled house; its proportions were suited to the expectations everyone had for the brilliant Far Eastern expert who worked overseas in the administration of the War Risk Insurance Bureau. But Straight's impact on Long Island affairs did not survive World War I; he died at the age of 38, a victim of the great influenza epidemic of 1918. (*Photograph by Henry Otto Korten; Nassau County Museum, #5365.683.*)

Above: **111. C. F. Norton Residence, 57 Hilton Avenue, Hempstead, ca. 1890.** "Getting and spending, we lay waste our powers..." In the last century we might have recuperated in the hammock on this spacious porch, or on the precarious "ordinary" bicycle, parked close to the steps for easier mounting. The small trees show that this is a newly developed residential area. Perhaps the owner was a member of the Norton family, prominent realtors in the southern part of the town of Hempstead. It is an appropriate home for a member of the nouveau riche, more pretentious than the ordinary household, but not yet a luxurious estate. (*Nassau County Museum, #1594.*)

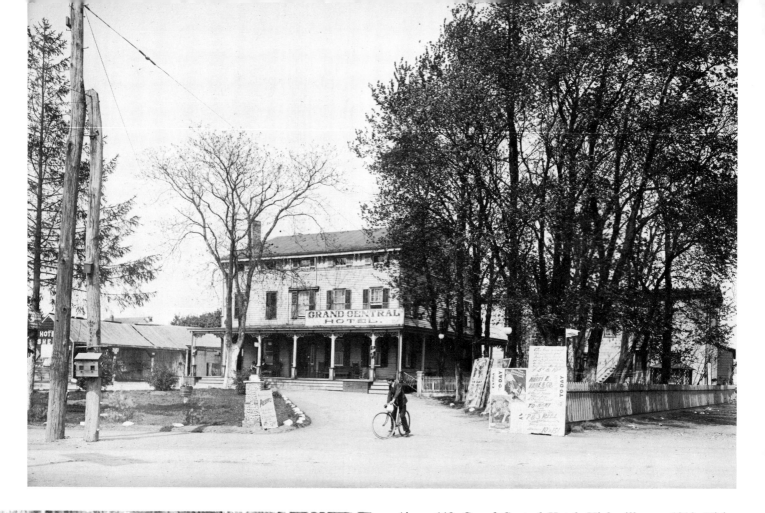

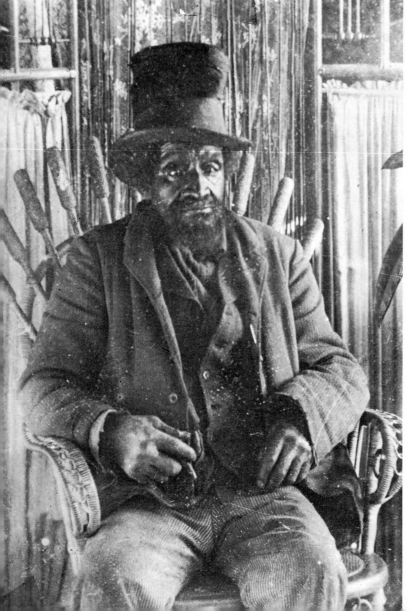

Above: **112. Grand Central Hotel, Hicksville, ca. 1910.** Hicksville was entered on the map in 1836, when a group of Quakers, including Elias Hicks, bought part of the plains of Jericho. Some historians say the town was named after the Quaker leader; others claim the honor for the second president of the Long Island Railroad, Valentine Hicks, under whose supervision the main line was extended through Hicksville to Greenport. This hotel, located on Broadway, was erected in the late 1830s. It also served travelers on stagecoach lines to Brooklyn and Huntington and, after 1908, on a trolley line. (*Photograph by Henry Otto Korten; Nassau County Museum, #5365.331.*)

Left: **113. Peter Blydenburgh, Hostler at the Grand Central Hotel, Hicksville, 1889.** Hostlers curried and fed the horses of individual travelers and those of the stagecoach companies. Peter Blydenburgh (1829–1903) was a beloved fixture in town; at his death, residents of Hicksville erected a headstone in his memory at Plainview Cemetery. (*Nassau County Museum, #1607.*)

Opposite, top: **114. Broadway, Hicksville, 1910.** Frederick Heyne and John Heitz bought over 1,000 acres from Valentine Hicks in 1849, converting the plains of Jericho into farmland in spite of the difficulty of collecting a sufficient water supply so far inland. In 1856 they laid out streets and advertised lots for sale among the newly arrived Germans in New York, but the town was slow to develop. In June 1870, 5000 German-speaking immigrants were brought to Hicksville in open railroad flatcars in an attempt to interest them in settling there. Some of these Germans soon became Hicksville's major businessmen. (*Photograph by Henry Otto Korten; Nassau County Museum, #5365.327.*)

Opposite, bottom: **115. Broadway, Hicksville, ca. 1910.** In 1838 Daniel Treadwell wrote of Hicksville: "It has been liberally laid out, but sparsely peopled. The principal population seems to be dogs. There is no future in sight for Hicksville." Despite this dismal prophecy, the town had developed a substantial main street by 1910, symbolized by this ambitious brick building housing the New York Clothing Store. Even after the disastrous fire of 1937 destroyed much of the business area, commercial activity on Broadway flourished. Hicksville's Broadway has been widened beyond recognition. (*Photograph by Henry Otto Korten; Nassau County Museum, #5365.339.*)

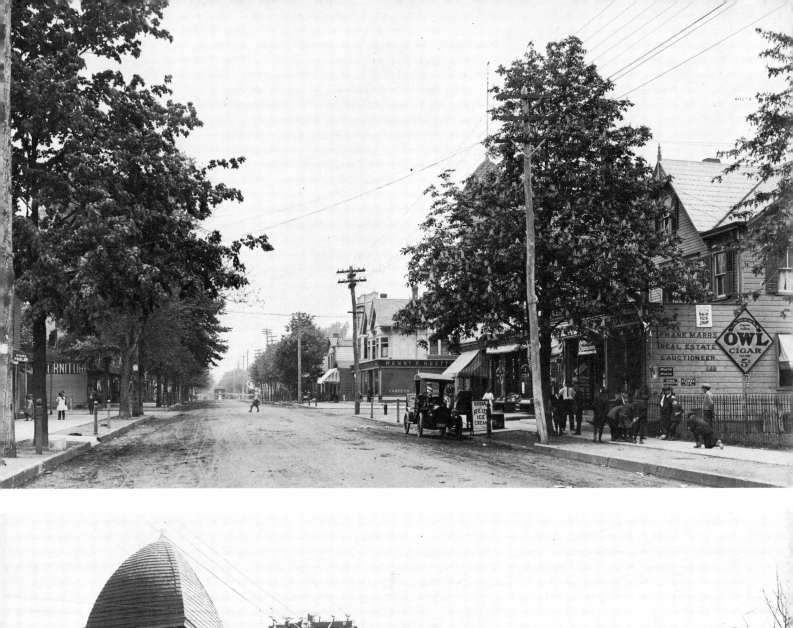

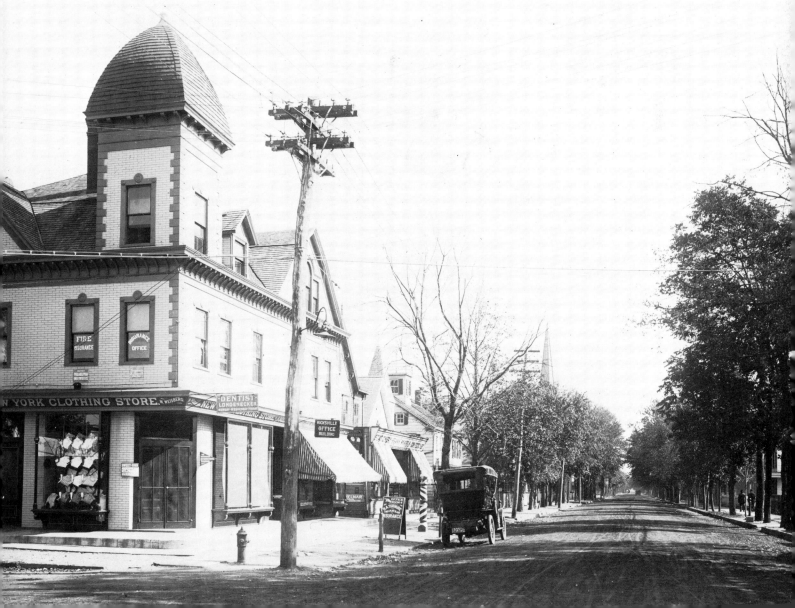

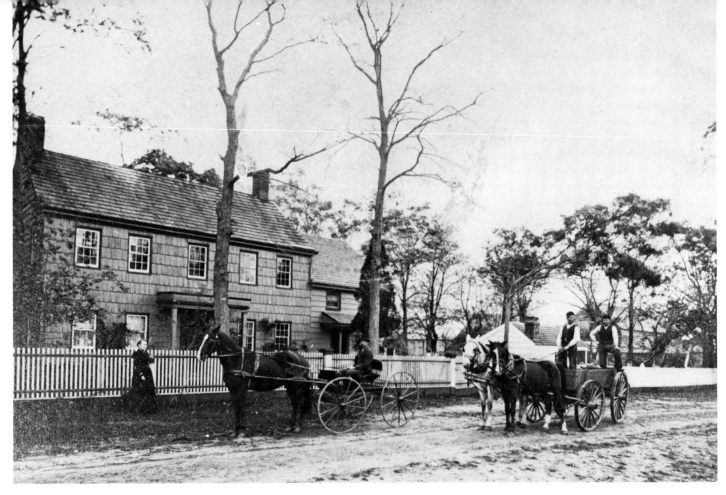

Above: **116. The Hubbs Homestead, Bethpage, ca. 1900.** This prosperous homestead (still standing) of a long-established Bethpage family was built before 1810 at what became the intersection of Farmers and Stewart Avenues. Stewart Avenue was named after Alexander T. Stewart, who built a special railroad connection at Bethpage between his brickyard, one of the largest in Nassau County, and construction sites in Garden City. In the photograph are the homeowner, George Hubbs, and a neighbor, Elizabeth Van Size. Her relative, Ruth Van Size, boarded at the Hubbs' house in the 1890s while she was a teacher in the local school district, then called Bedelltown. Paying school teachers in food, clothing and shelter was typical of rural districts in the nineteenth century. When Ruth Van Size married Joseph Jarvis, she lost these dubious benefits under the prevailing rule: "Women teachers who marry or engage in other unseemly conduct will be dismissed." (*Nassau County Museum, #1180.*)

Opposite, top: **117. Main Street, Farmingdale, ca. 1910.** The earliest settlement here was a farming community known as Hardscrabble, a name which derived from the difficulty of cultivating topsoil in a dry area underlaid by gravel. By 1841, the Long Island and Central Railroads passed through Farmingdale, changing this comparative wilderness into a thriving settlement. The trains also brought horse manure from New York City to enrich the farmlands; farther east, as far as Riverhead, the uncultivated lands stretched into a barren waste once thought uninhabitable. By the turn of the century Farmingdale had developed beyond agriculture to include a brickyard, pickle works, a picture-frame company and a school of technology. In 1910, its main street ran north past the Quaker meetinghouse to Bethpage, and south through Brush Plains (now Massapequa Park) to the gristmills on the inlets of the Great South Bay. (*Photograph by Henry Otto Korten; Nassau County Museum, #5365.223.*)

Opposite, bottom: **118. Brown's Hotel, Farmingdale, ca. 1910.** When he focused on this advertisement for Brown's Hotel, Henry Otto Korten hoped to persuade the proprietor to pay for its publication as a postcard. Today, it helps us document the popularity of large-scale duck raising, begun in about 1890 on Long Island and still a profitable business. Since female ducks can lay as many as 150 eggs per season, poultry farmers soon encroached on the market once supplied by baymen, who skillfully carved

decoys and brought thousands of wild fowl to New York. Another local product is in evidence on the corner, in the Bank of Farmingdale; it is likely that its bricks were brought from the nearby brickworks, established in 1872 by Alexander T. Stewart and still in operation today as the Nassau Brick Company. (*Photograph by Henry Otto Korten; Nassau County Museum, #5365.207.*)

Over: **119. Kuloff Hotel, Rockaway, 1902.** Purchased from the Indians by British colonists in the seventeenth century, "Re-kan-a-wa-ha-ha" (place of the laughing waters) referred to lands south and west of Hempstead. Until 1809 most of this area was owned by members of Cornwall (Cornell) family, who entertained at an estate where they kept horses, hounds, a deer park and a racecourse. The westerly neck of beach and grassy marshland was reserved for salt-hay gathering and common pasturage by the town of Hempstead, to which it belonged until the creation of Nassau County. In 1830 John L. Norton bought considerable property from Cornell heirs, and with Philip Hone and Governor John A. King formed the Rockaway Association to develop the peninsula into a summer resort. In 1834 they built the $43,000 Marine Pavilion Hotel, with 160 rooms and a 235-foot piazza supported by Ionic columns. Once the most famous resort on the Atlantic coast, it was reached by carriage and stagecoach by such distinguished patrons as Longfellow and Washington Irving. In 1835, Hone made this entry in his famous diary:

> We had last night at the Pavilion a farewell hop in the dining room, at which the girls enjoyed themselves very much. At eleven o'clock I retired to my room, lighted a cigar, and seated myself at the front windows. The view was unspeakably grand. The broad red moon, setting over the tops of the mountains of Neversink, threw a solemn light over the unruffled face of the ocean, and the lofty columns of the noble piazza, breaking the silver streams of light into dark and gloomy shadows, gave the edifice the appearance of some relic of classical antiquity.

Before the hotel was destroyed by fire, the South Side Railroad had extended its branch to Rockaway, making the resort area accessible to a larger public. By the time of this photograph, the Kuloff was one of the many hotels and summer colonies built along the waterfront. (*Photograph by Hal Fullerton; Suffolk County Historical Society, Fullerton Collection, #L227.*)

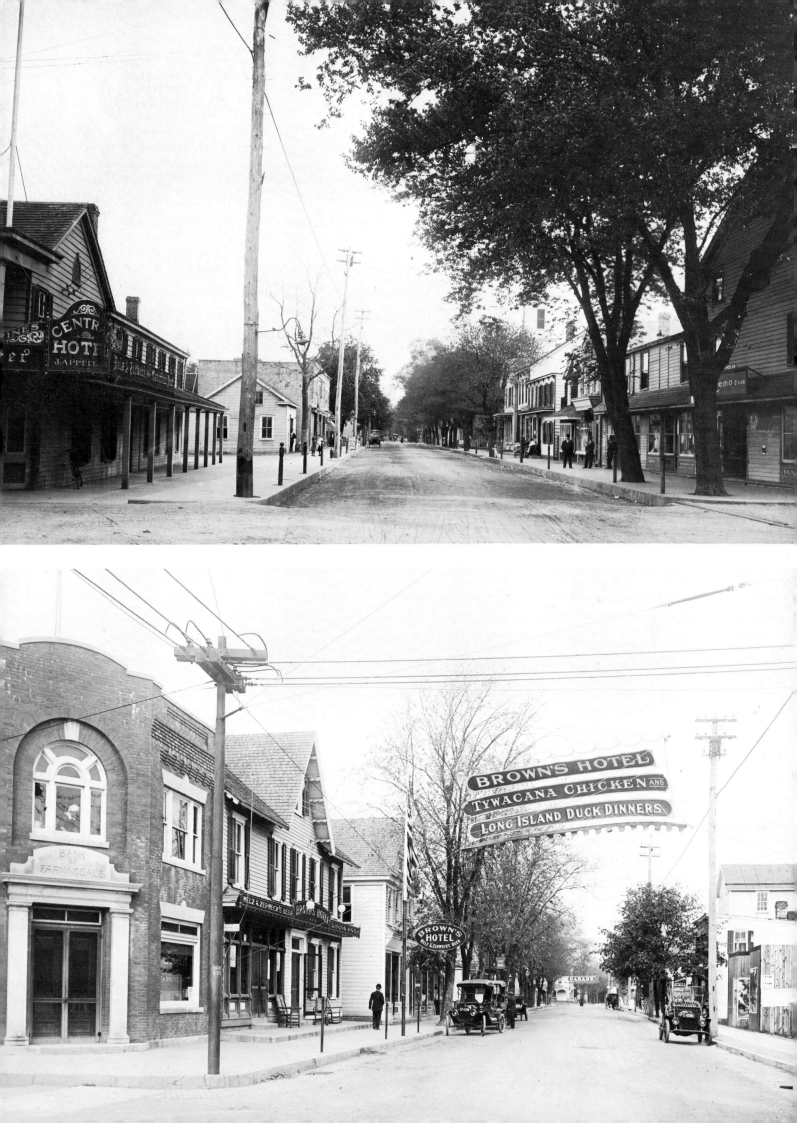

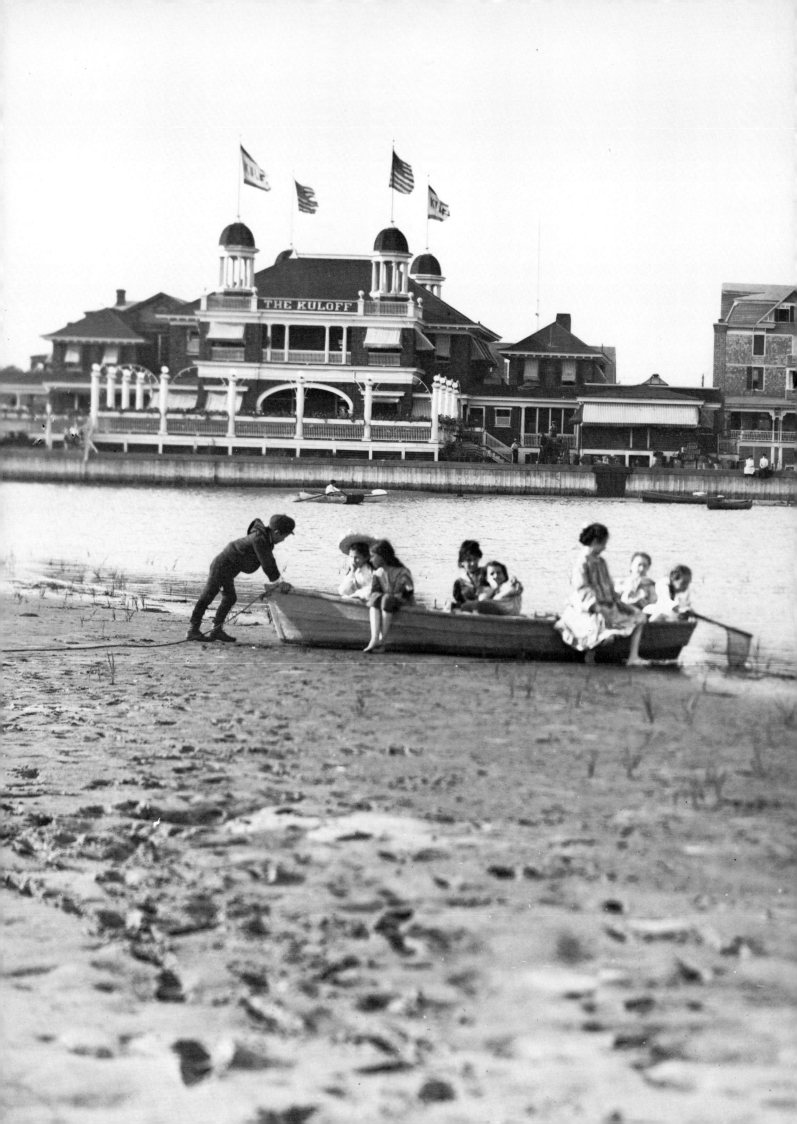

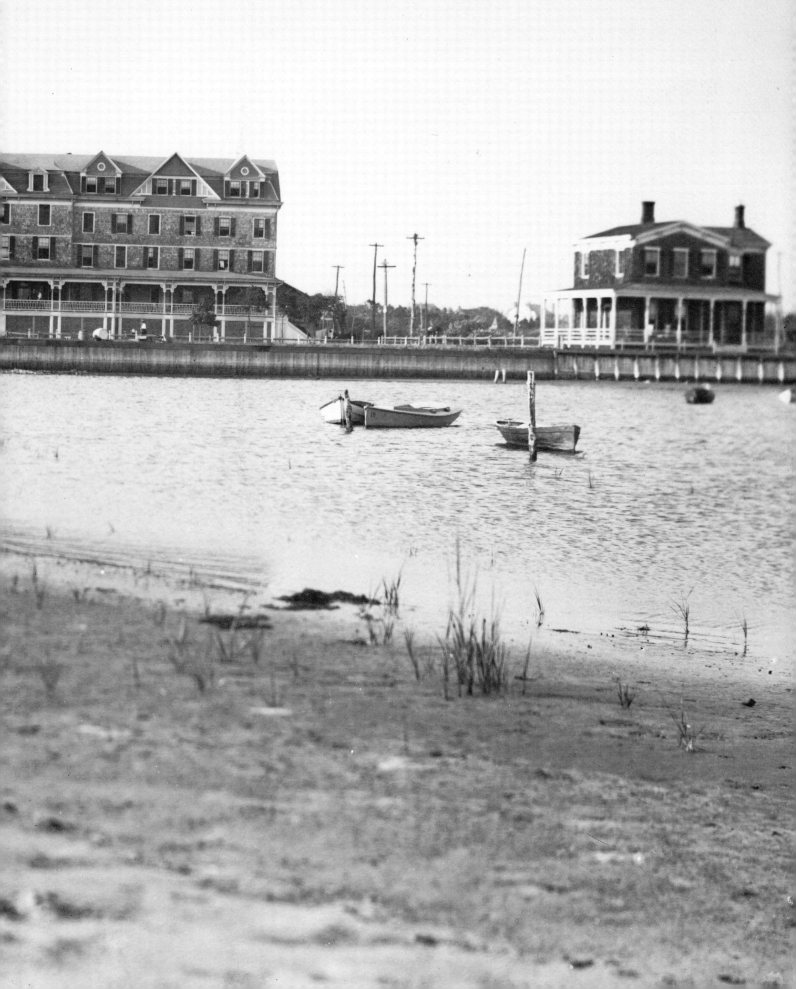

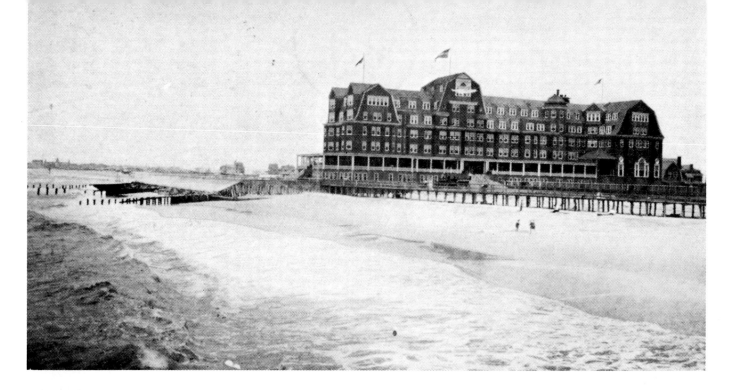

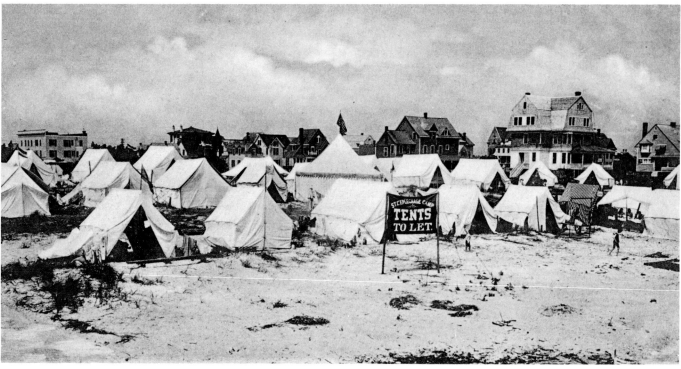

Top: **120. Edgemere Club, Far Rockaway, ca. 1910.** In 1892, Frederick J. Lancaster bought a section of land west of Wavecrest and Arverne, which he called "New Venice" because of its many creeks and inlets. Lancaster filled marshlands and built roads in preparation for the 1894 opening of the lavish Edgemere Club. As the Long Island Railroad handbook promised: "Here may the careworn broker, free from the fevered whirl of Wall Street, inhale the purest of oxygen, and banish from his thoughts for the time being the fluctuations of stocks." (*The Lightfoot Collection.*)
Bottom: **121. Tent Colony, Rockaway Beach, ca. 1910.** After the turn of the century and its incorporation into Greater New York,

Rockaway became the nearest and most accessible beachfront resort for city dwellers. Those who could not afford hotels or summer cottages could still enjoy Rockaway Beach in a tent colony at Steeplechase Camp. Tides and winds, as well as economic forces, were reshaping the Rockaway peninsula; beaches and inlets were continually shifting, and seven miles of sand had been added to the western tip since the seventeenth century. (*The Lightfoot Collection.*)
Top: **122. Nigey's Fifth Avenue Hotel, Rockaway Park, ca. 1910.** Farther west on the peninsula, Rockaway Park included stores, a school, firehouse, and picture theater, boardinghouses and hotels.

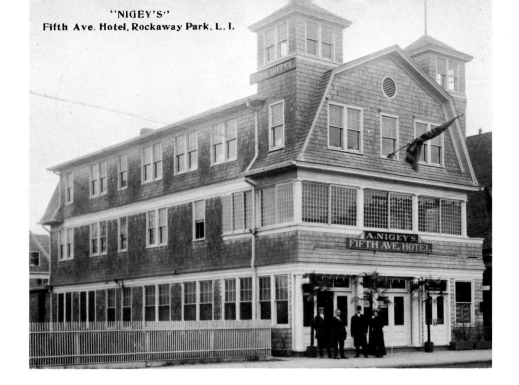

"NIGEY'S"
Fifth Ave. Hotel, Rockaway Park, L. I.

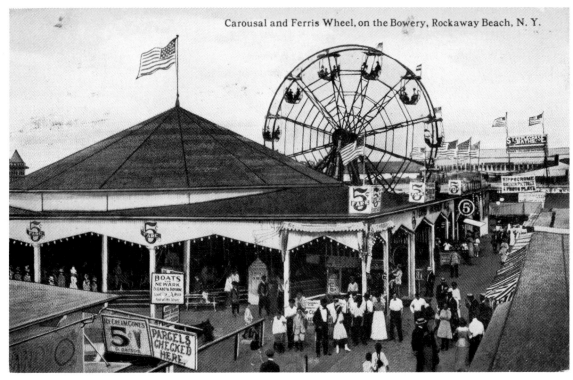

Carousal and Ferris Wheel, on the Bowery, Rockaway Beach, N. Y.

Nigey's was a typical family-run small hotel, its square towers and many windows taking advantage of the sea breezes. One visitor wrote on the back of the postcard from which this view is reproduced, "Went clamming and baiting, driving and automobiling every day." A seaside experience for the less fortunate was made possible by St. Malachy's Home for Boys and by the Hebrew Home, also located on the oceanfront at Rockaway Park. (*The Lightfoot Collection.*)

Bottom: **123. Amusement Park on the Bowery, Rockaway Beach, ca. 1916.** Adjacent to Rockaway Park, the area called Seaside included the summer amusement section. In 1917 Alfred Bellot,

a local historian, described the "innumerable attractions on the Bowery and Steeplechase section of the boardwalk, where roller coasters, picture theatres and the dark caves offer ample means of passing the time pleasantly at the ocean front." In those days, five cents bought an ice-cream cone or a ride on the carousel. Tiring of the honky-tonk amusements, one could catch a boat at the foot of the street for Newark, Elizabeth or Bayonne. (*The Lightfoot Collection.*)

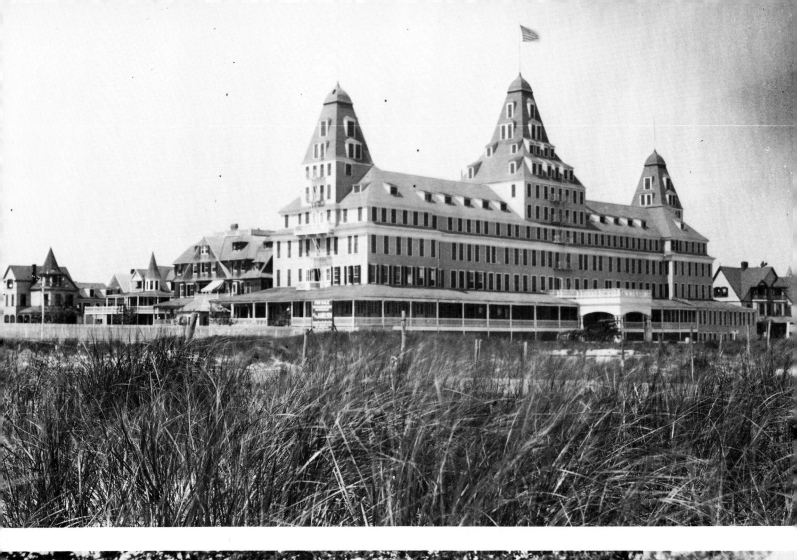

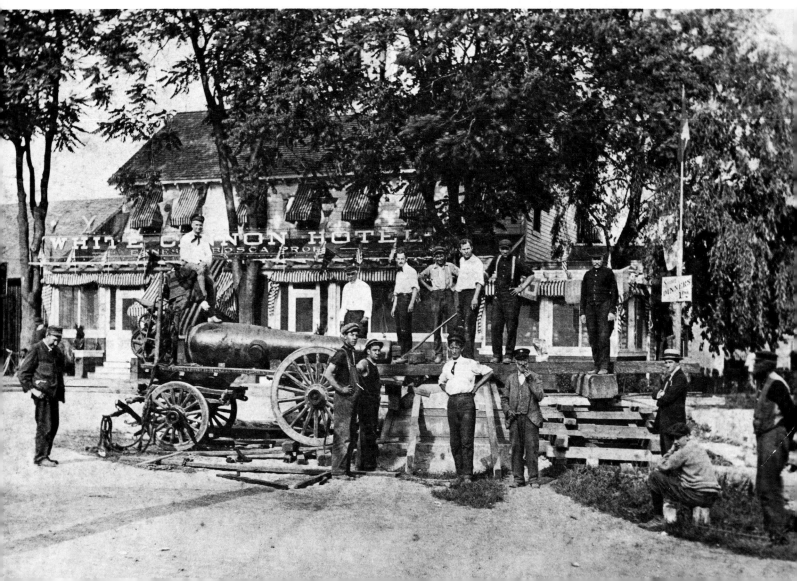

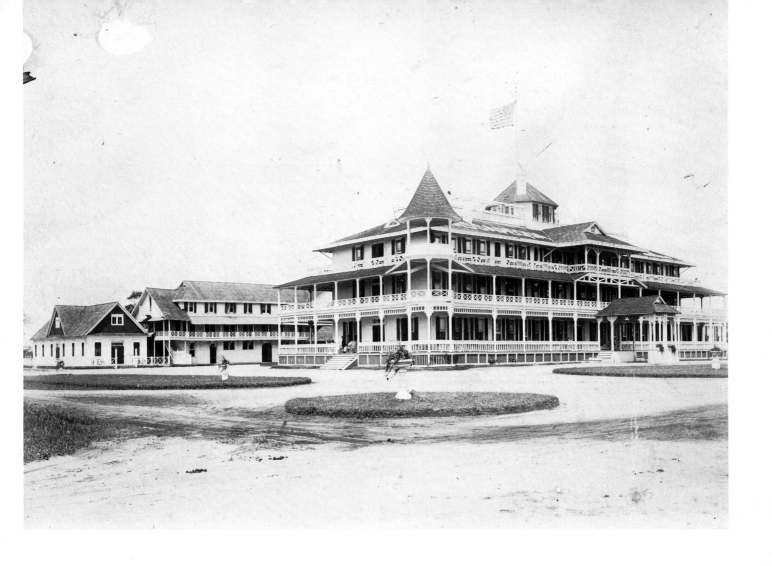

Opposite, top: **124. Hotel at Arverne, 1902.** In 1882 New York attorney Remington Vernam built two houses on the beach at the northeast corner of the Rockaway Peninsula. Where there had been sandy wastes, a few cedar trees and two or three shacks, Vernam planned a fashionable resort similar to those already underway on the Rockaway peninsula. The real-estate development was named Arverne, after R. Vernam, its chief promoter, who put through the main thoroughfare, Remington Avenue, in 1888. In 1900 the Arverne boardwalk, an elevated timber structure ¾-mile long, drew summer visitors to promenade and bathe in water said to be free from treacherous currents. Some of the earliest and best-known summer carnivals were held at Arverne-by-the-Sea, which had a theater seating 800. Cycling on the beach, Hal Fullerton took this picture showing a large hotel with an ominous "for sale" sign at the edge of the dune grass. Winter weather was a regular hazard at the beach; on January 5, 1914 a violent storm tore up streets, washed away houses and wrecked the boardwalk. Though it never achieved the success of Long Beach or Far Rockaway, Arverne maintained a modest popularity into the 1930s, when the Chamber of Commerce listed seven hotels whose German proprietors charged an average of $30.00 per week for room and board. (*Photograph by Hal Fullerton; Suffolk County Historical Society, Fullerton Collection, #L175A.*)

Opposite, bottom: **125. White Cannon Hotel, East Rockaway, 1904.** When these gentlemen posed next to this Spanish American War cannon, it was still possible to buy a Long Island shore dinner for $1.00. Perhaps they have gathered, some in uniform, in anticipation of a ceremony for war veterans. Behind them is the famous White Cannon Hotel (Ernesto Bosca, proprietor), a modest but fashionable turn-of-the-century resort, complete with stables and waterfront dining room. The local post office once was housed in a building on the hotel site, next to the boat basin. (*Nassau County Museum, #1131.*)

Above: **126. Hotel at Massapequa, ca. 1910.** The Gilded Age left its mark on Long Island in large rambling wooden hotels, located at places we no longer think of as resorts. An example is this structure at Massapequa, then a notable holiday spot for fishing and shooting small game and marsh birds. Originally known as Fort Neck or South Oyster Bay, the name of this locale on the southeastern border of Nassau County was changed in 1890 to honor the Marsapequa (translated as Near-the-Great-Bay) Indians, who sold the land in 1639. Still almost as well-watered a territory as it was in Sachem Tackapausha's time, Massapequa today is interlaced by canals, creeks, lakes and rivers. (*Photograph by Henry Otto Korten; Nassau County Museum, #5365.444.*)

127. Crowd Around Flagpole, Cedarhurst, September 12, 1924. This aerial view shows Cedarhurst in the course of its evolution, no longer the farmland Thomas and Samuel Marsh laid out in building lots in 1869, and not yet the completely developed suburb. Originally called Ocean Point, its name was changed to Cedarhurst when a post office was established at the nearby Rockaway Hunt Club in 1884. Central Avenue, the street running parallel to the railroad tracks in the upper part of the picture, was one of the first improvements made by developers. In 1924 there were houses along it and trees behind it, but none of the businesses that line the avenue today. The crowd around the flagpole may be engaged in a patriotic exercise, or perhaps they are about to witness an attempt at flagpole sitting, one of the more peculiar crazes of the twenties. The record in this enterprise was set by "Shipwreck" Kelly, who maintained his perch for 23 days, seven hours. (*Photograph by Air Service, U.S. Army; Nassau County Museum, #1031.*)

91

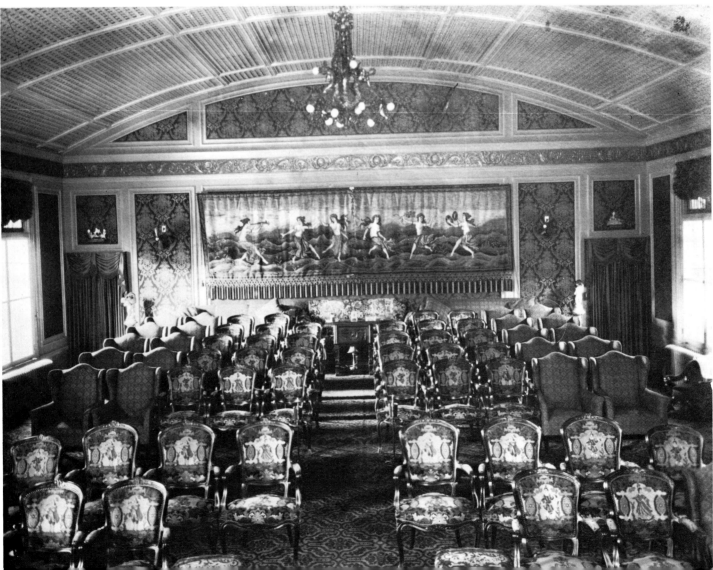

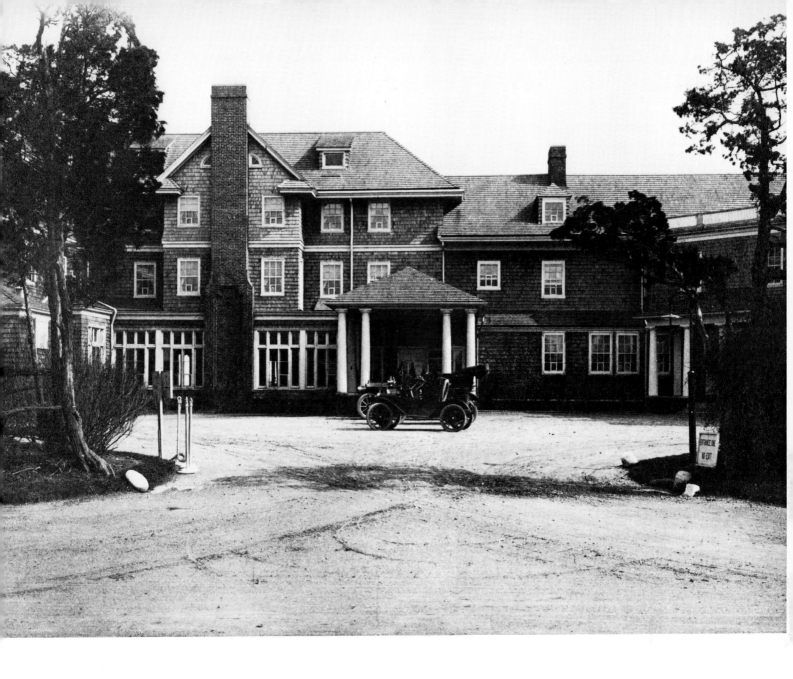

Opposite, top: **128. Fox Hall, Woodmere, 1930.** In 1917 a local historian observed: "Woodmere has a fine frontage to the bay . . . there is good fishing, bathing and anchorage for yachts and motor boats. The air is remarkably fine and invigorating." Such truthful promotion brought summer visitors and estate owners to the open farmland. Part of Woodmere developed into an exclusive neighborhood for the wealthy and socially prominent. William Fox (1879–1952), the movie magnate, lived here at Fox Hall in the 1920s. Born in Hungary, Fox first entered the motion-picture business in 1904, when he bought a nickelodeon in Brooklyn for $1600. He founded the Fox Film Company in 1915 and by 1929 his interests were valued at $300 million. In 1935, John Barrymore spent the weekend at Fox Hall. Shortly after this photograph was taken, however, Fox lost his fortune in the stock-market crash; plagued by lawsuits, he declared bankruptcy in 1936. (*Nassau County Museum, #3690.*)

Opposite, bottom: **129. Interior of Fox Movie Theater, Woodmere, ca. 1925.** The grounds of Fox Hall were known for beautiful rose gardens, and the interior for an elaborately equipped theater where films were presented nightly. Here, amid tapestried elegance, 125 guests could view the latest movies in the luxury of a private room with an orchestra pit and Wurlitzer pipe organ. (*Historical File, Hewlett-Woodmere Public Library.*)

Above: **130. Rockaway Hunt Club, ca. 1910.** In 1877, 12 wealthy young sportsmen met at Bernard Reilly's barn near the Jamaica Turnpike, Far Rockaway. So successful was their first pursuit of hares by hounds in a "paper chase" that the hunters leased Reilly's barn and formed the Rockaway Hunt Club in 1878. Live pigeon shooting, horse racing and especially polo were among the activities offered. One unusual feature of the club was a steeplechase course, arranged by the Rockaway Steeplechase Association, with fences, water-jumps and other obstacles; this activity drew large audiences between 1884 and 1889. In 1893 the original clubhouse was destroyed by fire and replaced by the building seen in this photograph. (*Collection of the Brooklyn Public Library.*)

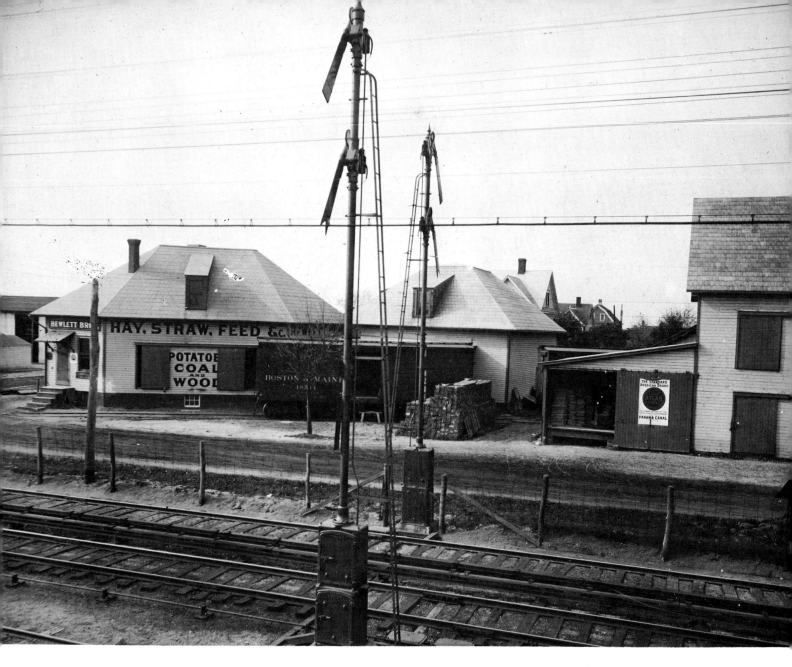

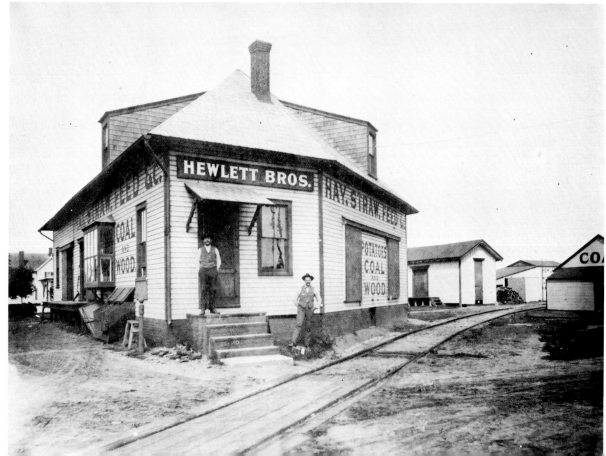

94

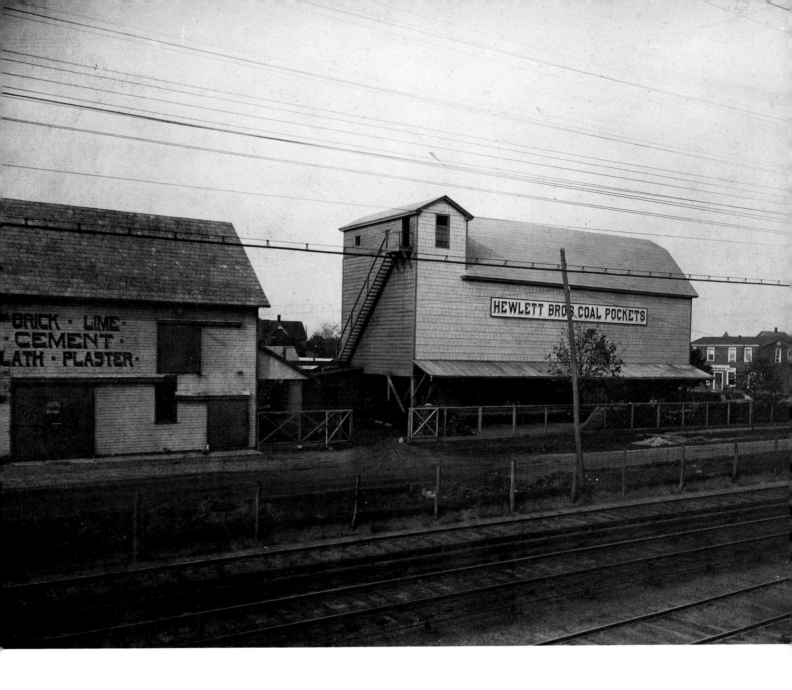

Above: **131. Hewlett Brothers, Woodmere, ca. 1915.** Founded in 1902 at Railroad Avenue and Irving Place, Woodmere, by Whitfield and Divine Hewlett, this company originally distributed hay, chicken feed and grain bought from the Pratt Food Company in Buffalo, New York. As its South Shore customers increased in number, the Hewlett brothers expanded their line of products to include anthracite coal from Wilkes-Barre, Pennsylvania. Various types of coal were stored in coal pockets, or individual compartments beneath which a vehicle could park in the large structure on stilts seen at the right in this composite photograph. The Hewletts also handled Long Island and Maine potatoes, lumber and building products and Atlas Cement, famous for its use in the construction of the Panama Canal. (*Long Island Research Associates.*)
Opposite: **132. Joseph and Herbert Hewlett, Woodmere, ca.**

1915. Joseph and Herbert Hewlett, owners of a thriving business at the time of these photographs, were members of a Long Island family whose ancestry in America dated back to 1649. Their progenitor was one of the judges who signed the death warrant for Charles I. The family name was sometimes spelled "Hulit" or "Owlett," showing the influence of its Yorkshire origin. The "Owlett" spelling also influenced the Hewlett coat-of-arms, composed of two owls on a shield, with a motto appropriate to this enterprising family: "By courage, not by craft." For more than 300 years Hewletts have been outstanding farmers and businessmen. The buildings of their Woodmere distributing company stood until the late 1960s, when they were demolished for a new shopping center. Near the site, Hewlett Oil Services still carries on the family name. (*Long Island Research Associates.*)

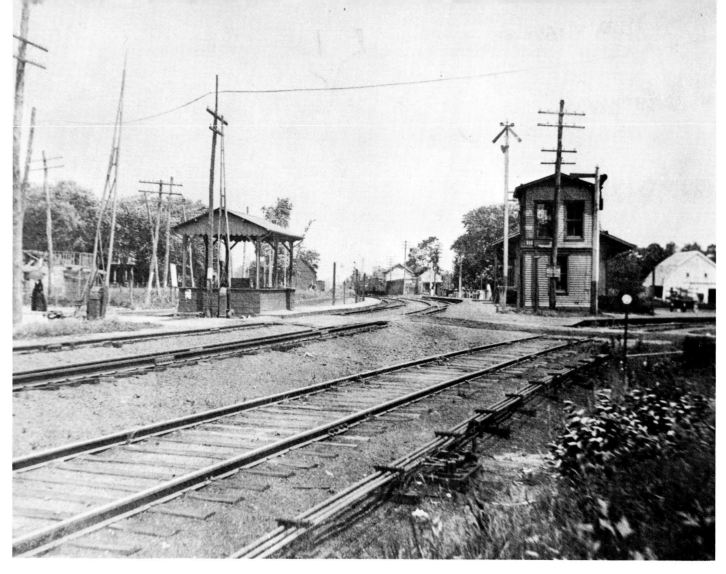

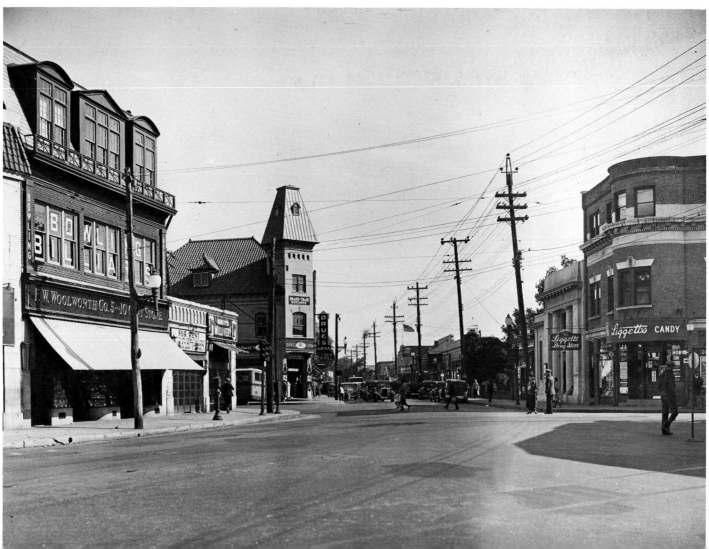

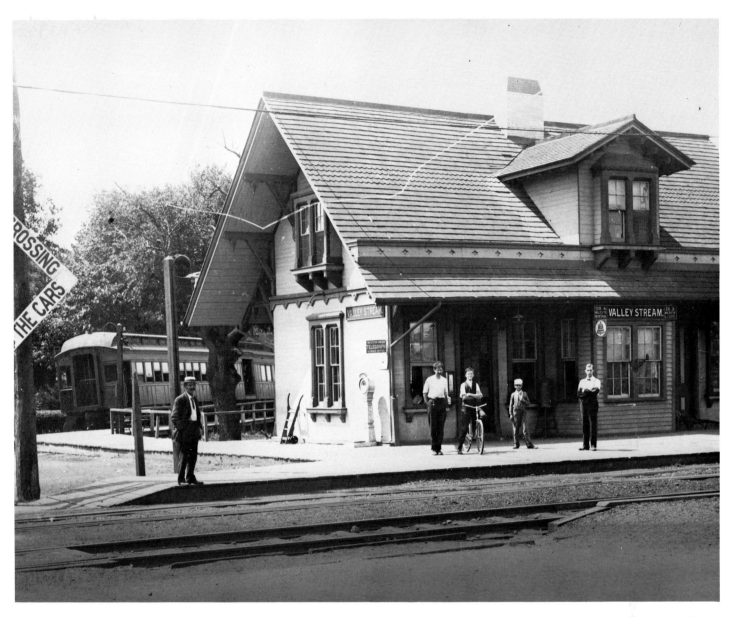

Opposite top: **133. Facing East at Atlantic Avenue, Lynbrook, 1906.** Called Bloomfield in 1785, this locality was composed of 40 houses adjacent to the Old Sand Hole Church and was served by a preacher who rode a 300-mile circuit on horseback over dirt roads. By 1850 the name of the town had been changed to Pearsall's Corners and stages could travel to Brooklyn over the Jamaica Plank Road. The Montauk branch of the railroad, seen on the left, brought steam trains here in 1865, carrying home Civil War soldiers who had gone to battle by stage. In 1880 a connection to Long Beach, at the right of the photograph, enabled passengers to reach the seaside resort. So many residents of Brooklyn came to Pearsall's that by 1895 it was renamed Lynbrook (Brooklyn's syllables reversed). The use of Lynbrook's Grassy Pond to supply the Brooklyn Water Company further linked this suburb with its namesake. When this picture was made, electric trains were still four years in the future. On the right, Atlantic Avenue continues south one mile to East Rockaway; on the left, it goes north, to end at the Five Corners intersection. (*Nassau County Museum, #2476.*)

Opposite, bottom: **134. Five Corners Intersection, Lynbrook, ca. 1925.** Looking north on Atlantic Avenue, the photographer faced the Five Corners intersection, still the hub of Lynbrook's business section. Once owned by Wright Pearsall and Son, who ran a general store here, "Pearsall's Corners" gave its name to the town for almost 50 years. The east-west road in the center is the Merrick Road, then and now a main street of Lynbrook. Hempstead Avenue is at the other side of the intersection, running north to Malverne and ending in Hempstead. At the time of the photograph, Lynbrook was considered "one of the most progressive towns on Long Island," with 70 trains a day and a trolley provid-

ing commuter service to New York City, 20 miles away. (*Nassau County Museum, #2477.*)

Above: **135. Railroad Station, Valley Stream, ca. 1910.** Built in the early 1870s between Rockaway Avenue and Third Street, this station originally served the South Side Railroad, which then ran from Jamaica to Babylon. Although this portion of the railroad was complete by 1867, Valley Stream was not included in the timetable until 1869, when the Far Rockaway Railroad Branch of Queens County established a connection there. Hotels and restaurants were built near the station to accommodate passengers waiting for their transportation to the popular bathing beaches. The area was known as Rum Junction in these years, continuing a tradition of nicknames applied to various parts of the town; these included Tigertown, Cookie Hill and Skunk's Misery. Robert Pagan, a Scots emigrant and founder of the first general store, gave the town its official name in the mid-nineteenth century, when he opened a local post office. (*Collection of Howard Ruehl, Valley Stream Historical Society.*)

Over: **136. Fire Department Tournament, Valley Stream, 1920.** The growth of fire departments throughout Long Island provides an index to the development of towns. In Valley Stream, community fire fighting began in 1898 with a bucket brigade, progressed to horsedrawn wagons and, by 1917, included motorized equipment to protect the many new homes built on subdivided farms. The social aspect of these volunteer fire companies is illustrated by this photograph of a typical tournament parade on Rockaway Avenue. (*Collection of Howard Ruehl, Valley Stream Historical Society.*)

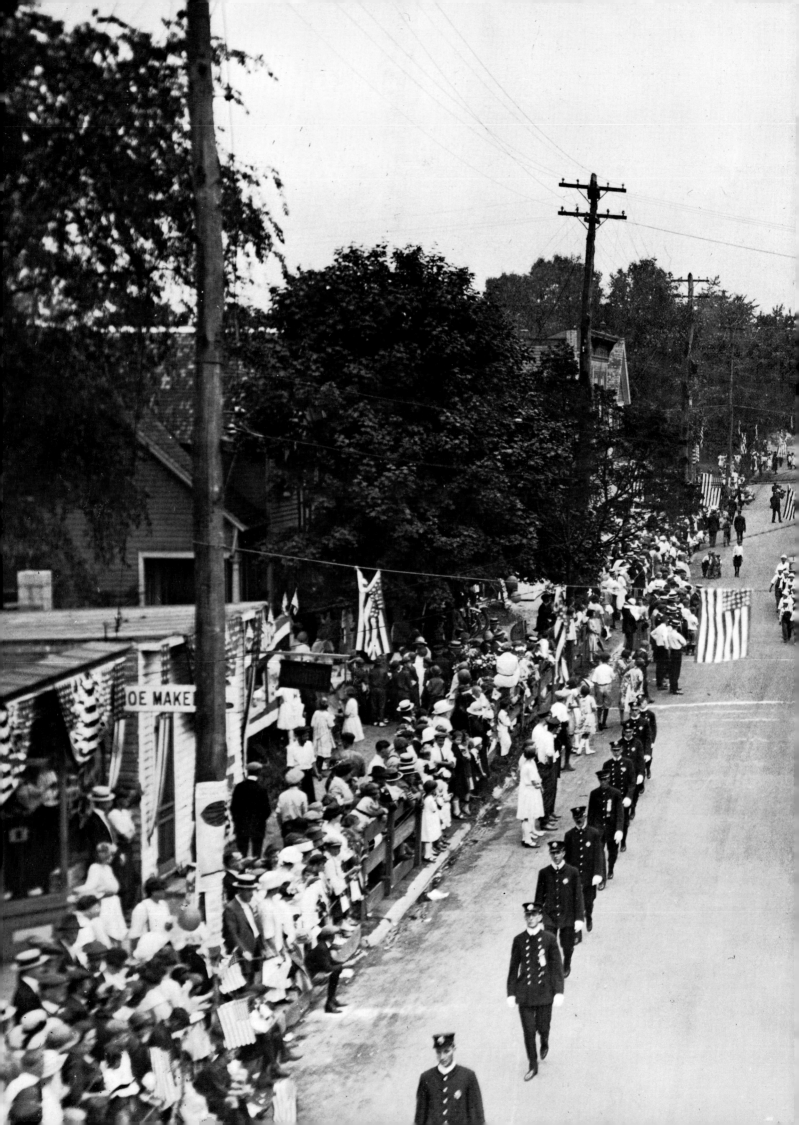

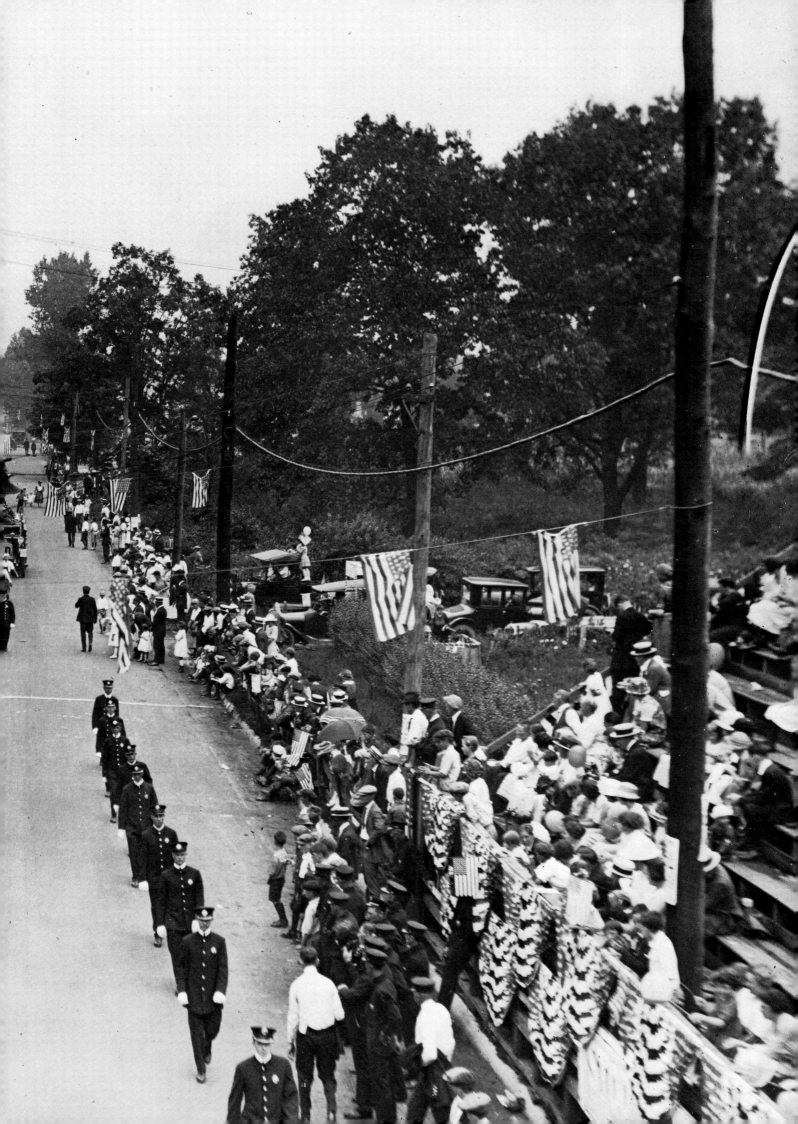

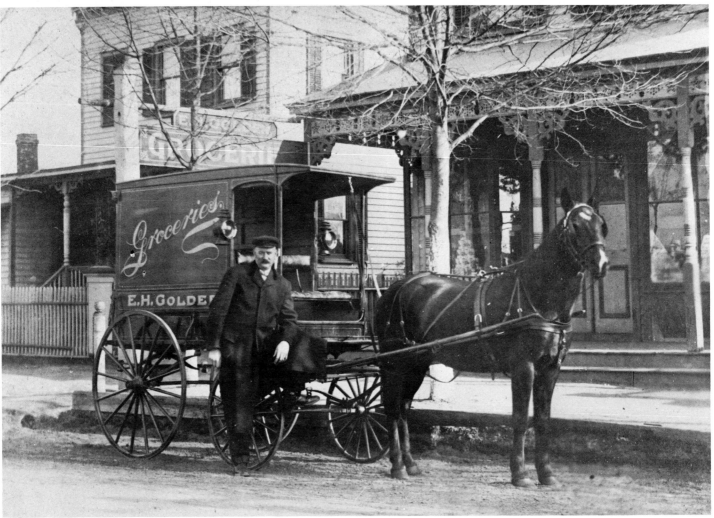

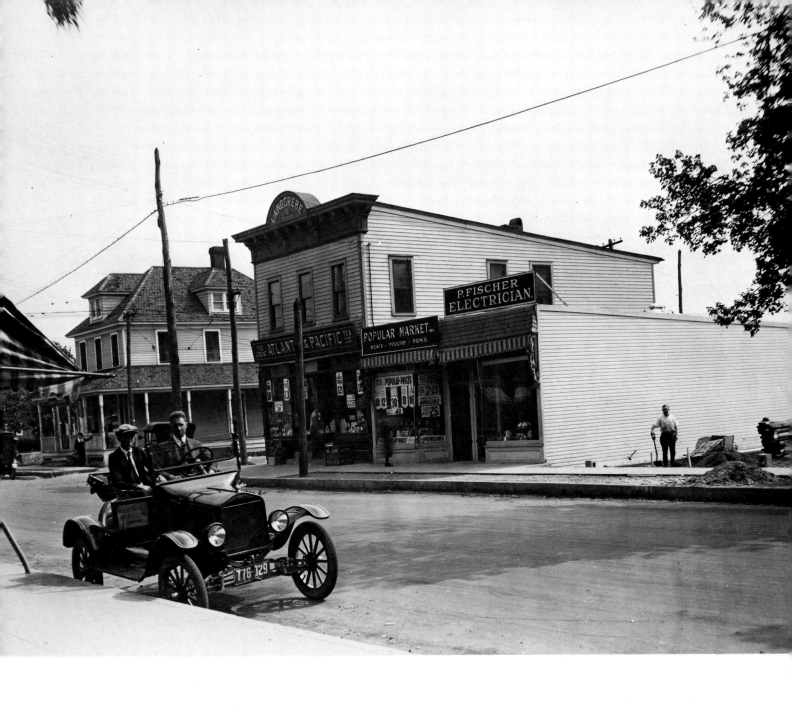

Opposite, top: **137. Joe F. Felton, Grocer and Seedsman, Valley Stream, ca. 1910.** The first telephone in Valley Stream was installed in 1896 in this grocery store located at Central Avenue and Merrick Road. Showing Felton's prosperity are the four proudly painted delivery wagons which, in winter, often had to be replaced by sleighs. At this time, the grocery business throughout Long Island relied on delivery rather than on over-the-counter trade. (*Collection of Howard Ruehl, Valley Stream Historical Society.*)

Opposite, bottom: **138. Elbert Golder and Delivery Wagon, Valley Stream, 1910.** Mr. Elbert H. Golder stands beside the delivery wagon in front of his grocery on Brooklyn Avenue. In 1898 a

group of local men selected him as first foreman of the Valley Stream Fire Department. The hand-drawn ladder-and-bucket truck, purchased for $150, was stored at Golder's Grocery. (*Collection of Howard Ruehl, Valley Stream Historical Society.*)

Above: **139. Queensboro Gas and Electric Company Car, Valley Stream, 1922.** Perhaps the gentlemen in their Ford roadster have come to read the electric meters on Rockaway and Jamaica Avenues. Complementing the small-scale automobile is the miniature A&P across the street and the single construction worker leaning on his shovel. (*Collection of Howard Ruehl, Valley Stream Historical Society.*)

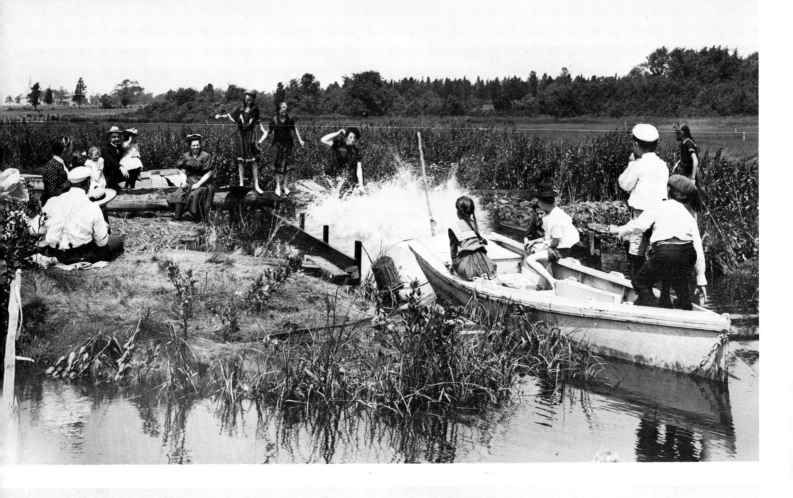

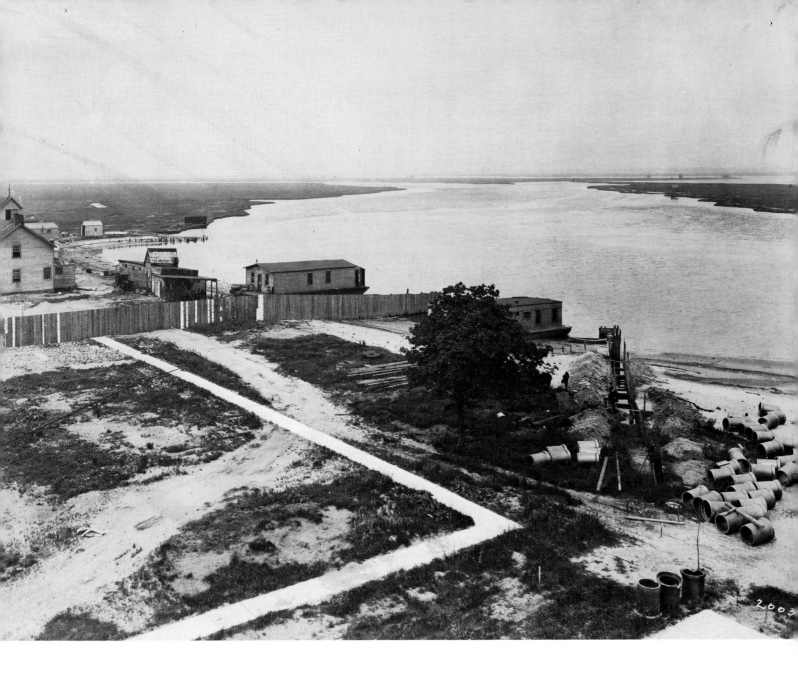

Opposite, top: **140. The Old Swimming Hole, East Broadway, Hewlett, 1900.** This marsh and farmland was located at the northeast end of the peninsula known as Rockaway. The towns of Hewlett and Woodmere (Woodsburgh) were officially differentiated when the South Side Railroad came through in 1869. Augustus Hewlett, one of a long line of settlers of that name, donated the land for the Hewlett railroad station. The Woodsburgh Station, later renamed to avoid confusion with an upstate village, was named for Samuel Wood, a retired importer who developed the extravagant Woodsburgh Pavilion. The possibilities for development as a resort were seen by several early investors, among them lawyer Carlton Macy, who built a famous steeplechase at Hewlett Bay Park. This turn-of-the-century photograph shows that the peninsula's great recreational resource, water, could also be enjoyed at a simple splashing party and picnic. (*Historical File, Hewlett-Woodmere Public Library.*)

Opposite, bottom: **141. Fire Department, Hewlett, ca. 1905.** Originally located at Franklin Avenue west of Broadway, the first Hewlett firehouse looked much like an old farmhouse. Its double-sloped gambrel roof, a typical architectural feature on Long Island, offered protection against rain and snow, as well as additional height for sleeping quarters. This adaptation of farmhouse design to firehouse needs also featured the high square bell tower which alerted the volunteers. Hewlett's Engine Company No. 1, which was organized in 1891, was incorporated three years later, a handpumper being its first piece of equipment. In 1903 it joined with the Hewlett Volunteer Hose Company No. 2 to build the firehouse pictured here. This structure was moved across Broadway in 1925; a new brick building was erected on the site in 1927. (*Historical File, Hewlett-Woodmere Public Library.*)

Above: **142. Meely's Camp, Island Park, ca. 1910.** Facing Reynold's Channel on the southern edge of Island Park, this complex of buildings was used to house immigrants who, in return for food and shelter, provided manual labor, including refuse collection. According to local legend, Meely exploited the Italian and Irish newcomers. Before it was renamed in 1921, Island Park had been known as Hog Island because its marsh grass was forage for local livestock. Contrary to popular belief, the island was not named for showman P. T. Barnum, but for Sarah A. Barnum, wife of a rich clothing merchant of East Meadow. According to the *South Side Observer* of March 13, 1874, Mrs. Barnum rode through a snowstorm to buy the island before developers turned it into a summer resort. She deeded it to the county for use as a poor farm. (*Island Park Village Hall.*)

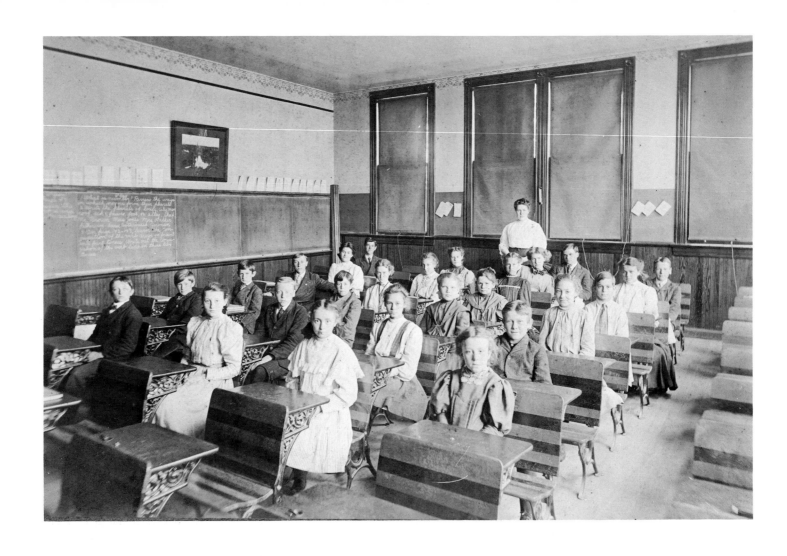

Above: **143. Woods Avenue School, East Rockaway, ca. 1900.** Hands folded primly in their laps, these children were among the first in the Woods Avenue School (grades one through eight). Built in 1898, when there were no schools from Lynbrook to Far Rockaway, the original structure cost $10,000; additions made in 1904 and 1915 required another $15,000. By 1925 it had grown to eight rooms, but was demolished in 1937 when there were not enough pupils. The school bell was gilded and installed in the belfry of the new high school. Now the East Rockaway Museum stands on the site. (*Grist Mill Museum, East Rockaway.*)

Opposite, top: **144. The *Sarah Boyd*, East Rockaway, 1900.** Once one of the principal towns on the South Shore, East Rockaway (previously known as Near Rockaway) was favorably located for boat building and oystering on the west side of Mill River. Vessels like the *Sara Boyd*, one of the largest and last built here, traded up and down the East Coast from this port. Farm produce and oysters were sent to the cities; coal and molasses were returned to the

farmers. One East Rockaway schooner, the *Experiment*, sailed to Cadiz, Spain, carrying flour milled in East Rockaway, boards from Rockville Centre and local beeswax. (*Grist Mill Museum, East Rockaway.*)

Opposite, bottom: **145. Davison's Lumber Mill, East Rockaway, 1898.** Built in 1688 on Mill River at the end of Long Lane, now the southeast corner of Ocean and Atlantic Avenues, the old gristmill passed through several ownerships until 1818, when Alexander Davison purchased it. He and his descendants operated it as grist- and sawmills, using tidal waters to operate a turbine wheel. The water rights were sold 102 years later, and the old mill was moved to Davison's Lumberyard on Ocean Avenue, where it was used for storage. In 1962, when the lumberyard was sold, the Village of East Rockaway acquired the mill and moved it a third time to its present location in Memorial Park, where it serves as a museum. (*Grist Mill Museum, East Rockaway.*)

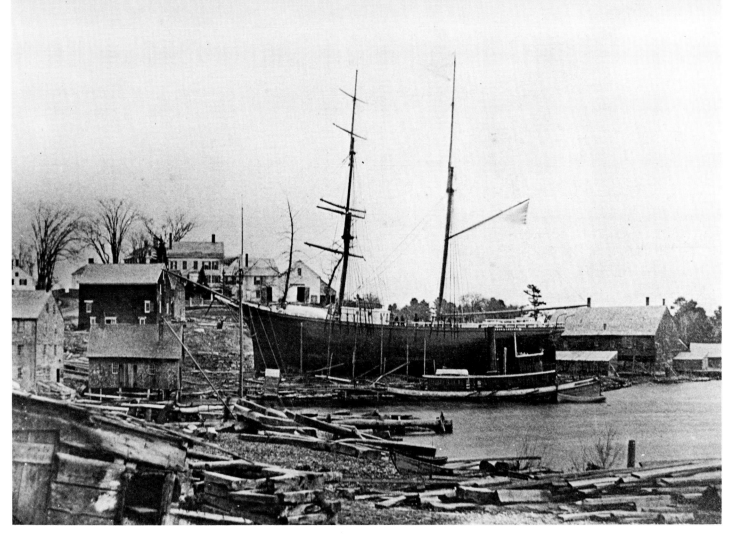

Lumber Boats "Reaper" and "T. O. Smith"
DAVISON'S LUMBER MILL
About 1898

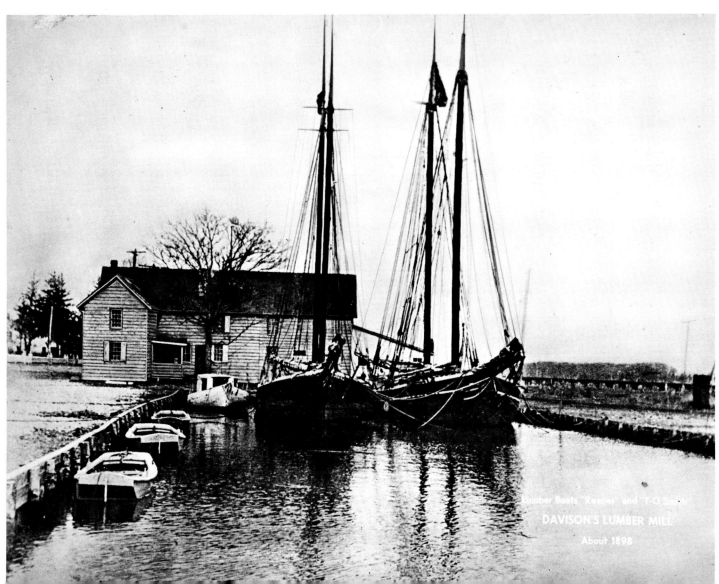

Above: **146. Mordecai Smith House, Rockville Centre, April 3, 1874.** Originally settled by Michael De Mott, who built a milldam here in 1710, this pond was purchased by Israel "Rock" Smith in 1780. (The nickname "Rock" was inherited from his great-grandfather John, an early Connecticut colonist who is said to have built the fireplace of his house against a huge rock.) Israel's son, Mordecai, the fourth generation of Smiths, took over the mill in 1806. Justice of the peace, preacher, miller, he became the leading citizen of the village. When the townspeople set up a post office in 1849, they adopted the nickname of his branch of the Smiths for rockless Rockville Centre. Mordecai Smith died in 1852; in the following year, his property was acquired by the Brooklyn Water Company for $11,500. The house has been demolished. (*Photograph by George Brainard; Nassau County Museum, #773.104; Brainard Plate #563.*)

Opposite, top: **147. The Iceman, Rockville Centre, ca. 1870.** Abundant underground water supplies fed Long Island's many ponds and streams. Not just a hot-weather resource, the ponds provided essential ice for the storage of foods throughout the year. Cut in large blocks during the winter by teams of horses pulling sharpened blades, the ice was packed in straw and kept in icehouses for delivery to customers in the summertime. (*The Baldwin Historical Society.*)

Opposite, bottom: **148. Putting in the Vault Doors, Bank of Rockville Centre, 1907.** Founded in 1890, the second commercial bank in Nassau County was the Bank of Rockville Centre, shown here as the vault doors were being installed at its new location. The three-story building, on the northeast corner of Village Avenue and Merrick Road, was once considered the finest of its kind on the South Shore. Rockville Centre was the business capital of Nassau County from 1889 to the 1950s, when bank mergers ended independent enterprises. In the early 1960s, the building was razed and the bank merged with Chemical Bank New York Trust Company. (*The Phillips House, Museum of the Village of Rockville Centre.*)

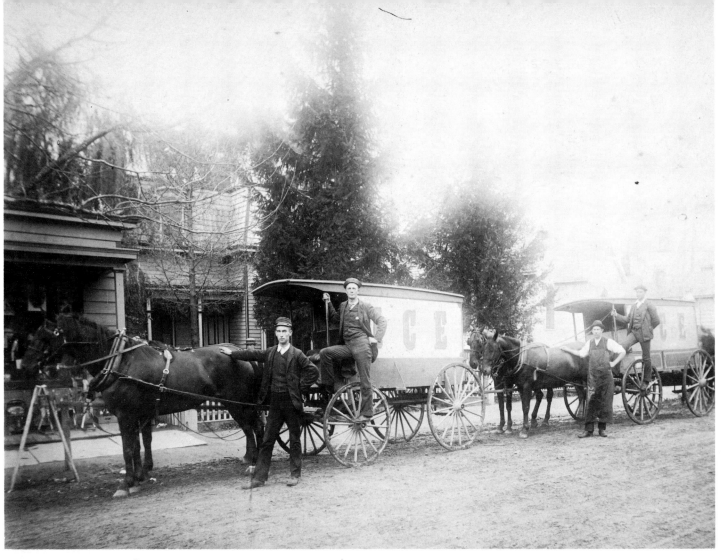

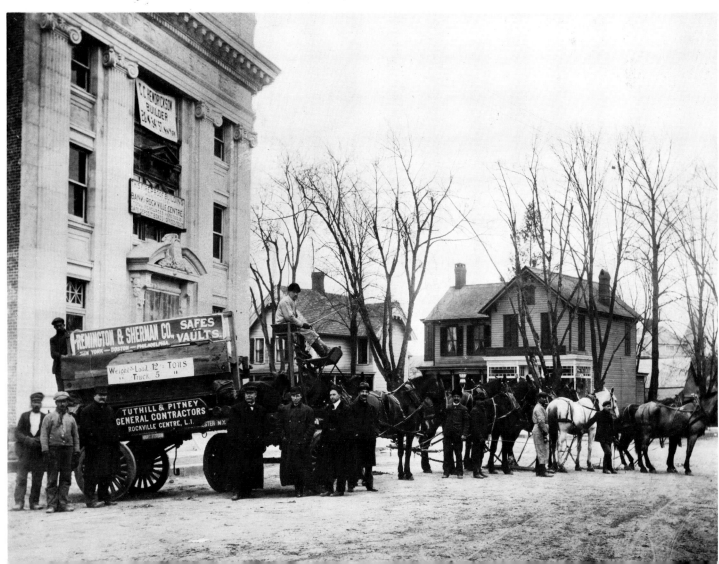

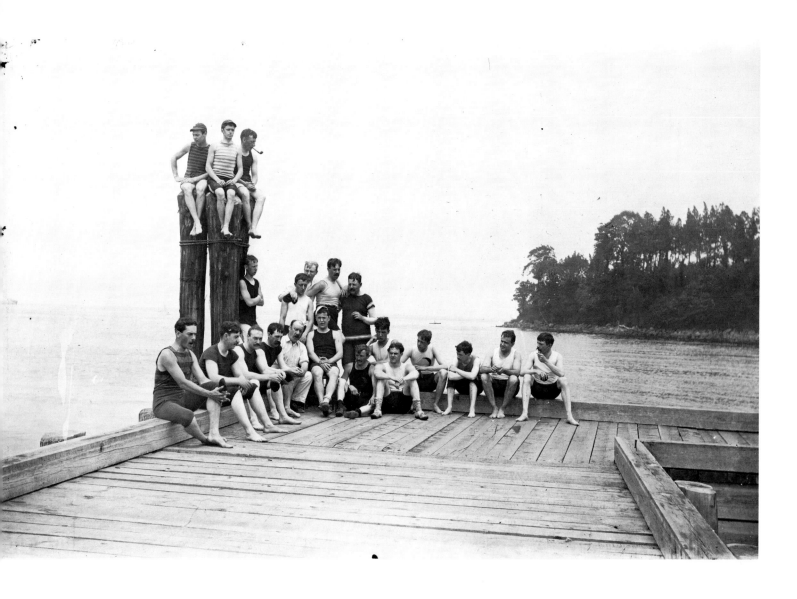

Above: **149. Men and Boys in Swimsuits, Sewanhaka Club, Rockville Centre, ca. 1895.** The waters surrounding Long Island were always a source of recreation as well as food supply. As transportation improved, clubs and resorts lined the bay and shore waterfronts. Seasonal tourist trade also provided a source of income in the months when shell fishing was restricted. In the gay nineties new and daring attire appeared on the beaches. Women wore knee-length beach dresses with black stockings; men wore the long shorts with sleeveless shirts seen here. As Clarence Day put it: "We liked flesh. It didn't have to be bare, and it wasn't, but it had to be there." (*Photograph by Hal Fullerton; Suffolk County Historical Society, The Fullerton Collection, #6051.*)

Opposite: **150. Midmer-Losh Organ Works, Merrick, ca. 1930.** This is one of the giant pipes for which the Midmer-Losh Company was known. The business was founded in Brooklyn in 1860 by Ruben Midmer; in 1907 he moved it to Merrick, where it occupied a large brick-and-frame factory on the north side of the railroad station, east of Merrick Avenue. The original 30 employees established the business by making organs for movie theaters, but by 1930, when sound movies had supplanted silent films, this market declined. At this time, however, the Midmer-Losh Company was building its most famous organ, the 33,000-pipe instrument at the Atlantic City Convention Hall. The largest pipe organ in the world, it took four years to construct. Unamplified, it carried sound through a seven-acre auditorium. The organ works were run by George and Siebert Losh until 1967; a few years later it was incorporated into the Hicksville business of William F. Benzeno. (*Nassau County Museum, #2584.*)

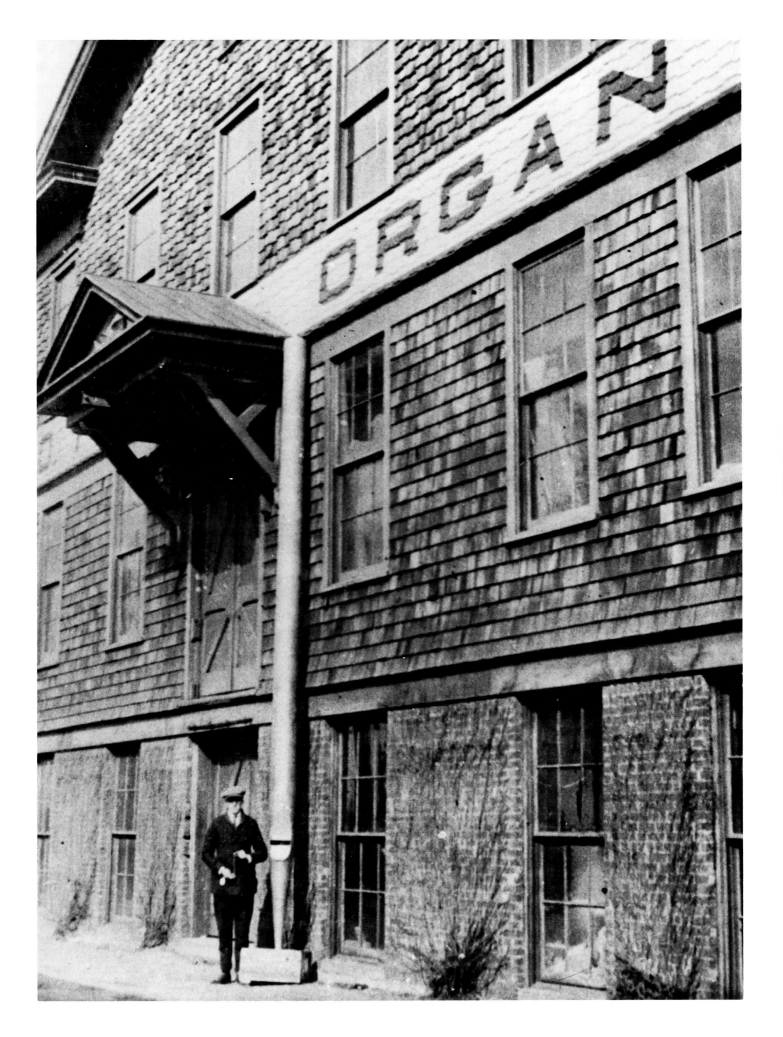

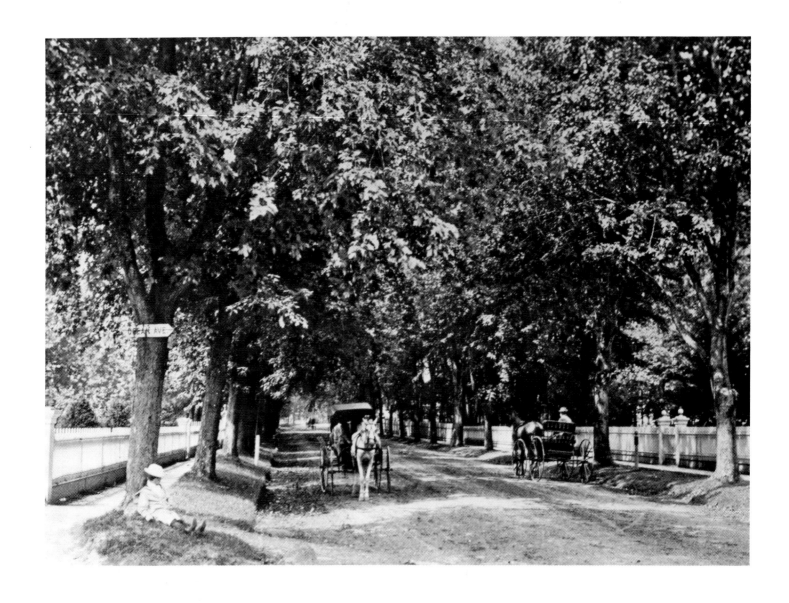

Above: **151. The Famous Merrick, ca. 1900.** With Hempstead, the oldest community on western Long Island, Merrick was settled in 1643. It was chiefly an agricultural village, with the advantage of a navigable creek into the bay, close to town. The first road in the vicinity was the old Merrick path, an east-west route later extended for stagecoach traffic from Brooklyn to Babylon. Today the Merrick Road is still the southernmost continuous east-west route from Jamaica to Montauk Point. Intersecting Ocean Avenue at the town of Freeport is Merrick Road, the subject of this photograph. Before 1850, it was a cow path known as Whale Neck Road which ran from Merrick Bay north to the railroad station. It was rebuilt after 1850 and extended to and beyond the Methodist campgrounds, established a mile north at the village in 1869. A turn-of-the-century historian calls it "as fine a road...as can be found on Long Island. It is, the greater part, beautifully shaded, and has a macadam foundation." (*Nassau County Museum, #4024.*)

Opposite, top: **152. "The Merrick," Lawrence Railroad Station, 1874.** In 1869, the South Side Railroad Company built tracks through the present "five towns," beginning the development of what was then known as Rockaway Neck. The railroad brought land investors from New York; among them were Newbold, Alfred and George Lawrence, who formed the Cedarhurst Company, bought farmland and laid out residential communities. In 1870 they built this railroad station at Lawrence Avenue. In this photograph taken four years later, the locomotive "Merrick," a 4-4-0 type, built by Mason in April 1868, is ready to take passengers to Long Island City for the then-substantial fare of 55 cents. (*Ron Ziel Collection, Bridgehampton.*)

Opposite, bottom: **153. Hal Fullerton Testing the Runway, June 1899.** Gathering for an extended Fourth of July celebration, some Long Islanders must have wagered on the unusual race between manpower and steampower. Charles M. (Mile-a-Minute) Murphy, riding a bicycle on a wooden track behind a Long Island Railroad train, attempted to set a speed record. On the first try to cover a mile in a minute, the engine couldn't reach the required speed. On the actual record ride, taken on July 7, 1899, the weight of the engine rocked the track and nearly killed Murphy, who had ridden the mile in 57.8 seconds. In the picture, Long Island Railroad photographer Hal Fullerton is seen testing sections of the track one month before the race. (*Photograph by Hal Fullerton; Suffolk County Historical Society, The Fullerton Collection, #1405A.*)

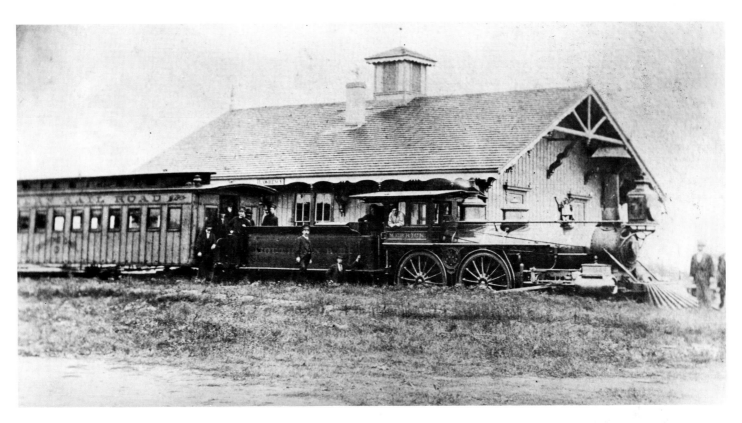

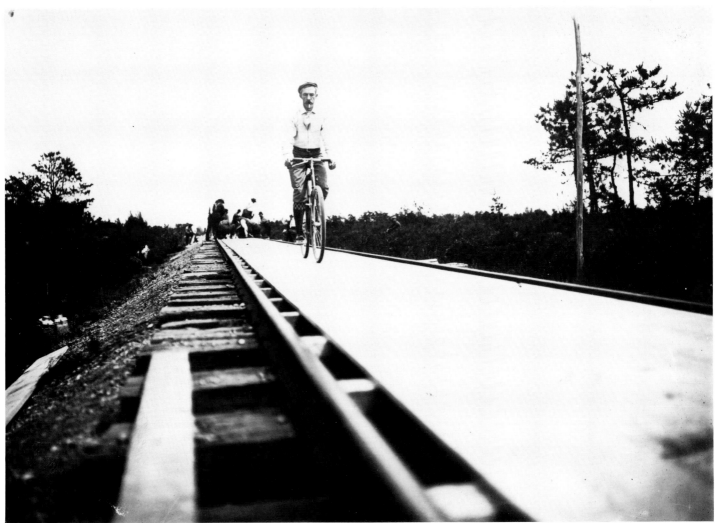

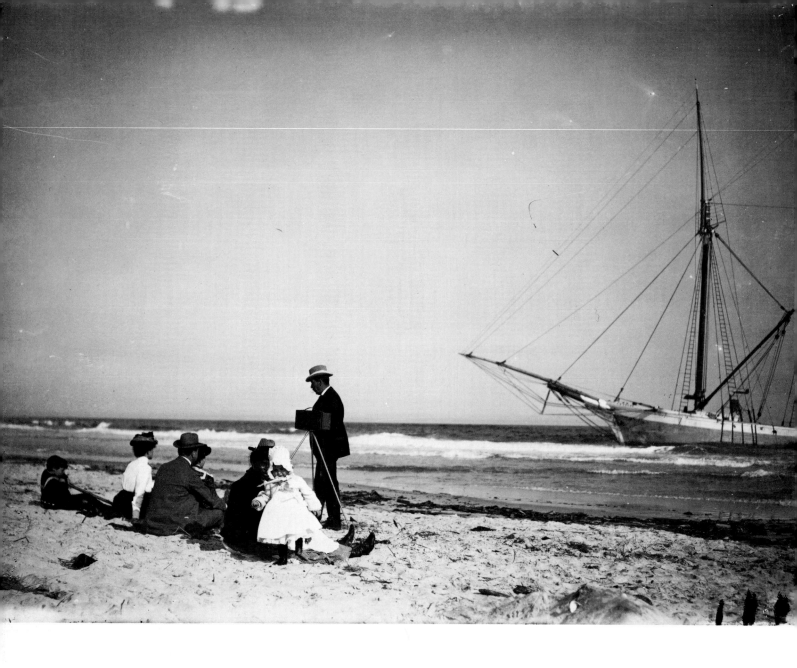

Above: **154. Big Wreck, Long Beach, 1901.** Phtographer Hal
Fullerton and his family are viewing the wreck of a sailing vessel,
a frequent scene along the sand bars of the South Shore. Owned
by the town of Hempstead since 1644, the 15-mile stretch of ocean
frontage at Long Beach was developed into a small resort during
the 1880s. In spite of the efforts of such financiers as Austin
Corbin and J. P. Morgan, the resort fell into bankruptcy and
activity at Long Beach was dormant until about 1905. (*Photograph
by Hal Fullerton; Suffolk County Historical Society, Fullerton Collection,
#5376 A1.*)
Opposite, top: **155. Hotel at Long Beach, June 1905.** An old
beachfront hotel with cottages, these buildings belong to the
period just before massive development would transform Long
Beach. The major resort at this time was the Long Beach Hotel
and its 25 cottages, built in 1881 for $1.25 million. After a series
of bad seasons, the hotel fell into bankruptcy and was offered to
the City of New York at $2 million as a peoples' beach, the site for
a sanatorium to be known as the Convalescent and Recreation
Seashore Colony of the City of New York. Opposition from local

townspeople defeated this plan and The Long Beach Improve-
ment Company, a wealthy syndicate, purchased the property in
1906. One year later, the Long Beach Hotel burned to the ground,
but plans for development of the beach were already underway.
(*Photograph by Hal Fullerton; Suffolk County Historical Society, Fullerton
Collection, #1053 B.*)
Opposite, bottom: **156. Elephants Building Boardwalk, Long
Beach, 1907.** One unusual feature of the work at Long Beach was
the use of elephants in the demolition and construction. Brought
from Bostock's Animal Show in Coney Island, they substituted
for teams of horses in wrecking old frame cottages and hauling
lumber for the boardwalk. This innovation was short-lived; the
exotic beasts did not adapt to winter at the beach. Fifteen hundred
men were also employed on the job by the fall of 1907, many of
them delegated to the task of building two miles of boardwalk at
the cost of $136,000 per mile. The reinforced steel-and-concrete
boardwalk could support 25,000 pounds to the square foot; its
planners claimed it would "rank with the pyramids in endur-
ance." (*Long Beach Public Library.*)

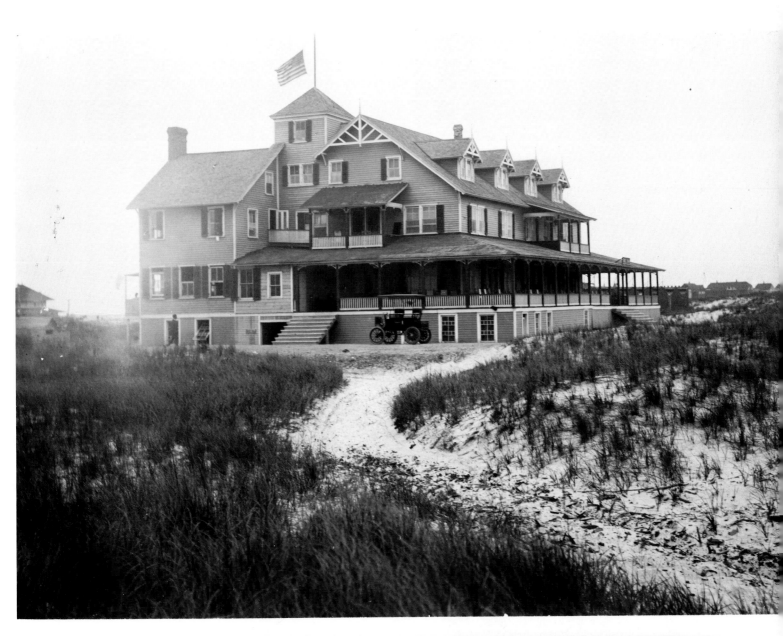

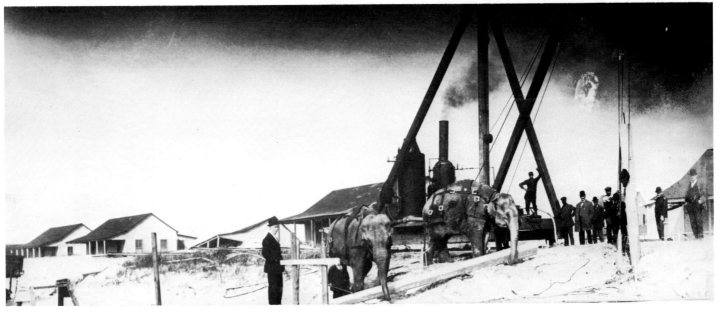

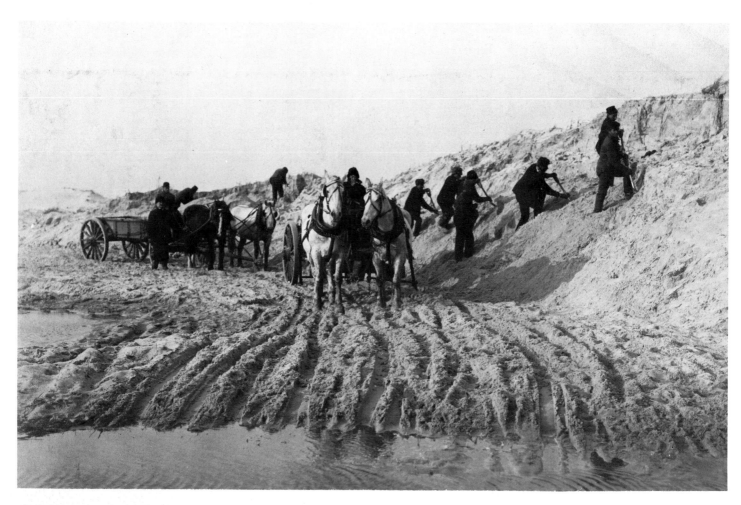

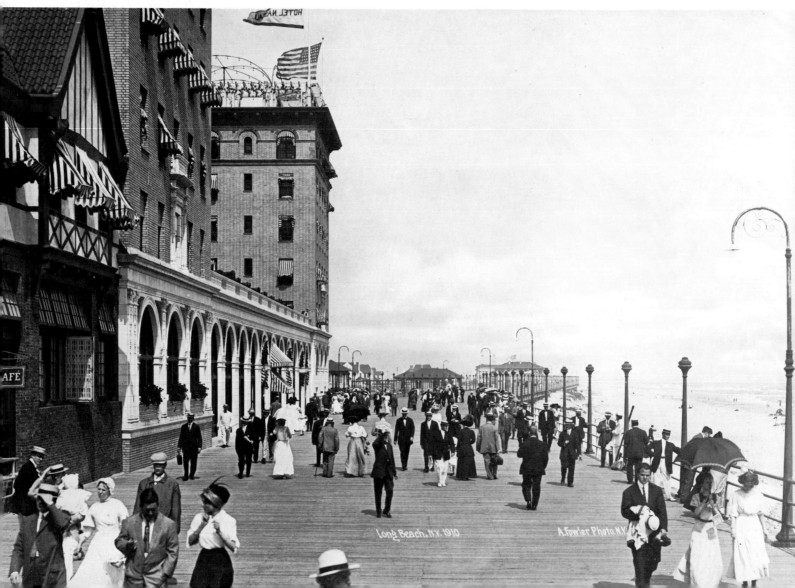

Long Beach, N.Y. 1910 A. Fowler Photo N.Y.

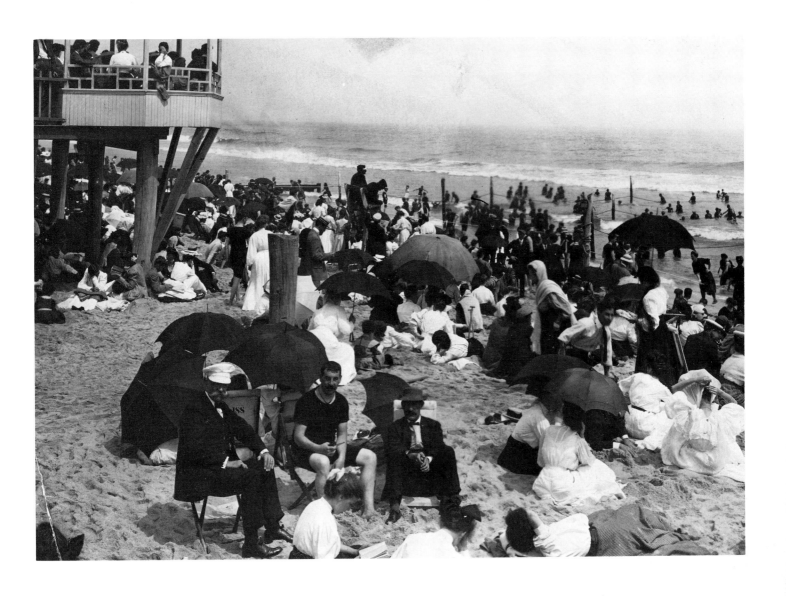

Opposite, top: **157. Clearing Down the Sand Dunes, Long Beach, February 20, 1908.** William H. Reynolds was the chief figure among the wealthy developers who initially invested $4 million in Long Beach. As part of their project to see "grains of sand converted to bars of gold," the Estates of Long Beach Company employed the largest steam dredge in the world to prepare Reynold's Channel. Three dredges worked round the clock to transport 60,000 cubic yards of sand a day. Laborers used teams of horses to clear the dunes and planted clumps of beach grass to stabilize the sand. An observer reported, "There is nothing like Long Beach in the history of land improvement in the world. It is a masterpiece of American business methods." (*Long Beach Public Library.*)

Opposite, bottom: **158. View of Boardwalk, Long Beach, 1910.** Holidaymakers strolled the two-and-a-half miles of completed boardwalk in the optimistic days when vacationing at Long Beach was the height of fashion. One year old at the time of this photo-graph, the 300-room Hotel Nassau, built at a cost of $900,000 by John L. de Saulles and Henry L. Gillespie, fronted 300 feet of the boardwalk. The architects, Lewis R. Kaufman and B. E. Stern, designed the building in Spanish Renaissance style, its exterior of terra-cotta and brick decorated with varicolored faience. Here 1,000 guests could dine on "cuisine Française" or fresh seafood from the Atlantic, dance to a Neopolitan orchestra in the rooftop garden, and recover their health by taking "hot or cold sea baths." (*Photograph by A. Fowler; Long Beach Public Library.*)

Above: **159. Beach Scene, Long Beach, ca. 1910.** The advertisements for this thriving resort claimed that there was "no more danger during immersion at Long Beach than in the household bathtub." There was certainly no danger of sunburn for these well-covered bathers who crowded the sand at this Sea City Beautiful (known also as Neptuna-by-the-Sea). It seemed, at the moment, that Reynold's dream of a resort to rival Ostend, Brighton and Atlantic City would be realized. (*Long Beach Public Library.*)

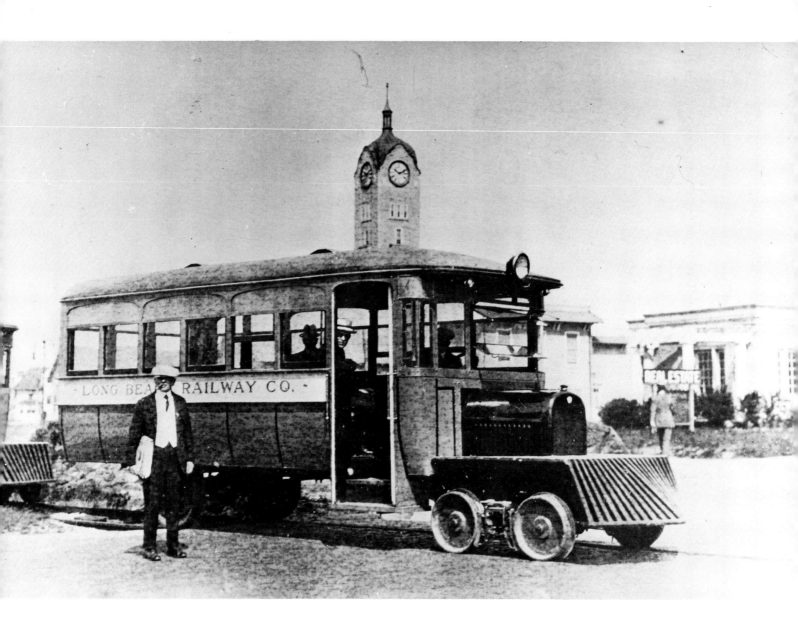

Above: **160. Gas-Engine Bus, Long Beach, ca. 1925.** After 1922, when Long Beach became a city and William H. Reynolds its mayor, improvements continued to be made: salt-water fire protection, extension of the electrical system, sewage, wide boulevards and ten miles of trolley tracks. This curious Reo gasoline bus, which ran on the Park Avenue railroad tracks from Maple Avenue to New York Boulevard, was one of the newfangled vehicles to be seen in the developing city. By 1925 Mayor Reynolds had been convicted for misappropriating funds, but the loyal citizens of Long Beach remained grateful for his foresight. (*Nassau County Museum, #2216.*)

Opposite, top: **161. Jones Beach, July 1933.** In his wildest dreams Major Thomas Jones, High Sheriff of Queens County, could not have foreseen this crowd on the coastal barrier he owned at the end of the seventeenth century. On the losing side in the Battle of the Boyne (1690), Jones escaped to France, became a privateer, and emigrated to Massapequa, where he and his wife, Freelove Townsend, built the first brick house on Long Island. In 1700 Jones, who owned more than 6,000 acres, established a whaling station on the outer beach near the site of the present park. This tract of sand and marsh remained unused and inaccessible for more than 200 years until 1925, when it came to the attention of Robert Moses, president of the Long Island State Park and Recreation Commis-

sion. At first opposed by local real-estate owners, public beach construction was finally approved in December 1926. The beach opened on August 4, 1929 and was visited by 1.5 million people during its first year. Developed ambitiously for many forms of public recreation, Jones Beach includes 2,413 acres, six miles of ocean beach frontage and half a mile of bay frontage. (*Long Island State Park and Recreation Commission.*)

Opposite, bottom: **162. Lifeguard Staff, Jones Beach, July 11, 1932.** Construction of the water tower in the rear center of this photograph was begun December 1926. Nearly 200 feet high and modeled on the campanile of St. Mark's in Venice, the tower stored the fresh water used for showers and drinking. By the time the West Bathhouse opened on July 2, 1931, the popularity of the beach caused traffic problems that led to the construction of the Meadowbrook Parkway and a causeway in 1934. An enthusiastic public responded to the comfort and beauty of the beach, as well as the variety of recreational activities available, from archery and roller-skating to concerts and calisthenics. A large uniformed staff, including these orange-and-black-suited lifeguards, served and protected the crowds who made this formerly unused strip of land famous around the world. (*Long Island State Park and Recreation Commission.*)

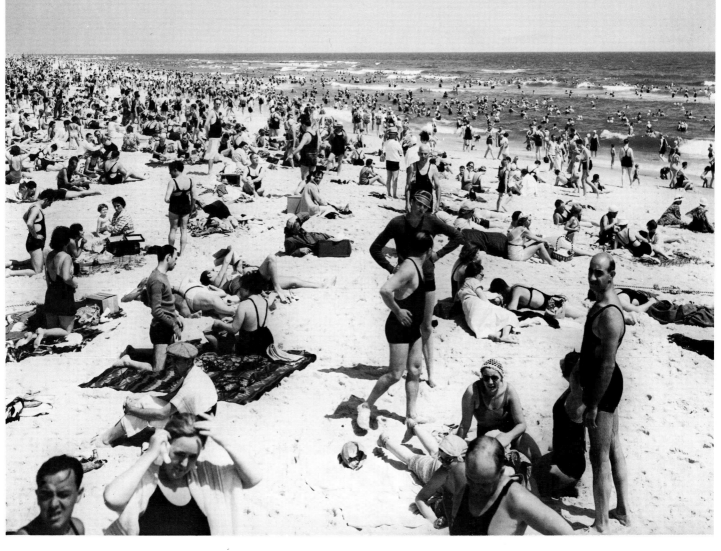

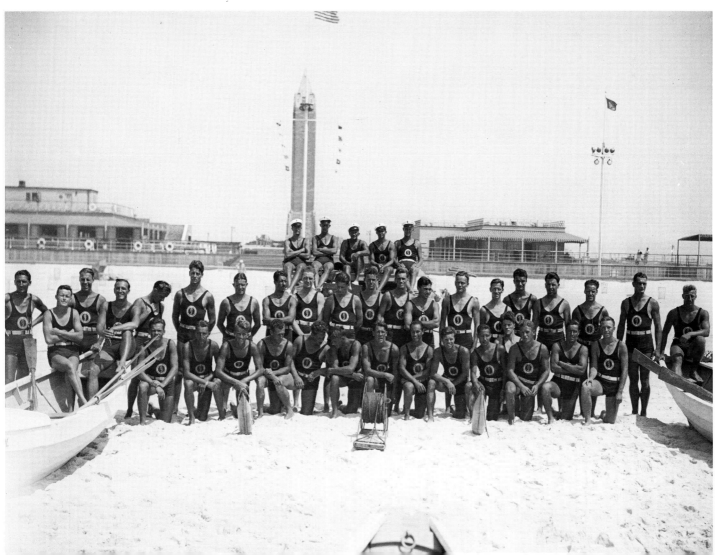

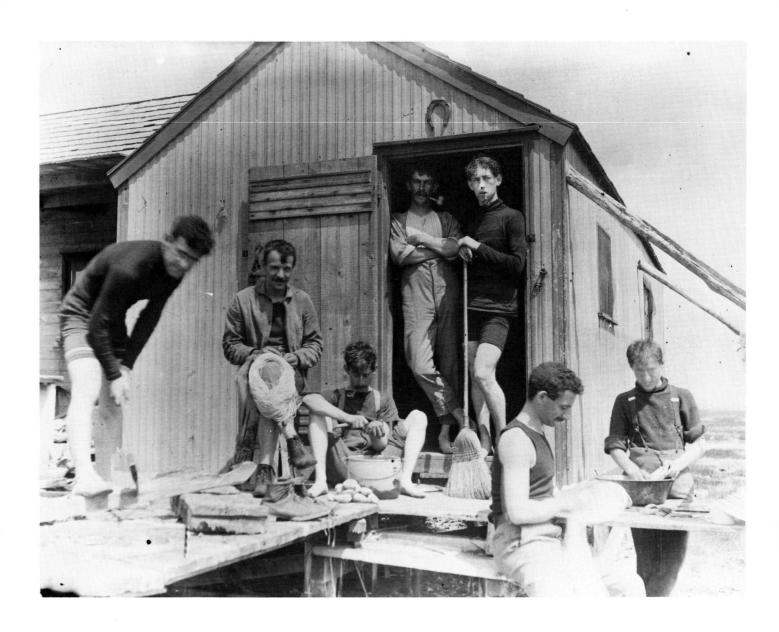

Above: **163. Boys at Work, Great Island, Great South Bay, July 5, 1902.** Along the South Shore of Nassau County, within the limits of the barrier beaches divided by Jones Inlet, many small uninhabited islands with such names as Crow, Snipe, Egg and Seadog fill the Great South Bay. One of the largest is Great Island, now part of the causeway chain to Jones Beach. When these young men camped there, they enjoyed the abundant supply of clams and oysters for which the bay was known since earliest settlement. Even in the colonial period, when the bay was a source of food supply for individuals, an oyster-protection measure had to be enacted in 1719 to limit the harvest to local fishermen. In the early nineteenth century, regular gathering by baymen took place from September to April. As the natural beds decreased in number, artificial seeding was begun. Scientific methods of oyster farming were not enough to forestall the eventual destruction of a once prosperous industry, ravaged by dredging and pollution. (*Lightfoot Collection.*)

Opposite, top: **164. Wantagh Spur, March 6, 1929.** Before the Wantagh State Parkway was built south from Westbury to the Jones Beach causeway, through farmland and marsh, residents of towns now vanished (Jerusalem, Ridgewood Station, Smithville South) sighted black geese and glossy ibis over the Great South Bay. Trapping muskrats and selling their pelts for 15 cents each was a popular pastime around 1910. At that time the whole southern shore of the county was more interpenetrated by waterways and marshes; a few dirt paths from the Merrick Road led to landings.

Today the area is called Cedar Creek Park, taking its name from the East Bay inlet which still runs north almost to the Merrick. The houses in the left foreground are part of the new development of bungalows at Wantagh. In 1925 a three-room house sold for $3,500. (*Long Island State Park and Recreation Commission.*)

Opposite, bottom: **165. Baldwin Pipeline, ca. 1911.** In 1889 the city of Brooklyn, caught without sufficient water resources for its population, tapped the fresh supply of nearby Queens County by creating a series of five reservoir ponds. As part of the 161-square-mile system, the pond near Baldwin provided nearly 20 million gallons of water. Still a rural community, Baldwin (then called Millburn) and its environs had not yet lost underground reserves to paving, sewers and drains. By 1900 the volume of water pumped by the Brooklyn Water Company was so great that it affected the flow of fresh water in local streams, permanently injuring the South Shore oyster industry. This photograph shows the installation by the Brooklyn Water Company of an additional 72″ pipeline near Grand Avenue. At its completion, people could walk along "Pipeline Boulevard" from Baldwin to Rockville Centre. Sunrise Highway was constructed through Baldwin following this route in 1927. By the 1930s, Brooklyn's heavy use caused serious lowering of the water table in Nassau County; a 1933 law restricted the abuse of dwindling supplies. By this time, the City of New York was drawing water from its reservoirs upstate. (*Baldwin Historical Society & Museum.*)

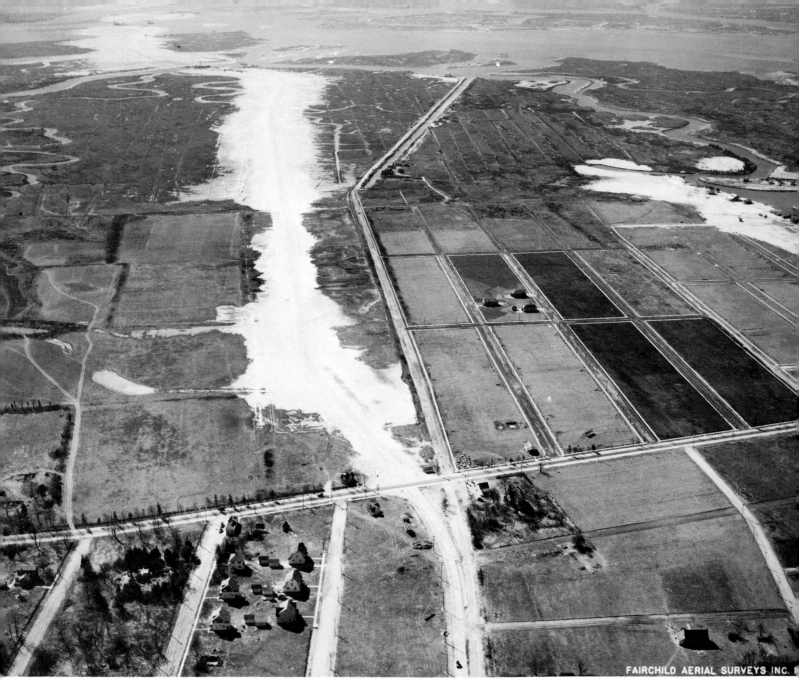

FAIRCHILD AERIAL SURVEYS INC.

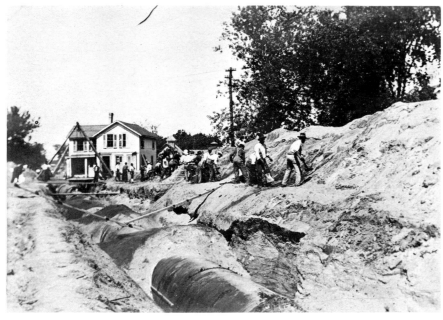

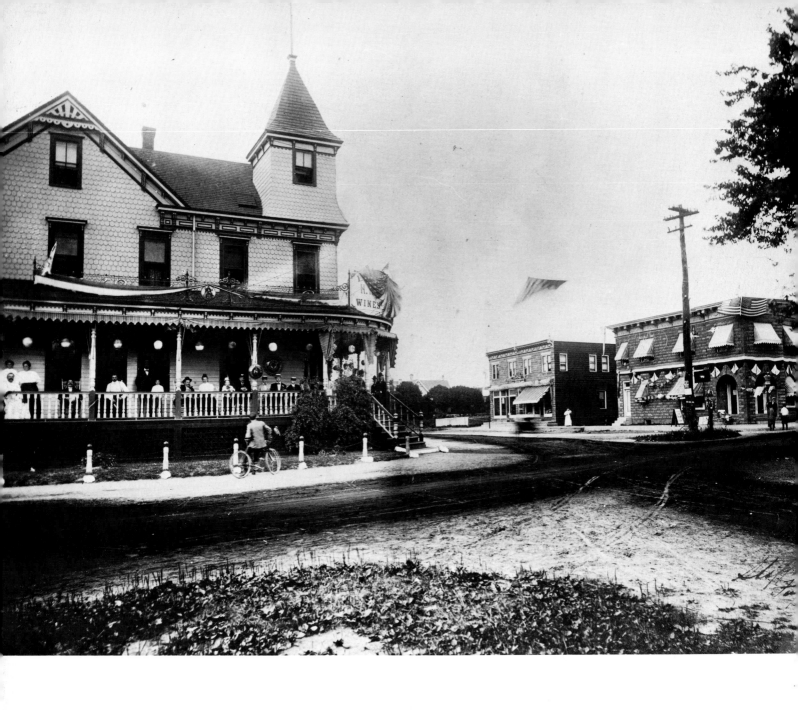

Above: **166. Henry Hebenstreit's Baldwin Inn, July 4, 1908.** A typical turn-of-the-century gathering place, this building was located at the intersection of Grand Avenue and Merrick Road, where it stood until the early 1950s. A Long Island Railroad handbook describes Baldwin then as "conveying to the traveller a delightful idea of rural life." Perhaps some of the people gathered on the porch for this Fourth of July celebration took advantage of the railroad's one-dollar excursion fare from Long Island City. One of the attractions they came to see may have been the large mansion and grounds of Frances B. Baldwin, from whose family the town took its name. (*Baldwin Historical Society & Museum.*)

Opposite, top: **167. Baldwin Inn Bar, ca. 1906.** In the gaslit interior of Hebenstreit's Bar, a straw-hatted gentleman, perhaps a salesman, seems satisfied with his five-cent purchase. The regulars may have come in to see who the Queen Contest candidates were, or to take a chance on a raffle for a gold watch. (*Baldwin Historical Society & Museum.*)

Opposite, bottom: **168. Seaman Block, Baldwin, ca. 1905.** Torn down in the 1950s for a parking lot when the railroad was elevated, the Seaman Block on Grand Avenue was named for its owner, John R. Seaman, member of a prominent Long Island family. Note the hitching post—still a necessity in the town where hay and feed were major commodities. While a traveler waited for the railroad, he could satisfy his sweet tooth on Reid's Ice Cream, confectioner's goodies or a bottle of Moxie. (*Baldwin Historical Society & Museum.*)

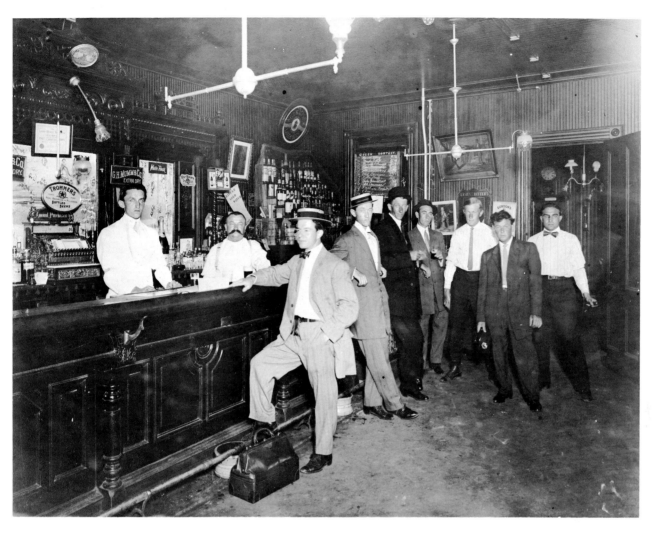

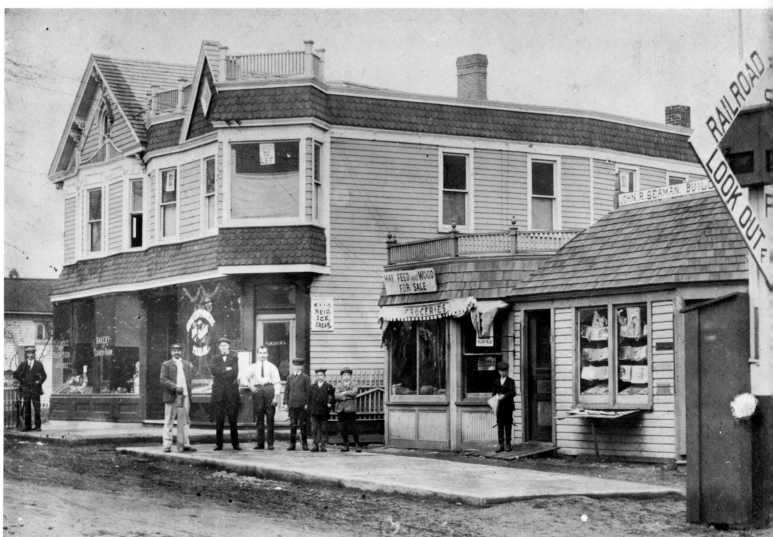

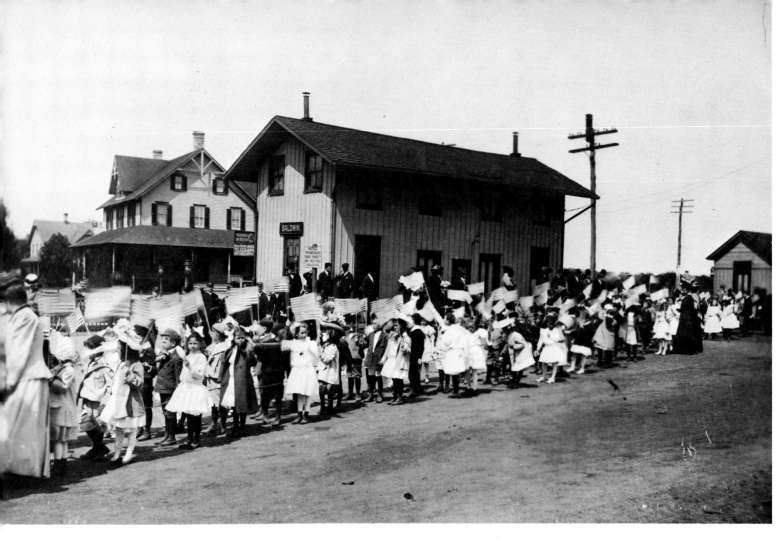

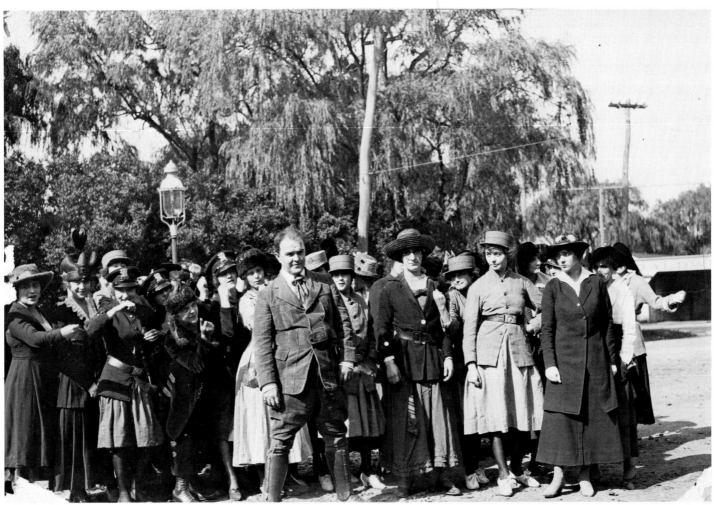

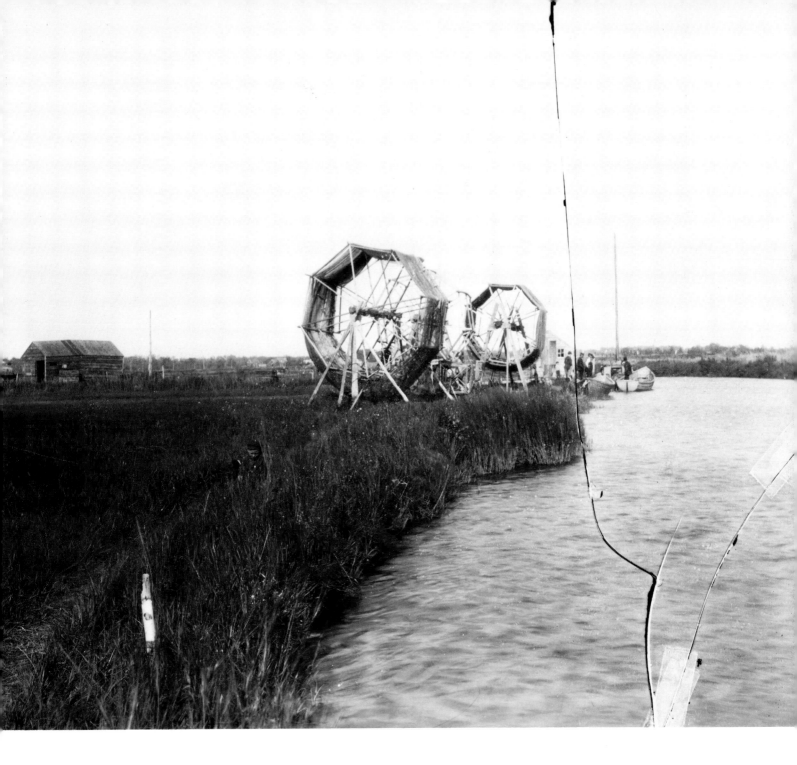

Opposite, top: **169. Baldwin Students Pulling Cornerstone to High School, May 24, 1907.** Gathered at the Grand Avenue railroad station, these flag-waving children are at the head of an unusual procession. This ceremony of pulling the cornerstone to School Street must have been some schoolmarm's idea of symbolizing, in concrete terms, the toilsome burden generations of youth would assume. The first students' names are sealed in a metal box buried in the cornerstone of the building, now serving as the Prospect Street Elementary School. (*Baldwin Historical Society & Museum.*)

Opposite, bottom: **170. Victor Moore and His "Klever Komedies," ca. 1917.** Before the film industry had shifted most of its production to Hollywood, movie stars made their homes in communities along the North and South Shores of Long Island. Victor Moore, an actor and director who in later years went on to make sound movies, had homes in Baldwin and Freeport. He is seen here near the Baldwin Inn, posing with his silent movie cast of formidable females. (*Baldwin Historical Society & Museum.*)

Above: **171. Fishnet Reels, Freeport, ca. 1890.** The rich tidal mixture of salt and fresh waters in its creeks and marshlands promoted Freeport's shellfish industry. In the left rear of the photograph is an example of an old weathered oyster house where shellfish were stored before being taken to market. In 1885 Freeport had a $100,000 oyster industry; the peak harvest in Nassau County occurred in 1901, when more than 3.5 million bushels were harvested. In the same year Freeport alone shipped 974,366 pounds of fish, including fluke, flounder and weakfish from the Bay and bluefish, tuna, sea bass, porgies and cod from the deep sea. A common sight along the Freeport creek were the large wooden reels used to dry fishnets. Although pollution, dredging and lowering of the water table have destroyed the oyster industry, and fishing is much declined, the name "Free Port" still reminds us that in the 1880s captains sailed through Jones Inlet to avoid paying tariffs at New York Harbor and Sag Harbor, the main ports. (*Photograph by Hal Fullerton; Suffolk County Historical Society, Fullerton Collection #L1400.*)

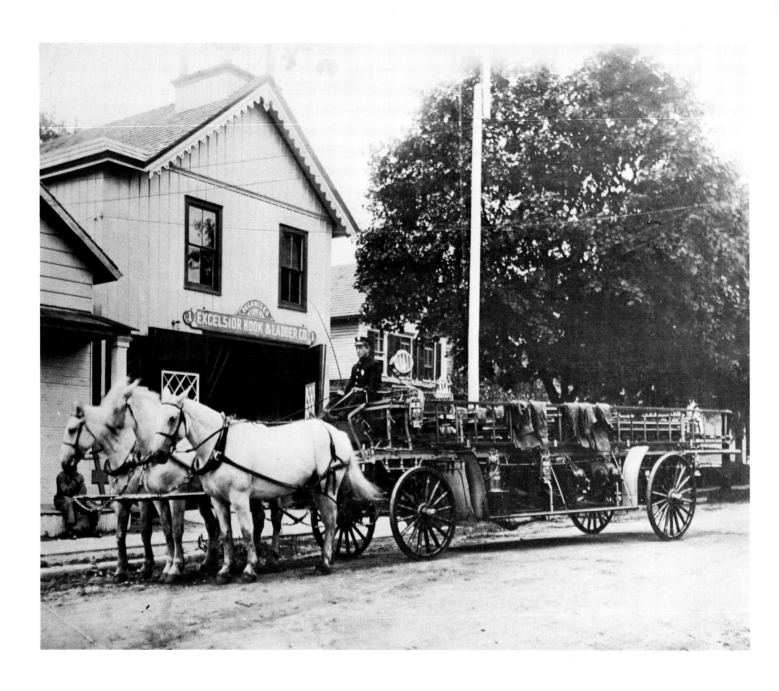

Above: **172. Excelsior Hook and Ladder Company, Freeport, 1895.** Originally called Raynor South (after Edward Raynor, who guided settlers there in 1659), Freeport was slow to develop. Organized in 1874, when the population was only about 700, the Excelsior Hook and Ladder Company first used men and boys to pull its equipment. In January 1893, a disastrous fire in the wooden school at Grove and Pine Streets was stopped from spreading to surrounding buildings when firemen threw snowballs on rooftops. This episode showed the necessity for the more modern fire-fighting apparatus shown in the photograph. (*Freeport Historical Society.*)

Opposite, top: **173. The Freeport Garage, Freeport, ca. 1908.** Capitalizing on two trends, one at its height, the other just beginning, the Freeport Garage in 1905 sold more bicycles than autos. Roads in the area were unpaved and interrupted by marshland; they were often unpassable for any kind of conveyance. The terrors of the automobile were appreciated fully by the Freeport Village Board, which passed an ordinance in 1908 that motorists could not exceed ten miles per hour. The punishments, disproportionately high for the day, were fines mounting to $100 and/or ten days in jail after the second offense. (*Freeport Historical Society.*)

Opposite, bottom: **174. Farmhouse of Mort Bright, Freeport, May 10, 1903.** Although this Freeport scene was recorded in the early twentieth century, it might well have looked the same a hundred years before. Like many such houses on Long Island, it grew with the size of the family from a one-and-a-half story single dwelling, one-room deep and two-rooms wide, to a double house with a side lean-to extension. The far slope of the roof is not visible in the photograph, but it probably is deeper than the front, as in the saltbox style. When the addition was made, a matching chimney was placed opposite the original, offering pleasing proportions and additional fireplace heat. These brick chimneys not only conserved the heat of the cooking fires, but warmed the sleeping quarters above. In this case, the additions were functional rather than decorative, reminding the viewer that this was once pioneer territory and that the first houses here reflected their English heritage in layout and design. (*Lightfoot Collection.*)

Over: **175. Grove Street Trolley, Freeport, ca. 1915.** This is the "Fishermen's Delight," on its first trip, at the corner of Merrick and Grove. It ran from what is now Sunrise Highway to the dock on Woodcleft Channel. In those days Freeport was a summer resort, known for its fishing. At least six hotels clustered there in the early 1900s, including the Crystal Lake House on Grove Street, which accommodated 150 guests. The trolley ended its service in 1923. (*Freeport Historical Society.*)

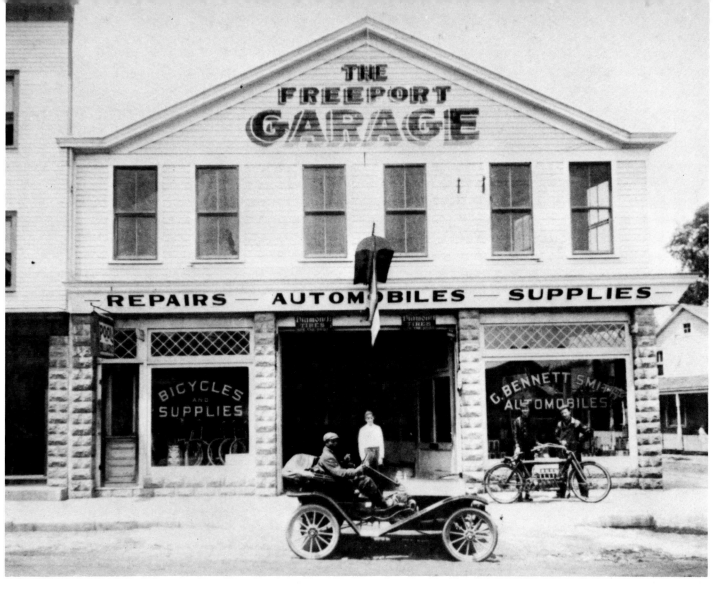

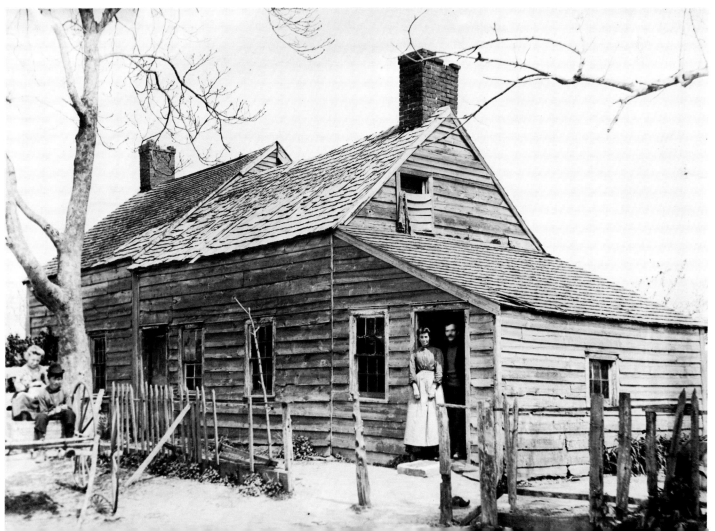

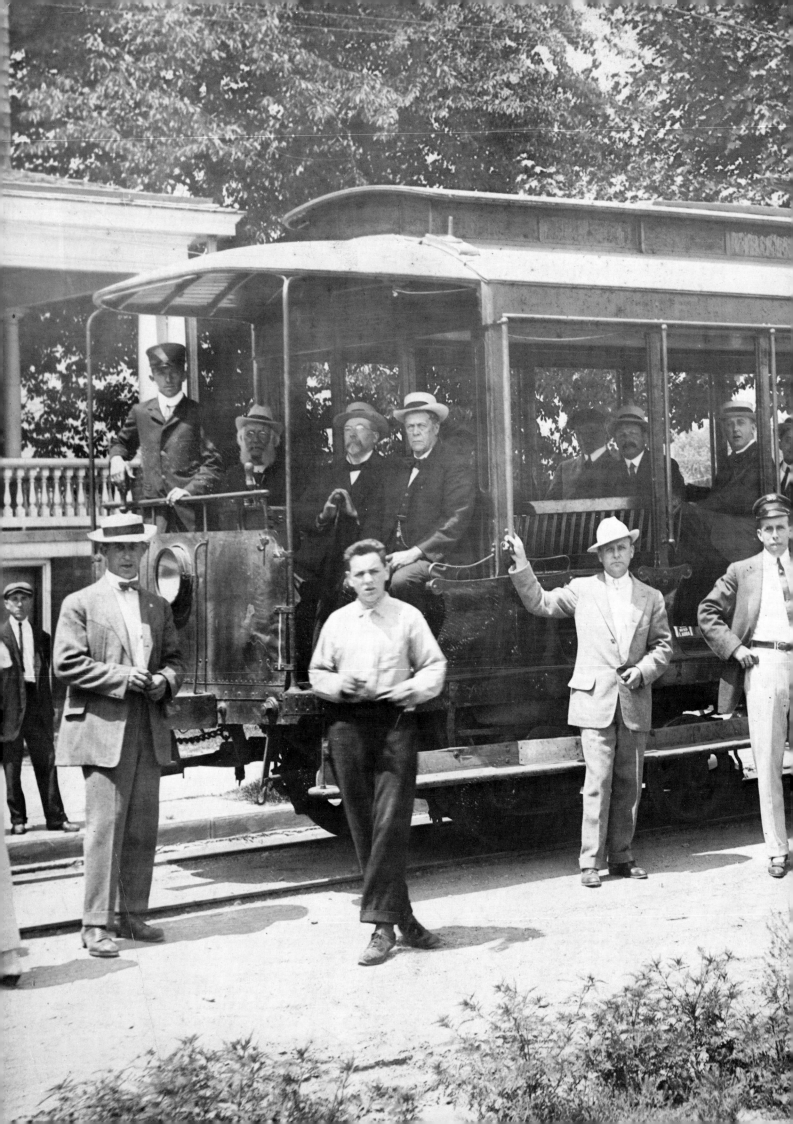

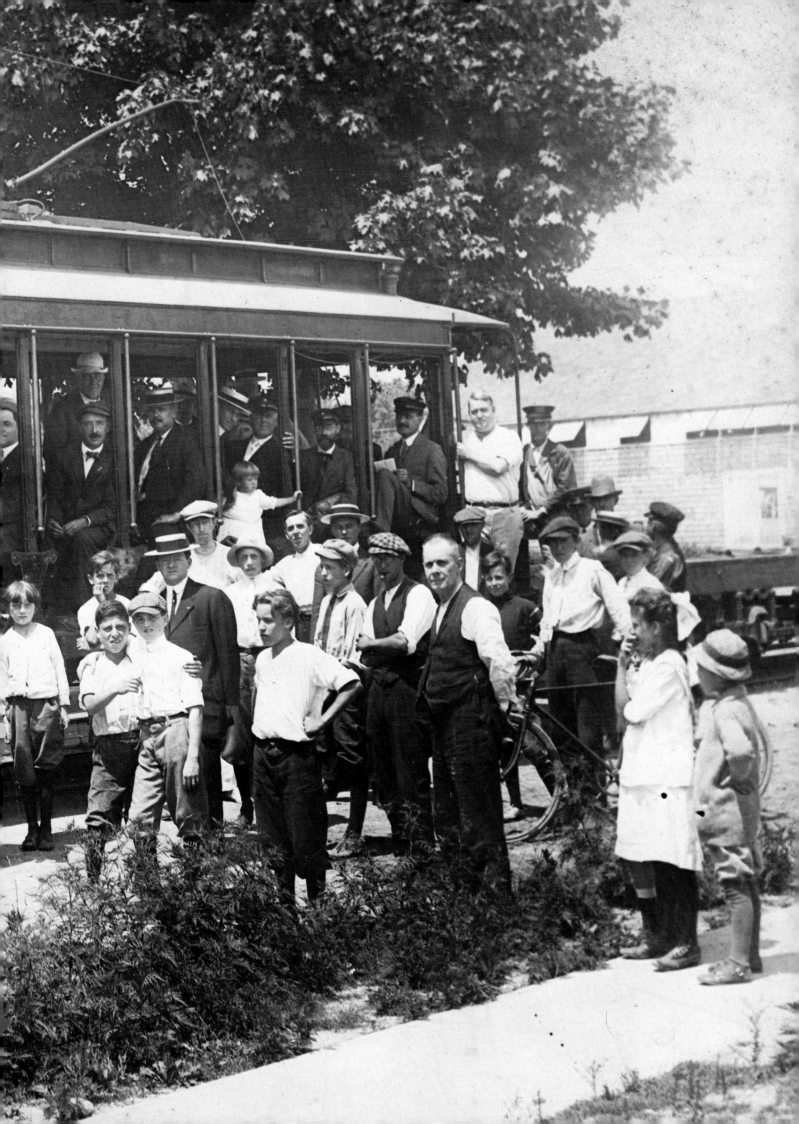

GENERAL INDEX

This index lists persons (including photographers), businesses, buildings, ships, constructions, monuments and estates mentioned in the captions to the illustrations. Unless otherwise noted, the numbers used are those of the illustrations. Streets, neighborhoods, rivers and other sites are not included.

CHRONOLOGICAL INDEX OF PHOTOGRAPHS

The numbers used are those of the illustrations. The indication "ca." is disregarded for the purposes of this index.